# HOW . TO . PAINT

## *Living*

# PORTRAITS

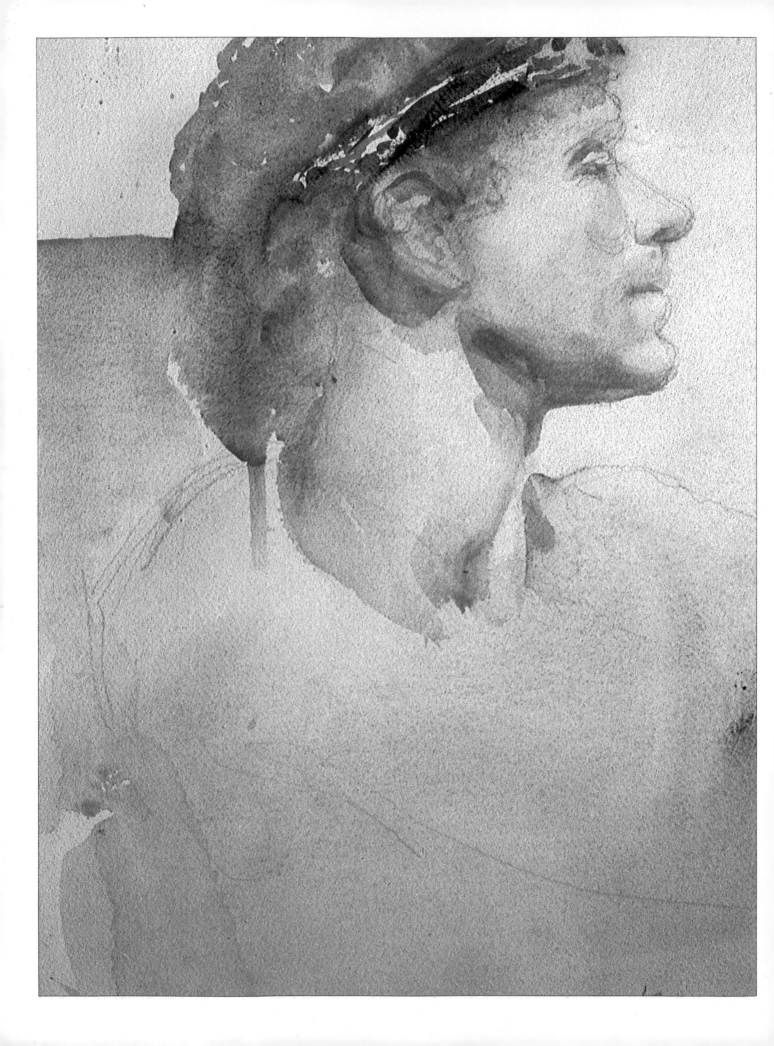

# HOW TO PAINT
## *Living*
# PORTRAITS

### ROBERTA CARTER CLARK

NORTH
LIGHT
BOOKS

Cincinnati, Ohio

Four years went by between the time this book was started and its completion. I wish to thank Mary Kennan for encouraging me to begin, and my family and friends for their patience and loyalty as I struggled to wrestle this monster to the ground.

Heartfelt gratitude also goes to Wendy Jennings for working so closely with me on the photography; to Patricia Lafferty for the jacket photo; to Andrea Ericson Hogan, the former director of Portraits, Inc., for her support and for sharing her intimate knowledge of contemporary portraiture; to Nancy Hale Bowers and to Prescott D. Schutz of Hirschl and Adler Galleries, Inc., who helped me track down the work of Lilian Westcott Hale, Mrs. Bowers' mother; to Nonda Biemiller, art teacher and good friend, who volunteered to be the first to read the entire manuscript; and to my editors, Bonnie Silverstein and Kathy Kipp, who, with their sensitivity and vast knowledge, whipped all my words and pictures into a finished work, never doubting the value of this project.

A special "Thank You" goes to my son, Dean Fittinger, for giving so freely of his time and energy, devotion and dedication, thereby helping immeasurably to bring this effort to conclusion.

*—Roberta Carter Clark*

## About the Author

Roberta Carter Clark has been affiliated with Portraits Incorporated in New York City for over 15 years, and has painted portraits of clients from California to New York, from Maine to Texas, and in England as well. She is an avid supporter of many art groups in her adopted home state of New Jersey, and has served as the president of the New Jersey Water Color Society for three years. Her work has earned her many awards and membership in Knickerbocker Artists, the Midwest Watercolor Society, the Pennsylvania Watercolor Society, and the Rockport Art Association.

**How to Paint Living Portraits.** Copyright © 1990 by Roberta Carter Clark. Manufactured in China. All rights reserved. No part of this book may be reproduced in any form or by any electronic or mechanical means including information storage and retrieval systems without permission in writing from the publisher, except by a reviewer, who may quote brief passages in a review. Published by North Light Books, an imprint of F&W Publications, Inc., 1507 Dana Avenue, Cincinnati, Ohio 45207. (800) 289-0963. First paperback edition 2001.

Other fine North Light Books are available at your local bookstore, art supply store or direct from the publisher.

05  04  03  02  01    5  4  3  2  1

**Library of Congress has catalogued hardcover edition as follows:**

Clark, Roberta Carter
    How to paint living portraits / Roberta Carter Clark.
        p.   cm.
    Includes bibliographical references.
    ISBN 0-89134-326-1 (hardcover)
        1. Portrait painting—Technique. I. Title.

ND1302.C54   1990
751.45'42—dc20                                    89-27776
ISBN 1-58180-179-3 (pbk.: alk. paper)             CIP

The self-portrait on the cover painted by Roberta Carter Clark.

*This book is dedicated to Judi, Dean and D. E., with love.*

# C O N T E N T S

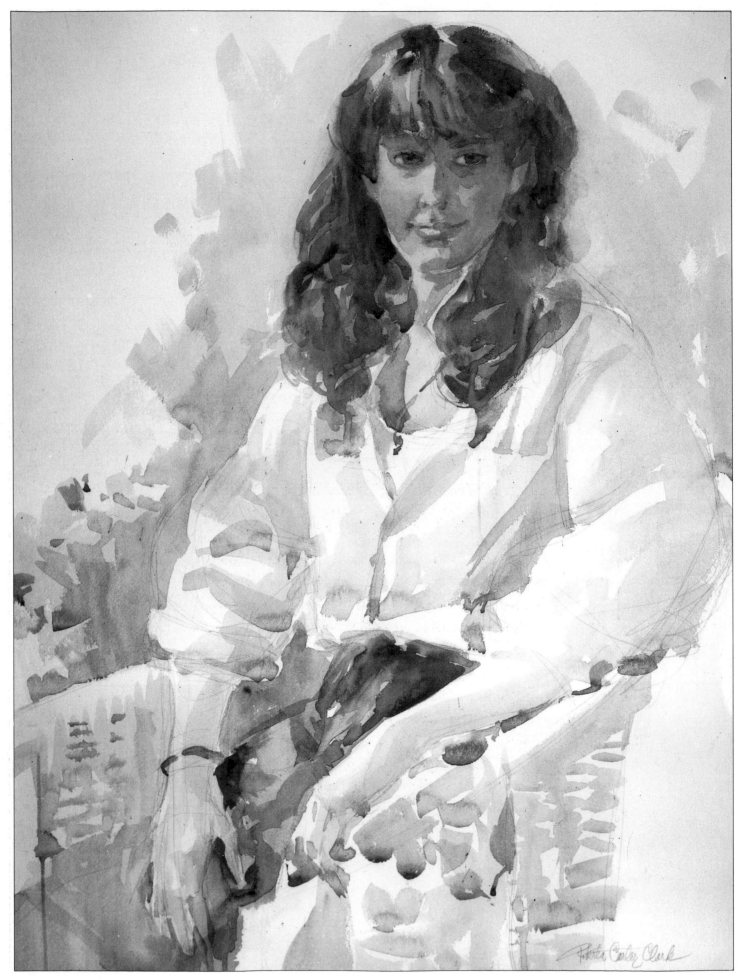

Roberta Carter Clark, *Jeannie in Pink*, watercolor. Collection of Mr. and Mrs. William C. Barr.

# P R E F A C E

Those of us who are interested in producing a portrait of another human being are usually so enchanted by this prospect that every other kind of artistic endeavor pales by comparison.

It's an interesting phenomenon that every person on our planet has two eyes, one nose, and one mouth, and yet each of us looks completely different from everyone else. This is the uniqueness that the portrait painter must catch. This "differentness" plus the specific personality projected make up what we call "the likeness," and the painter's skill and sensitivity in being able to capture these elements are what make the portrait successful.

I'm hoping that you have had some previous experience in drawing and painting before tackling this book. To learn the use of charcoal, oil, and watercolors by painting people is a most difficult task, and as a beginner, you may lay down your tools in frustration. However, once you've had some success with faces you may never again find the same sort of excitement depicting landscapes and still life.

If you can achieve a recognizable image in charcoal and understand something about mixing and applying colors, you will gain a great deal from this book. Just remember, no one is born knowing how to paint a portrait. Each of us has to learn—by studying, thinking, and working. If you have the desire, you will surely learn too.

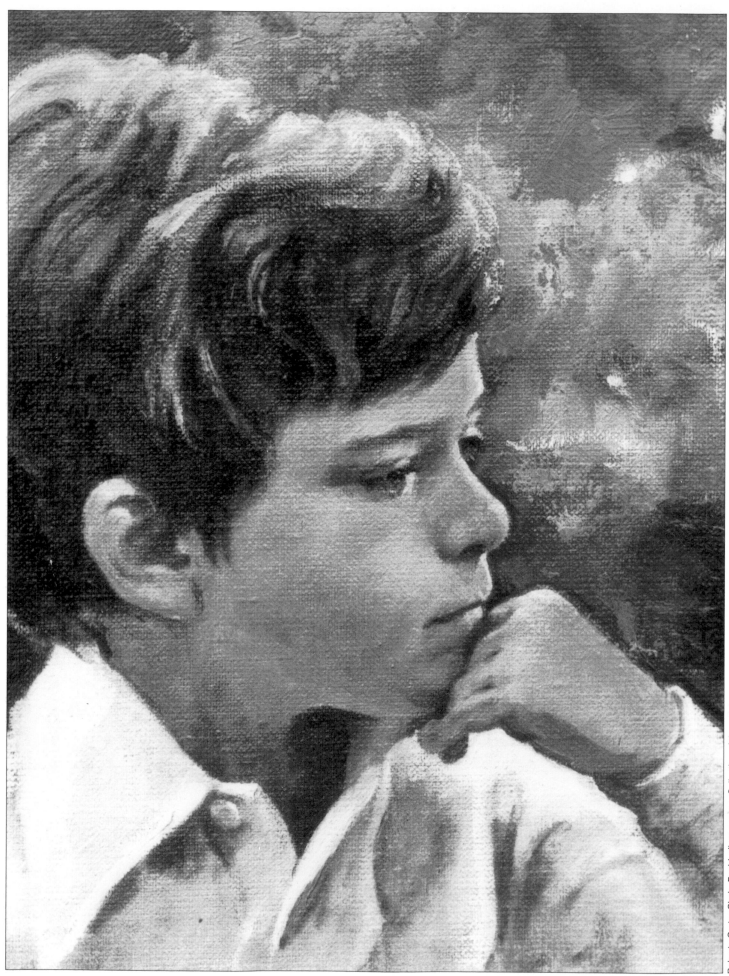

# THE PROPORTIONS OF THE HEAD

The success of a portrait is largely determined by how well the parts of the head interrelate: how the nose relates to the ears, the mouth to the jaw, the eyes to the nose, the facial area to the head—all these things must be discovered. This isn't overwhelming if you have a plan or blueprint of the way these parts fit together.

# Considering Solid Forms

Before we can draw and paint portraits we must learn to simplify very complex subject matter—the human head and body. Every portrait painter trains him or herself to perceive these forms in simple masses, overlooking details until the larger forms are satisfactory.

It is possible to draw a head shape using line alone. A circle is a basic beginning, but an egg shape resembles the human head more closely:

If we want to draw or paint a head that will appear to look solid, round, three dimensional, we have to begin to think about light and shadow and how to add these elements to our linear egg shape.

First we need to decide where the light source is that shines on this egg-shaped head. Study the drawings below. The part of the form that faces the light source is our light area, *A.* Another part will receive no light, the shadow area, *B.* Notice that this very distinct jump from light to shadow really doesn't help to indicate round form—do you agree?

We need an intermediate step between the light and the shadow. This transition step is called the *halftone.* It is a very narrow area, *C,* which indicates a rounding of the form from the light area into the shadow area.

Now we are thinking in terms of light, shadow, and halftone, but there is one more element to consider—*reflected light.* If our ovoid head form were on a body wearing a colored garment, we would see that color reflected up into the shadow area on the jaw or under the chin, *D.* This bounced light is subtle and *never* as light as the halftone: Remember that reflected light is part of the shadow, and if it is made too light the head will no longer appear solid.

A                    B                    C                    D

**Exercise:** With pencil or pen and paper try drawing *A, B, C,* and *D* yourself. After about twenty oval "heads" you will find you can draw these solid forms with ease and understanding.

In these drawings we have used shadow to define form. Artists call this "modeling the form." We look for the *lights* first, but the only way the lights can be defined on white paper is to draw in the *shadow* first. This makes the "seeing process" different from the "doing process."

# Step-by-Step: **Making an Egg Head**

As a prelude to working with an actual head, we'll learn about the relationships between light and dark by using an actual egg. Experimenting with an egg head has an advantage at the beginning of your study of the head and features: You can set it at any angle you choose—yet it won't move. To make an egg head, take an egg and make a hole in each end with a pin. Hold the egg over a bowl and blow into one end, and the inside will come out, leaving the empty shell. Rinse it out with clean water, handling it carefully. (When you begin to use your egg as a model to draw form, you'll find you can make it stand on end by using an empty pill bottle or a bottle cap as a base.)

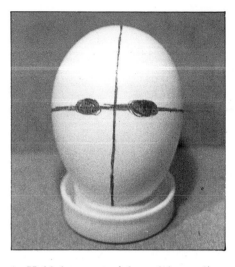

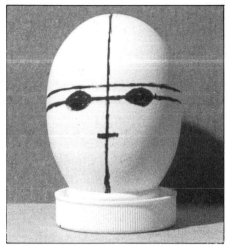

1. Hold the egg upright and draw a line with a fine marker or a pencil straight down the shell's center, top to bottom. Now draw a second line horizontally around the egg, halfway down and at right angles to the first line. On either side of the vertical line, draw eye ovals on the horizontal line—this is called the "eyeline."

2. Add a second horizontal line just above the eye ovals. This will be the "eyebrow line." Now, not quite halfway down between the eyebrow line and the very bottom of the egg, make a mark for a nose, crossing the central vertical.

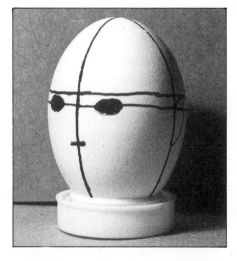

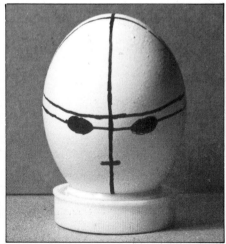

3. Now try turning the egg a quarter turn to the right. You may need to add another vertical line from top to bottom halfway around the side where the ear would be. The egg now resembles a football.

4. Tilt the egg slightly forward and you will see the eyeline appears to round downward at the center front and curve up at the sides. This curve is what makes the head "look down."

## Lighting the Egg

Hold the eggshell so the brightest light from a window or a spotlight strikes it at the upper left front, and study the shadows on the shell. Do you notice the way these shadows change with even the slightest tilting of the shell? Place the egg on the stand so the shadow pattern remains constant. You'll see several different types of lights and shadows on and around the egg. Between the light and shadow areas on the "face," you'll see the halftone. (You'll always see the halftone on planes where the light is deflected from the face and glances off of it.)

Now draw the egg, indicating the light, shadow, and halftone areas as you see them, and letting your strokes go across the form. You now have your first "head." Add mouth, ears, hair, and a neck, if you wish.

**Exercise:** Make twenty drawings of egg heads, tipping your egg slightly to the right and left. Also try turning it a quarter turn to the right, then left, or looking up or down. For three-quarter views you may need to add another vertical line from top to bottom halfway around on both sides where the ears would be. (The egg will then resemble a football.)

*Note:* When you add mouth lines to your ovals, think of the mouth line as closer to the nose mark, not halfway between the nose and the base of the egg.

## Cast Shadows and Reflected Light

On a real head, you'll also notice cast shadows and reflected light. The cast shadow is very important, though in portraits it's somewhat subtle. We see it, for instance, when the nose casts its shadow on the curve of the cheek or on the area between the nose and the upper lip. Or when the chin, as it projects, casts its shadow on the cylinder of the neck. The cast shadow tells us something about the size and the shape of the object casting the shadow. It also describes the contour of the surface on which the shadow falls. It makes the features look "real" (three dimensional) and tells us the light direction. A final element to consider in modeling form is reflected light, which, in a way, is the opposite of a cast shadow. When the light source shines so brightly that the light bounces off a light-colored shape, like a shirt or blouse, and back onto the face, the bounced light is aptly termed "reflected light." Reflected light is subtle, and never as light as the halftone. If you make the reflected light too light, the solidity of the form will be destroyed.

**LIGHT: The part of the head facing the light source.**

**SHADOW: The area of the head facing away from the light source where direct light does not strike.**

**HALFTONE: The plane of the face that exists at an angle to the light source so light is deflected and glances off. It is not light, not shadow, but a side plane. On a rounded form like the face, the halftone is the transition area between the light plane and the shadow plane.**

# *Step-by-Step:* **Drawing the Adult Male Head in Profile**

When drawing the head, it's important to know what to look for even before you have a model. On the following pages, you'll find methods of constructing the head and for accurately drawing proportions for heads from babyhood to old age. Draw the diagrams again and again until you can do them with ease. Copy the diagrams at first, then draw from imagination. Don't use mechanical devices; try to train your eye to judge relationships. Think about what you're doing.

You'll need a pen or pencil, paper, kneaded eraser, and ruler (also graph paper, if you wish) for these exercises. For a change of pace, you may want to draw the proportional divisions you'll work with here over photographs of heads in magazines. This should help carry you from the idealized proportions you'll learn here to actual ones of real people of all ages and types. You'll be amazed at the variety you'll find.

Since the most basic way to get a likeness is in profile, we'll begin with that. The drawings you'll study on the following pages are based on two-inch squares, each divided into four one-inch squares. On your paper, make several squares in ink (or use graph paper), and chart the heads on them in pencil. In actuality, the life-size head of a six-foot tall Caucasian male would measure nine inches from the top of the skull to the bottom of the chin, and nine inches from the tip of the nose to the back of the skull.

1. Place the eye on the horizontal halfway mark (*1-3*) as if the line passed through the lower eyelid. (The eye is actually halfway down the head.)

2. Divide the left edge of the square into seven equal parts. Try to measure by eye, not with a ruler.

3. The eyebrow sits at line *c*, along with the forward projection of the skull above the eyeball.

4. The bottom of the nose sits at *e*, halfway between brow line and chin line. There is a wing of cartilage flaring over the nostril, and the bottom of that curve is on line *e*. The tip of the nose may turn up

above that line or curve down below it.

5. The top of the ear also lines up with the eyebrow at *c*. The bottom of the earlobe lines up with *e* at the base of the nose. The ear is placed at the vertical halfway mark (*2-4*) extending toward the back of the skull.

6. Draw the forehead up from *c* in a squared curve to top center *2* and continue in the squared curve to *3* at the back of the skull. Continue the curve until a point level with the base of the nose and ear is reached, lined up with *e*, forming the base of the skull.

7. The mouth is between *e* and *f*, with the lower lip projecting above *f*. Drop a chin line to *g* on the bottom line and extend it to *h*.

8. Now, with a slight curve, draw the jawline from *h* to the back of the skull with a dashed line.

9. Sketch a light diagonal line from the brow projection at *c* through *h* under the chin for the front of the neck.

10. Parallel to the line you just drew, draw a diagonal line from the top of the skull at *2*, through the base of the skull for the back of the neck.

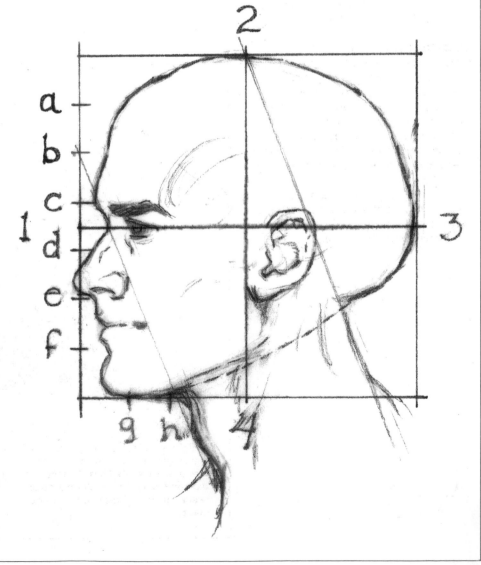

# Step-by-Step: **Further Practice**

Now for some fun. Place tracing paper over the charted head you just drew and add hair, or a beard, a hooked nose, or a receding chin. Look at the variations in structure for a Black man, an Oriental, and a Native American that follow. No two heads are alike, but the charts will help you learn what to *look for* in the people around you and in models who pose for you. Draw twenty heads a day until you become fluent at this.

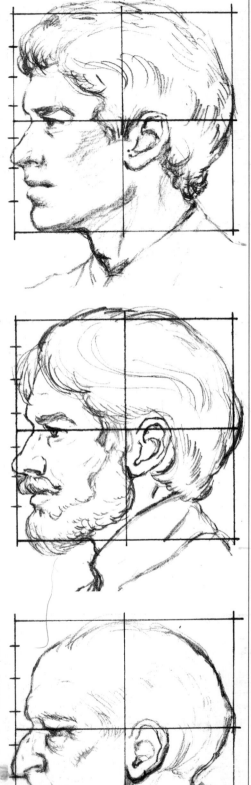

The classic Caucasian male.

The same man with longer hair, a moustache, and a beard. *Warning:* A beard must be drawn with extreme care, or your man will resemble a dog!

A Caucasian male at age eighty. His teeth are gone, so the lower part of his face has become shorter (as it is with an infant). The fatty tissue has disappeared, making the skin less firm and the bones under the skin more visible. Gravity has the greatest effect in aging all of us—eyelids, nose, cheeks, all are pulled downward. The spine is less erect and the head extends farther forward.

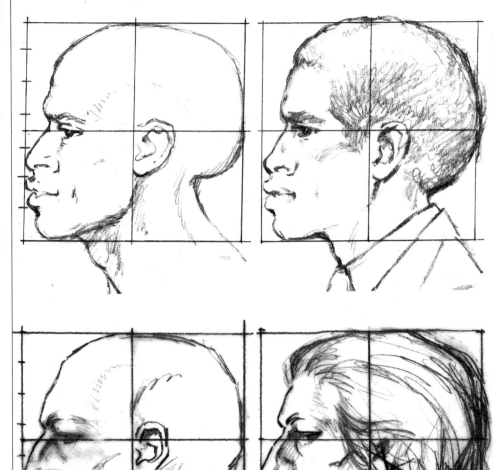

(Left) The classic Black male. Notice that the mouth structure may protrude beyond the nose, which tends to be flatter than the nose of a Caucasian. (Right) The same Black male with tightly curled hair clipped close to the scalp.

(Left) The classic Native American male. The facial structure actually varies from tribe to tribe; this head has the strong, angular features most of us picture as Native American: a very pronounced brow and arch of the nose, high cheekbones, and a lean, square chin. (Right) The same man shown with long, straight, black hair. Native Americans have no facial hair, so never draw them with a moustache or beard.

(Left) The classic Oriental male. Notice the flat, broad face, high cheekbones, and heavily lidded eye (which does not actually slant) that are characteristic features of Orientals. (Right) The Oriental male has straight black hair and very little facial hair, so again, no heavy beards, please.

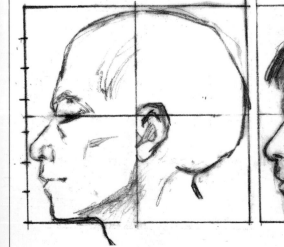
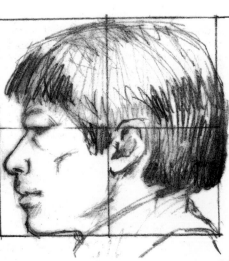

# Step-by-Step: **Drawing the Female Head in Profile**

Again we begin with a two-inch square divided into four one-inch squares. The process is much the same as for the male profile except that the forms are softer, so try using more curved lines than straight. The life-size head of a female of average height measures 8¼ inches from the tip of the nose to the back of skull, and 8¼ inches from the top of the skull to the bottom of the chin. Again, this charted female head is a more or less "ideal" classic Caucasian.

1. Place the eye on the halfway mark—the line would be through the center of the pupil if the eye were looking straight ahead. The front edge of the eyelid may be drawn approximately one-third of the distance from the left side of the square, *a* to *f*, to the center vertical line *2* to *4*.

2. After dividing the left edge of the two-inch square into seven parts, draw the brow and the skull projection at *c*. In females the eyebrow is often higher and more curved.

3. Put the base of the nose at *e*, halfway between the brow and the bottom of the chin.

4. The top of the ear is on a line with *c*, the bottom of the earlobe and base of the nose are at *e*, and the front of the ear is at center vertical line *2* to *4*.

5. Note that her forehead is much more curved than the male's. Draw this line from *c* curving to the top of the skull at *2*, around to the back of the head at *3*, still curving to a point level with *e*, the base of the nose.

6. Place the mouth between *e* and *f*.

7. Drop a curving chin line to *g*. Sketch a jawline from *g* to the base of the skull.

8. Since the female neck is more slender and often longer than the male neck, try drawing a slightly curved diagonal from *c* at the brow, back and down, so that the pit of the neck lines up under the earlobe.

9. Parallel to the line you've just drawn, draw a slightly curved diagonal from the top of the skull at *2*, touching the top of the ear to the base of the skull for a guide-line indicating the back of the neck.

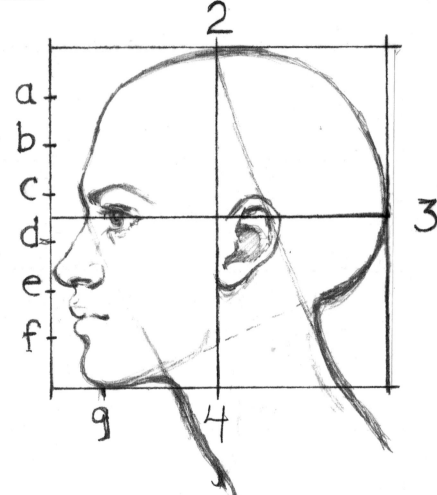

# Step-by-Step: **Further Practice**

After making several charts, put tracing paper over the head, drawing the woman with some hair as shown in the two top drawings below. Change her hairstyle—maybe to your own. Note how these changes affect her age and personality. Try at least ten different looks. Draw her middle-aged, then make her eighty years old.

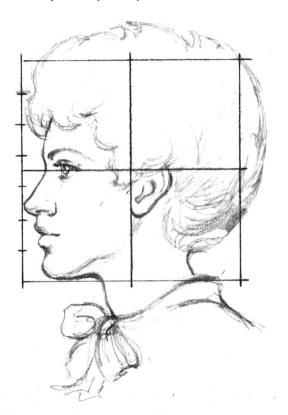

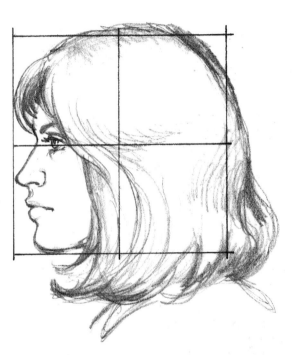

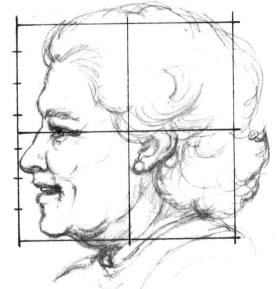

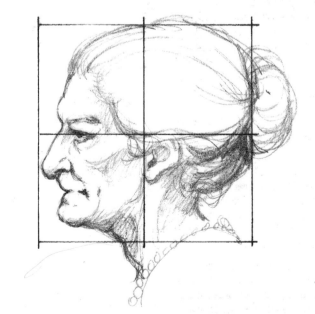

Study the features in the drawings on the previous page, then draw the woman as a Black, then an Oriental. Begin to really look at the heads of people around you. Remember, there is no substitute for thoughtful observation of life.

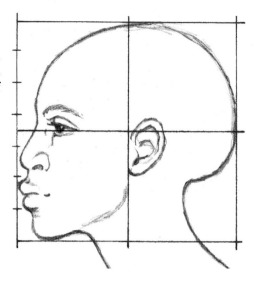

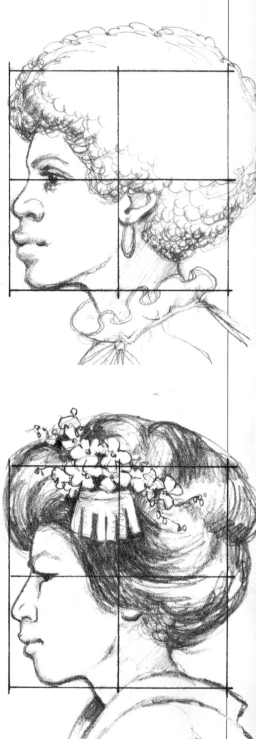

(Above) A classic Black female head. The mouth structure may project a bit more than the nose, which is slightly flat. The chin is very rounded. The brows are high and the eyes quite large. (Right) A modified Afro hairstyle and a collar are added.

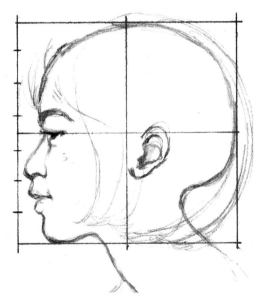

A classic Oriental female head. Because the facial plane is slightly flatter than that of a Caucasian face, the bridge of the nose is less defined. The skin, not being pulled taut to cover a more projected nose bridge like that of the Caucasian face, forms the Oriental eyelid. The eye does not really slant, but in many instances, it lacks the extra fold of the Caucasian upper eyelid.

You'll seldom have an opportunity to paint the portrait of a woman in a geisha wig, but I wanted you to see the dramatic change this hair treatment makes.

# Step-by-Step: **Drawing the Infant Head in Profile**

An infant's head is quite different from an adult's. The face itself (eyes, nose and mouth) takes up a relatively small area of the head, the face is much flatter, and there is virtually no chin.

The infant's face is sometimes nearly lost in fatty tissue. In profile, the cheeks can totally obscure the corners of the mouth. The distance from nose to chin is quite short, since there are no teeth. (This happens again in old age as the teeth are lost.) The eye appears very large in the tiny face because the eyeball is nearly the size of an adult's. Very little of the white of the eye is visible, but that which is observable is blue-white. The skull is sometimes flatter and longer rather than round. The infant usually doesn't have very much hair. You can try drawing the heads of babies of different races, but you'll find there are considerably fewer differences at this age.

1. Most babies have almost invisible eyebrows, but place a small eyebrow mark on the halfway line *1* to *3*.

2. Divide the lower half of the left edge of the square, at the face, into four segments.

3. Draw the eye at *a*, also a very shallow bridge of the nose. The eye is very round.

4. Make a small bump of a nose between *a* and *b*, and a projecting upper lip at *b*. Very often this upper lip protrudes even beyond the nose.

5. Pull way back and place a very tiny lower lip at *c*.

6. Add a round receding chin, very small, between *c* and *d*. A curving fold of fat rather than a jawline is evident here.

7. Place the ear, halfway back on the skull, from brow line *1* to *3* down as far as the base of the nose.

8. Add a very round skull curving from *1* up to *2* to *3*. At the back its base is on a level with *b*, the upper lip.

9. The infant's and child's head sits on a straight neck, but it is very short and not easily seen until the little one sits up at about six months. The head does not project forward as does the adult's.

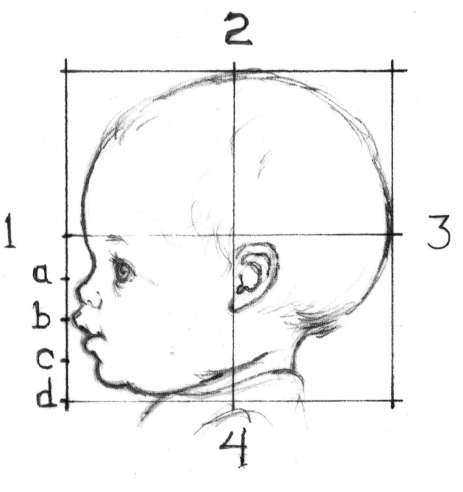

# *Step-by-Step:* **Further Practice**

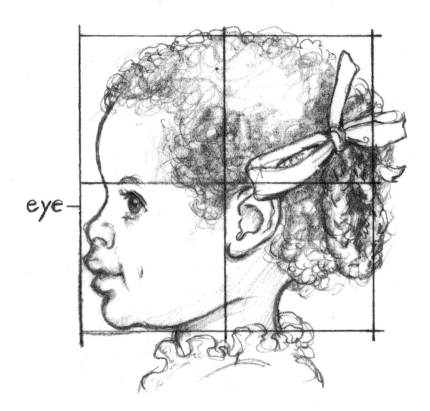

eye

**The Child** When the child is four or five, the face is still quite small in proportion to the entire head, but the eye has "moved up" from the infant proportion. This is because there is more mass in the lower quarter of the face — there are now upper and lower teeth and a jaw that has grown to accommodate them. This lengthens the facial mask. Study the illustration here and see if you can draw a child's head with similar features.

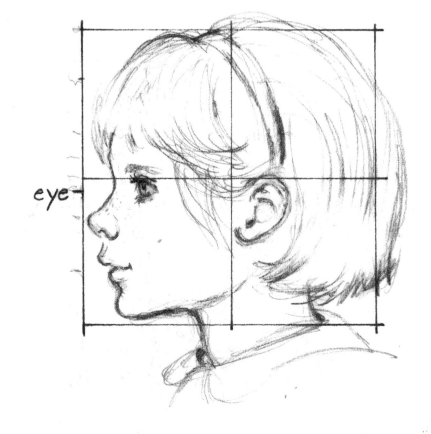

eye

**The Preteen** As the child matures, the eye "moves up" until it reaches the halfway line at adulthood. This child is eleven or twelve years of age. Baby fat has gone and is replaced by more clearly defined features.

It's quite difficult for an artist to get a child's age right at any stage of life, but from age eleven to fifteen this becomes a challenge to the best of us. Extra-careful observation is the key.

# Step-by-Step: Drawing Adult Heads, Frontal View

The major difference between the frontal view and the profile view is that the entire head, seen from the front, is considerably more narrow. A male head, 9 inches high, is 6½ inches wide, with maximum width just above the ears. The vertical proportions do not differ from the previous profile diagrams, that is, the eyes are halfway down the head at horizontal line *1* to *3*, the base of the nose is halfway between *c* (the brow line) and *g* (the chin line).

A rule of thumb says the head (on the eyeline) is five eye-lengths across. The outer two eye-lengths are normally somewhat obscured by hair.

The corners of the mouth (when it's not smiling) often fall in a line directly beneath the pupils of the eyes. The neck of the athletic male is as wide as the jaw, while the adult female neck is often more slender.

To make your own charts, copy these proportions onto a larger piece of paper or place tracing paper over these drawings and copy the basic structural lines. Then fill in the squares with your own versions of these heads, working freehand from the instructions provided above.

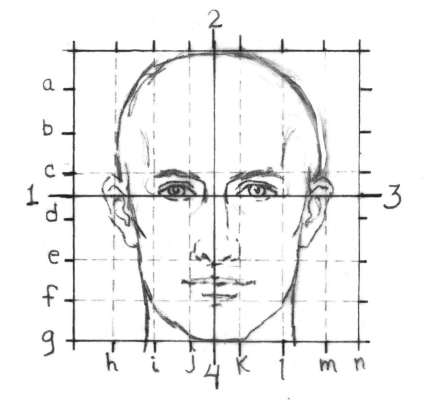

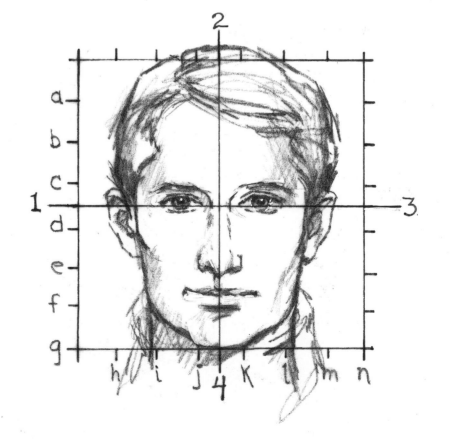

# Step-by-Step: **Further Practice**

Using the diagrams you have made, give your male and female drawings hair and collars. Try several more with different physical characteristics. Vary the race, the age. Add beards or eyeglasses. Remember, glasses must sit on the *bridge* of the nose and inside the top of the ears. Look at candid photographs in newspapers and magazines for ideas; every person is unique.

Try ten profile views one day, ten front views another, giving yourself at least four days on each view until you can draw the diagrams comfortably and without strain. Later you'll need only the vertical and horizontal proportional lines as corrective checks in case you get into trouble on a head.

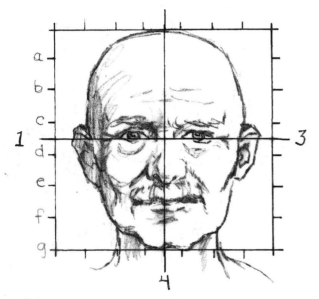

The sixty-year-old male.

Adding eyeglasses.

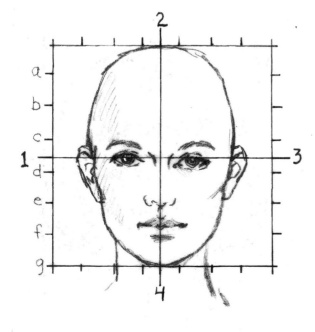

The adult female, front view.

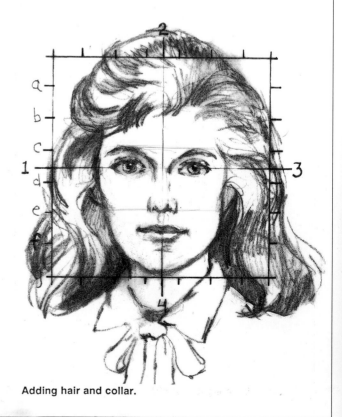

Adding hair and collar.

16

# Step-by-Step: Children's Proportions, Frontal View

Children are not that different from adults. Just remember, the younger the child, the *lower* the eyeline. And the child's head is wider in relation to its length, giving the whole head a more round appearance. As the child grows older, the eyes move up to the halfway eyeline, and the face (along with the entire body) loses the baby fat, becoming less round and more elongated.

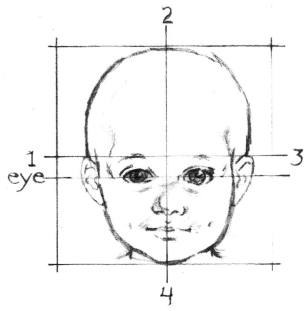

The toddler, front view.

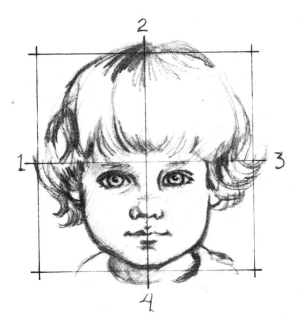

Toddler with hair and collar.

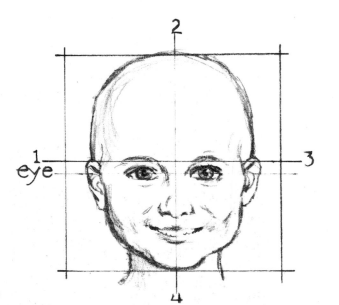

The six- to eight-year-old.

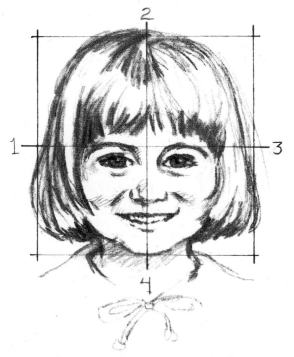

The six- to eight-year-old with hair and collar.

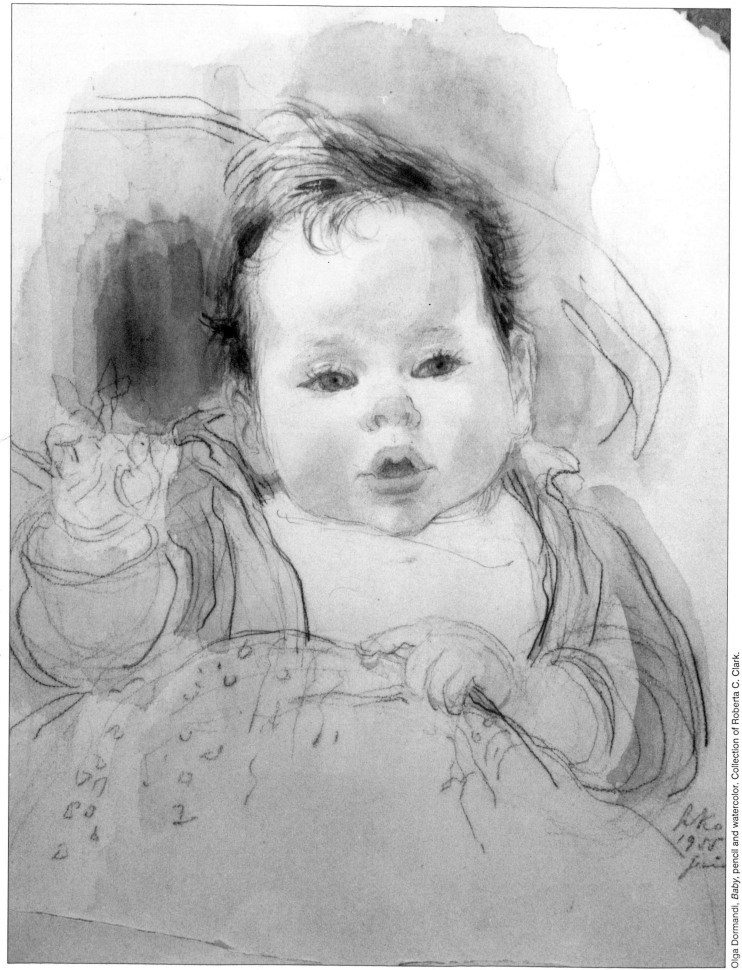

Olga Dormandi, *Baby*, pencil and watercolor. Collection of Roberta C. Clark.

# Drawing the Features

Every day of our lives we look at the eyes, noses, and mouths of our own faces and those of our companions. Indeed, we are so familiar with these features that in order to draw them we must step back and rediscover each one. To accomplish this we will try to reduce the eye, nose, mouth, and ear to their most basic components. In doing so, we will become more aware of their construction and form.

You may wonder why you will be asked, over and over again, to study your own face in a mirror. I have the best of reasons. The mirror studies that follow the description of each feature will help you become more observant. A fine portrait painter is sensitive to the most infinitesimal changes in shape and aspect of the facial features. The portraits you paint can only record what you've seen. *Seeing* is even more important than understanding color or knowing how to handle the brush. My most important obligation in writing this book is to help you to learn to see.

# The Eyes

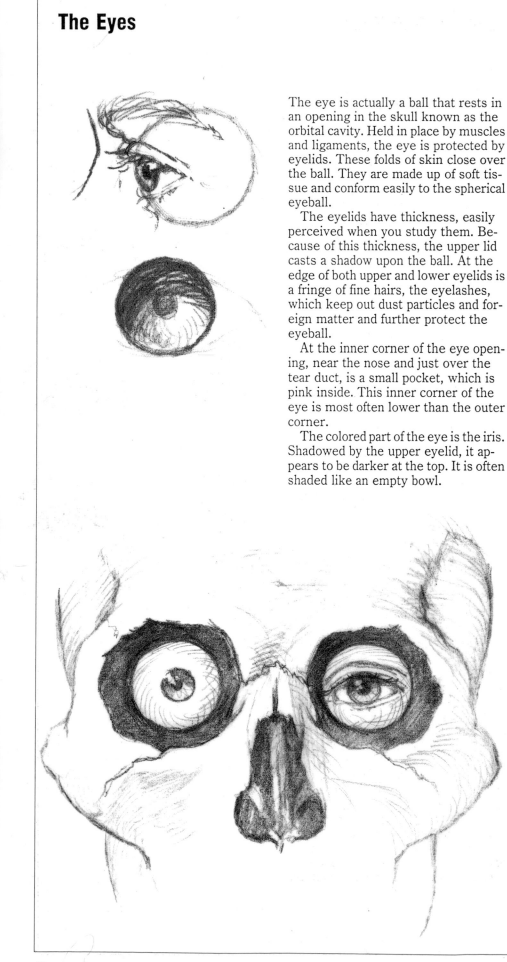

The eye is actually a ball that rests in an opening in the skull known as the orbital cavity. Held in place by muscles and ligaments, the eye is protected by eyelids. These folds of skin close over the ball. They are made up of soft tissue and conform easily to the spherical eyeball.

The eyelids have thickness, easily perceived when you study them. Because of this thickness, the upper lid casts a shadow upon the ball. At the edge of both upper and lower eyelids is a fringe of fine hairs, the eyelashes, which keep out dust particles and foreign matter and further protect the eyeball.

At the inner corner of the eye opening, near the nose and just over the tear duct, is a small pocket, which is pink inside. This inner corner of the eye is most often lower than the outer corner.

The colored part of the eye is the iris. Shadowed by the upper eyelid, it appears to be darker at the top. It is often shaded like an empty bowl.

The pupil in the center of the iris is black. It's actually an opening into the eyeball that admits light to the retina and enables us to see. The pupil grows larger in dim light, allowing more light to be admitted; in very bright light the pupil contracts to protect the retina (the light-sensitive membrane lining the inner eyeball).

The eyes move together—looking up, down, left, or right. And they always look wet and shiny because they are always bathed in tears.

The eyebrow follows the bone forming the upper edge of the orbital cavity. Where the light hits this bone, the brow appears lighter. This brow bone is called the *superciliary arch.*

The eyes are the very best indicators of mood, of emotion. As many have said, they are the "very windows of the soul."

## Observing the Eyes

Begin your study of the eye by observing your own features in a mirror. That way you don't have to look for someone to pose, and you can study each feature as intently as you like without embarrassing your sitter.

Find a place in fairly good light where you can sit or stand. You may want to use your easel for this study. You'll also need a hand mirror for the profile views, unless you have a three-way mirror.

Move your head slowly to one side, then the other, and notice how the shape of the eye opening changes. Now, move your head up and back so you're looking down your nose at the mirror. See how much smaller the eyes look? Move your head down, chin on chest, and look up at your eyes in the mirror; now they look quite round.

Scrutinizing your eyes this closely you may find that one eye is larger, or higher, or has a droopier eyelid. This is quite normal—don't be alarmed. Not one face in a million is perfectly symmetrical. Indeed, your close observation of these deviations from the expected will give you your likeness. Generalizing the forms you see takes away character and personality from your portrait.

# *Step-by-Step:* **Drawing the Eyes, Full Face**

You will need a soft pencil, drawing paper, and kneaded eraser for this study—and the mirror, of course.

1. Start with the sphere of the eye, lightly drawn. (Even though you can't see it, you know it's there.) Draw a second sphere for the other eye, leaving an eye's width between. (See the sketches at right.)

2. Draw the eyelids curving over the sphere as shown in the second sketch. Notice the lower lid has a different contour from the upper lid. And the upper lid casts a shadow upon the eyeball. Without this shadow, the eye will appear to be "popping"—too prominent.

   Now add the tearduct where the upper and lower eyelids intersect, next to the nose. Most often this corner is lower than the outer corner. Draw the fold line in the upper lid, and perhaps add some shadow as shown here to indicate the depression next to the bridge of the nose. Is there a fold line *under* the eye?

3. Draw the eyebrows. Remember the brow is made up of many small hairs; it's drawn with short strokes, not one continuous line. Lay in any shadows you see under the brow bone, and under the lower lid. Erase the eyeball circle line.

4. Put in the round, colored iris. If you open your eyes very wide, you'll see the entire circle; without stretching your eyes open, either the top of the iris will be covered by the upper eyelid or the bottom part by the lower eyelid, or, most likely, both the top and the bottom by both lids. It's very unusual to see the entire iris. Look carefully for the shiny white highlight, and leave that tiny area of the paper white (or you can lift it out later with the eraser).

   Now add the black pupil in the center of the iris. Make this very dark.

   Study the right eye. Add the eyelashes *only where you see them.* Check the alignment of the two pupils by laying your pencil horizontally across them, making sure you are holding it straight and not tilted. (This method is indispensable no matter what medium you're using to draw or paint eyes. It also works well on aligning the ears, and straightening up the mouth or the nostrils.)

**Finishing Up** With one last critical look, check your work by looking at your *drawing* in the mirror. Looking at your artwork in a mirror is a foolproof way to spot errors. In this instance, you could clearly see if one eye is larger, or lower, or out of kilter in any way. Correct any errors you find. Add whatever accents you see in the eyes that will bring your drawing to life. For example, you may wish to add an extra dark shadow under the upper lid. Or darken the upper third of the iris, which adds considerable depth to the eyes. Or you may want to add small dots of extreme dark or extreme light to add the "snap" that gives the eyes life.

Don't you really love drawing eyes? Isn't it exciting and challenging to make them look as if they might blink, or to have them convey mood? As you draw other people's eyes, try to get the age group right. For example, glamorous eyes with long sweeping eyelashes would be inappropriate on a child. Can you show wisdom in the eyes of someone who has lived quite a long time? Some eyes really do sparkle and dance. Can you portray this effect?

Incidentally, if the sitter is posed so that the eyes are looking at the artist, and the artist has painted the eyes as properly focused, the resulting portrait image will appear to be looking at anyone viewing the portrait and the painted eyes will "follow you around the room," a phenomenon that never ceases to amaze the viewer.

It's safe to say you will never be bored drawing eyes, for everyone's eyes are unique. The variety is infinite.

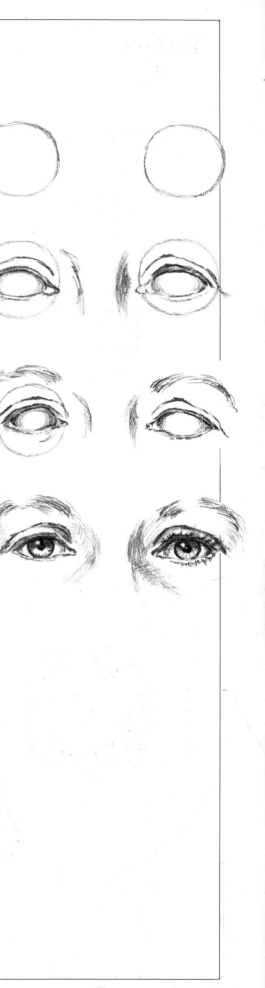

# Step-by-Step: *Drawing Profile Eyes*

The only way you can study your own eye in profile is to look at it in a second mirror, such as at a hand mirror reflecting your image from a wall mirror. (You can also use a three-way mirror if you have one.) This may seem a little cumbersome, but the information gained from this study is well worth it.

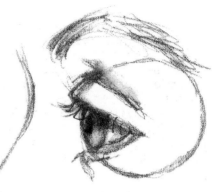

*Hint:* Try drawing some eyes in profile by observing other people. These are easier than full-face eyes, for they don't have to be looking at you. If you keep at this, you'll soon find you can do an eye quite quickly!

1. Begin with the lightly drawn sphere. Of course you can see only one eye when looking at the eyes in profile, for the other eye is hidden behind the nose, on the other side of the head.

   Draw the curve of the upper eyelid, then the lower lid. You will be unable to see the tearduct pocket.

2. Add the eyebrow, then the shadow under the brow, if there is one, and the shadow under the lower lid.

   Study the iris. You will see that it is no longer round from this angle, but is a flattened disk shape, and a part of it will be hidden by the eyelid. The highlight is even smaller in this view; study it carefully and try to leave it the white of the paper when coloring in the iris. If you can't manage this, pick it out with your kneaded eraser.

   Now draw the pupil, which is also a flattened disk shape, very dark. The darker you make the area surrounding the highlight, the brighter the highlight will appear. Put in the eyelashes, which are much more prominent in the profile view. Then add the accents.

   Finally, erase the lines indicating the sphere that are still visible, and there you have it!

# Step-by-Step: Drawing the Eyes, Three-Quarter View

This view requires even more careful observation than the full face or the profile. Most of the heads you will paint will be in a three-quarter view as this angle appears most natural and least posed. Look in a mirror and draw your own eyes, but each time you look, be sure your head is in *precisely* the same position as before. A half-inch turn to the right or left changes the perspective of the eyes.

1. Draw the two spheres and draw the eyelids over the spheres. Immediately you'll see why this view needs careful observation: the left eye is *very* different from the right. Coloring in the irises should help with the eyelids. (Try to leave the highlight white.) Add the fold line in the upper lid with care. Then the tear duct. See how the inner corner of the eye farthest away from you is partially hidden by the bridge of the nose. You may not even see the tear duct of that eye.

2. Add the pupils, very black. Leave the highlights the white of the paper or lift them with an eraser. Add the eyelashes only where you see them. Draw in the eyebrows. Then look for shadows—where? Usually there are shadows on both sides of the bridge of the nose at the inner corner of the eye, but don't add them unless you see them. Is there shadow under the lower lid, and at the outer corner of the eyes?

   Erase the sphere where it is still visible. Incidentally, these eyes are my own, drawn while I studied them in a mirror.

**Exercise:** Draw as many pairs of eyes as you can from life, magazines, and photographs, every day for a month. This effort will be of enormous benefit to you. I believe it's safe to say that the success of your portraits depends upon your finesse in drawing and painting eyes.

*Hint:* The three-quarter view is less static than the full face or profile. More movement is indicated because the head is facing one way but the eyes are looking another.

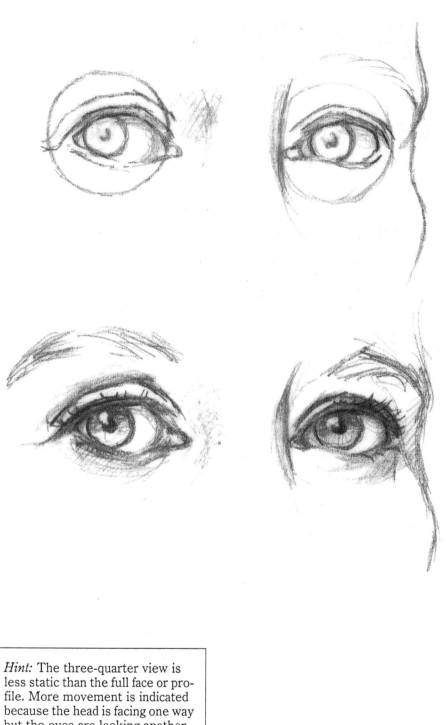

# Variations in Eyes

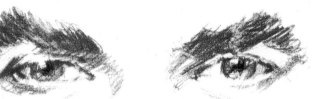
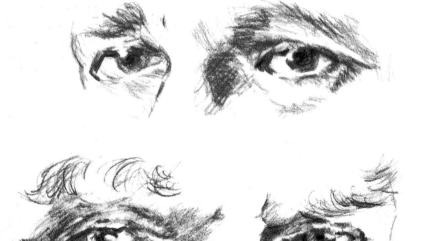

Compare the drawings of the eyes above, from the simplicity of the Oriental infant's eyes to those of a 35-year-old man, a 50-year-old man, and a 65-year-old man. The open gaze of a baby is quite different from the complex scrutiny of a man who has seen much and met many challenges.

These drawings are not included to show any drawing skill I might have, but to prove there actually is *no* formula for drawing eyes with meaning and intensity. Your ability to draw eyes will come from the hundreds and thousands of eyes you'll draw in the future, particularly from all you observe as you do these studies.

Study and analyze these drawings of eyes. To see them more abstractly,

turn this book upside down. This will make you even more aware that it's the *texture* that makes the eyebrows, that it's the *broken and uneven line* that gives action and structure to the eyes, that it is the placing of the very darkest dark next to the brightest white—*the accents*—that gives the eyes sparkle and life. Look at the page again right side up and you'll see that it's the way the dark pupils are placed that makes the two eyes focus. Finally, look at the way other artists in this book have handled eyes. John Singer Sargent and Edgar Degas—each has treated eyes differently. Every artist has his or her own way, and you will too. You can learn from every portrait you see.

## Common Errors: Drawing Eyes

*Making all edges too hard.* Keep the edges of the eyelids soft, saving crisp touches for accents. Keep the edge of the iris against the white of the eye relatively soft. Breaking the line of the lids helps add life to the portrait.

*Putting in too many eyelashes or making them too distinct.* Use restraint when indicating eyelashes. Nothing cheapens your work like having too many eyelashes lined up around the eyes like spidery legs. Remember, too, eyelashes are seen in perspective, with some coming directly at you.

*Making eyelashes too dark.* These can make a child appear too old, too sophisticated, and very unchildlike, as if made up with mascara.

*Making the highlights in the eyes too white or too large.* Placing the highlight in the eye is certainly the most fun of painting the entire portrait, but if you don't restrain yourself here you diminish the quality of your work considerably. Sometimes you may see a highlight in only one eye—if so, paint it that way. Also, try to decide which eye has the most dominant highlight—is one eye larger? Brighter?

*Painting the whites of the eyes too white.* Careful observation of values is important here; squint very hard to help you see them clearly. The next time you're in a museum, hold a piece of white paper in front of a favorite portrait; you will see instantly how far from white the eyeballs are!

# The Nose

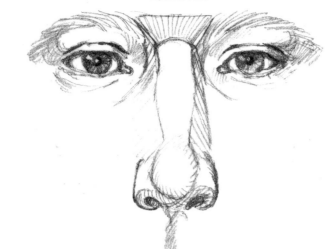

Students seem to have a great deal of trouble with the nose, probably because it projects. The easiest way to draw a nose is the way children do, with two dots indicating the nostrils:

Another simple way is to use a sort of seagull-shaped curving line:

However, these marks give us no information about construction of the nose, which we must understand before we can draw or paint this feature. The following facts will help you.

The nose is always centered between the eyes and is narrowest at the top, or bridge, where eyeglasses rest.

The nose is a vertical form, never horizontal, and is normally straight from top to bottom. If the nose has been injured or broken, it may veer slightly to the right or left.

There are two openings at the base of the nose on the bottom receding plane—the nostrils. Very often these are not clearly seen from the front view, and sometimes not even from the side view.

The nose has far less mobility than the eyes or the mouth. The nostrils can dilate, and the nose can wrinkle when a foul smell is noticed, or when someone is talking baby talk to an infant, but these movements are fairly infrequent and rarely occur in portraits. The only other way the nose changes is when the subject is smiling. Then it appears wider as the nostrils are stretched laterally.

## Observing the Nose

The nose begins where it meets the forehead and brow in an inverted wedge shape between the eyes and at the level of the eyebrows. Narrowing at the bridge, it then widens as it travels down the face toward the bulbous tip. On either side of the tip, the nose flares out, forming covering for the nostrils. The underplane recedes—hard to indicate from the front—and progresses to the indentation between the nose and the upper lip.

This a good time to talk about the wedge-shaped area where the nose meets the forehead and brows, called the keystone area (see drawing at top). There is a delicate shadow here and a light just under it where the bridge of the nose is indented, the spot where eyeglasses rest when they are worn. Experienced portrait painters work out this wedge and bridge area with extreme care, while beginners overlook this area entirely.

Nostrils are dark, but don't indicate them as black holes. Just incorporate them into the shadow area beneath the nose. When working in color, *always* make the nostrils warm, a reddish hue.

On the drawing below you'll see that beneath the skin and the muscle, the nasal bone extends downward from the frontal (forehead) bone of the skull about a third of the length of the nose, and ends at the nasal cavity, an opening in the skull.

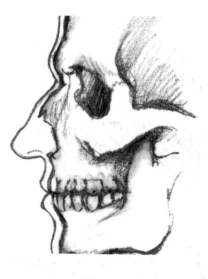

The nose itself is made of cartilage. This may not seem important to the artist, since the area where the nasal bone stops and the cartilage continues cannot be seen. However, when you *really* look at this area, you will perceive the slightest shadow *across* the form at this juncture. Study the drawings at left. Notice that if there is a bump in the nose, it is usually at this point where the bony structure comes to an end. You really need this change in plane to express the individuality and character of the nose on the portrait you are painting. When drawing the nose, break your highlight here.

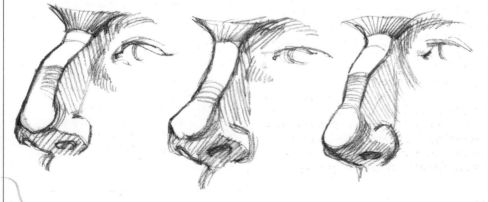

# *Step-by-Step:* **Drawing the Nose, Full Face**

You'll need a soft pencil, your sketch paper, a kneaded eraser, and a mirror for these exercises.

1. Looking in the mirror, study your nose and try to see it as a triangular block projecting from the facial surface. This form has a top plane, two side planes, and an underplane. You can't really *see* a line where the side plane of the nose meets and changes to the front plane of the cheek, but it helps to imagine such a line. It's easier to *feel* it than to see it. Press hard enough to feel the side planes of your nose, then the cheeks. (Also feel the higher cheekbones and the edges of the eyesockets all around your eyes.)

2. Refer to the top drawing at left and start to draw. Begin with the deep indentations on either side of the bridge of the nose, near the inner corners of the eyes. Then make a mark at the base of the nose. Whenever you draw any form, always lightly indicate its boundaries first. You can't just begin at one end and hope that all will come out right at the finish.

3. Lightly draw the triangular shape of the nose as shown in the middle left drawing. Thinking of the nose form as a solid block, draw the side plane on the shadow side, the side plane on the lighter side, and the top plane. It's important that you begin your noses this way, even if you do not actually *see* all three of these planes. It is important that you understand this structure. The lines defining the planes can always be erased later.

4. Now draw the fleshy rounded ball of the nose, as shown in the bottom left drawing, with rounded lines to express its more bulbous shape. Then the flaring wing-like shapes on either side.

5. Now indicate the bottom plane, the underside of our solid triangular block. Draw a light line where you think the side plane of the wing-forms turn under to become the bottom plane, and also where you see the top and front of the ball of the nose become the underside—and you're done!

6. The nose casts a shadow on the cheek or the area between the nose and the upper lip—or both. Do you see any cast shadows? Add them, but don't go too dark, or they'll look like holes. Look for the outer shape of the cast shadow; it will help define the shape of the form it's falling on.

   Do you also see the reflected light, bouncing up onto the bottom plane? Lighten your shadow area there just enough. Remember the reflected light can *never* be as light as your light area, or the solid form of the nose which you have worked so hard to achieve will just fall apart.

7. Clean up your drawing now by eliminating your construction lines, unless you like them there. Add small dark accents where your drawing needs more definition. Round off forms where necessary. Lift out the highlights: (1) at the bridge of the nose just below the keystone shadow; (2) on the bony part of the nose, a third or halfway down (not every nose has this highlight); and (3) the shine on the tip of the nose—the brightest, most obvious highlight. You might minimize this highlight on a beautiful woman; it could be a dashing slash on a man, second in importance and vigor only to the bright highlights in the eyes. On children this highlight is usually round and sharp. The proper placement and brilliance of this highlight will accomplish many things for your portrait. Look at John Singer Sargent's portraits for highlights; he was the master of them all! (See page 165.)

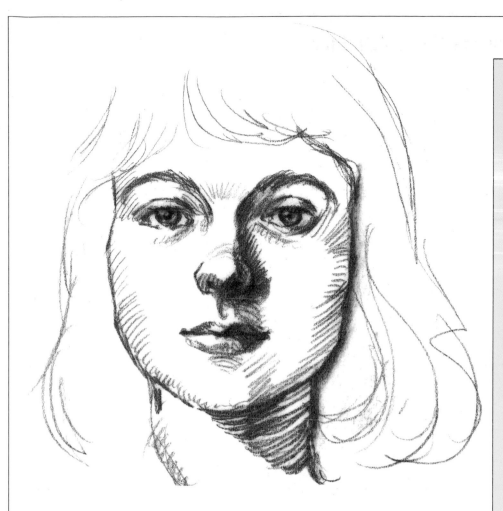

*Running a highlight down the entire length of the nose.* You will never see a highlight running from the nose bridge to the tip, straight, all the way down. So if you see one on a drawing or painting you'll know the artist wasn't really sensitive to his task, or the work was a highly stylized portrait.

*Not showing a delineation at the point where the bridge of the nose meets the forehead.* You will never see a nose come straight down from the forehead (the frontal bone) without a change in plane. There is *always* an indentation at the nose bridge. You don't always have to note this keystone underplane with shadow; you can indicate it with a change in color temperature.

*Making black holes for nostrils.* Remember, your sitter is *alive*. Just under that skin is a capillary system with blood flowing constantly. Remember that all the openings in the head are *warm*. In paint, mix some reds into the nostril color. In drawing, don't make these openings so black that they appear too prominent. The nostrils in the portrait become part of the shadow under the nose.

*Making the shadow under the nose on the area above the upper lip, or beside the nose on to the cheek, too solid or too dark.* Shadows should be luminous and transparent, so these shadows must be underplayed. If they are very dark on your drawing or painting, they appear to create a "hole" in the face and destroy the form.

*Cast shadow from the nose, hitting the lip.* If you ever see the shadow under the nose reaching down as far as the lip, change the lighting. This shadow pattern is most unattractive. The younger the sitter, the lighter the shadow under the nose.

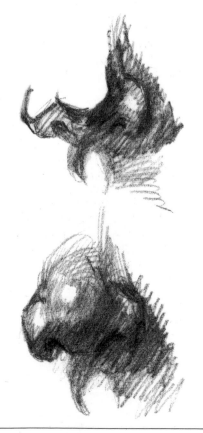

**Making the Nose Project** There are three ways to get the nose to project:

1. Make the shadows on the side plane and the underplane of the nose darker than the shadow on the side plane of the face, going back toward the ear.

2. Draw the tip of the nose crisply, not softly. *(Hard edges project!)*

3. Make the highlight on the tip of the nose crisp and sharp.

**Making the Nose Less Noticeable**
Conversely, to subdue a too-prominent nose you can de-emphasize it as follows:

1. Keep the shadows on the side plane and the underplane of the nose fairly light, or mid-value. Also minimize the shadows cast by the nose.

2. Keep descriptive lines soft.

3. Play down the highlight on the tip of the nose.

# Step-by-Step: *Drawing the Profile Nose*

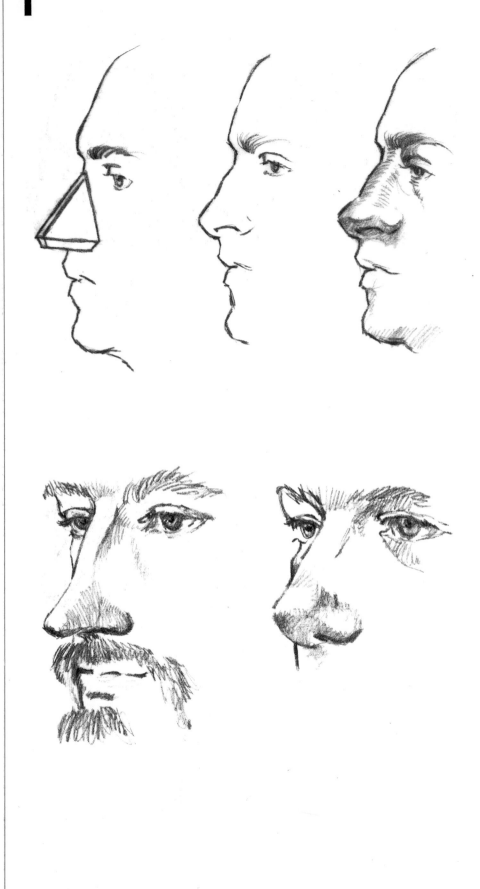

Study your nose from the side in a second mirror. Now block it in as a triangular shape projecting from the facial surface. Then start at the top with the keystone area between the brows. Look for the curved indentation at the bridge. The nose then projects from the bridge, rounds off at the tip, and recedes to the area above the upper lip. Add the curved wing growing into the cheek, then the nostril.

This appears easier than drawing the nose in the front view, but this is only partly true. While you can more easily perceive the shape in profile and therefore more easily draw it, it's more difficult to make it appear solid. This is one of the problems you'll encounter in drawing any of the features, and even the head itself: The drawing will look flat in profile, like a silhouette.

**Making the Nose Project** In order to give a feeling of solid form to the profile nose, you can shadow the underplane. Add a cast shadow from the nose form onto the upper lip area. Put in the halftone on the top plane and on the side plane of the nose, leaving the lights and highlights as white paper.

One way to avoid this flat appearance is to turn your head just enough to see the eyelashes behind the nose. *Now* you can draw the nose more solidly and, incidentally, the mouth as well. Follow the same order of activity as in the "flat" profile above: draw the keystone area first, then the indentation at the bridge of the nose. As you move down the nose, there is your top plane, the front plane at the tip, and the underplane. Do include the lines dividing each plane, to indicate your understanding of the division between these planes and the side plane. On the side plane, draw the curved wing over the nostril, then the nostril itself, if it's visible. Look at the illustration. Don't you agree that these noses look more solid?

# Step-by-Step: **Drawing the Nose, Three-Quarter View**

1. Study your nose in the mirror in a three-quarter view—meaning somewhere between the full face and the profile. The triangular block shape works for this view too; because the block is in perspective, the nostril on the far side is only partially seen, or suggested.

   Slight changes in the view of the head can easily throw you off, and you'll be frustrated knowing your drawing isn't right without really knowing why. The drawing at right shows how changing the head's position changes the relationships of the features.

   Each time you look up from your drawing to study the nose, make sure you see the nose at *precisely* the same angle as before. You can check the angle by taking careful note of how much of the cheek you can see beyond the nose.

2. Lightly indicate the angle of the nose. If it's hard to determine, hold your pencil up and align it with the angle of the nose in the mirror, then place your pencil carefully on the paper at that same angle. Starting at the keystone area between the brows, block in the top plane, the side plane nearest you, and any suggestion of the far side plane that you see. If you don't see any, leave that plane out.

3. Draw the wing area covering the nostril. Define the ball or rounded area, and the slight shadow where the ball meets the bridge. Is there shadow on the side plane?

4. Is there a front plane at the tip of the nose? If so, indicate the under-plane as the nose recedes to the facial plane. Then draw the nostril.

5. Pick out the highlights on the bridge area, the bony area, and the main highlight on the ball.

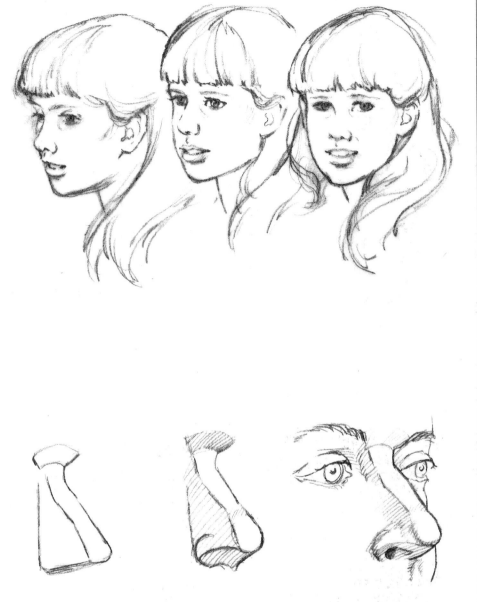

# The Mouth

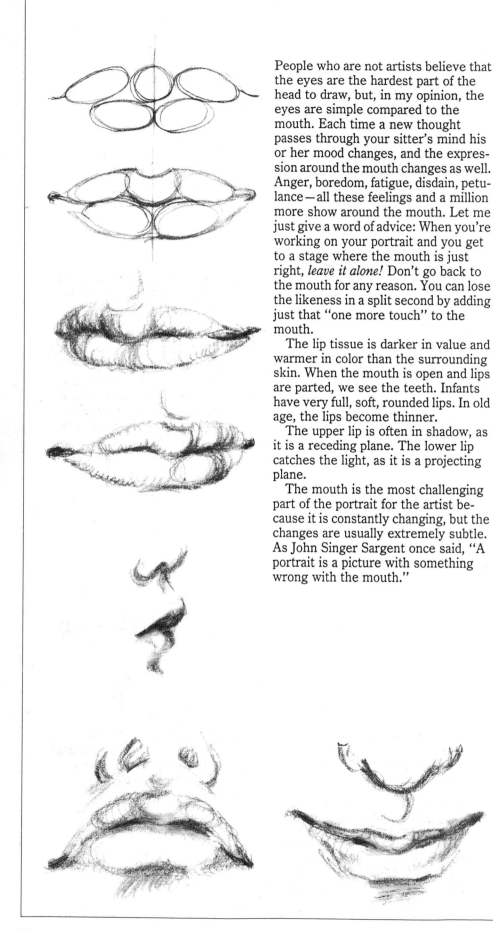

People who are not artists believe that the eyes are the hardest part of the head to draw, but, in my opinion, the eyes are simple compared to the mouth. Each time a new thought passes through your sitter's mind his or her mood changes, and the expression around the mouth changes as well. Anger, boredom, fatigue, disdain, petulance—all these feelings and a million more show around the mouth. Let me just give a word of advice: When you're working on your portrait and you get to a stage where the mouth is just right, *leave it alone!* Don't go back to the mouth for any reason. You can lose the likeness in a split second by adding just that "one more touch" to the mouth.

The lip tissue is darker in value and warmer in color than the surrounding skin. When the mouth is open and lips are parted, we see the teeth. Infants have very full, soft, rounded lips. In old age, the lips become thinner.

The upper lip is often in shadow, as it is a receding plane. The lower lip catches the light, as it is a projecting plane.

The mouth is the most challenging part of the portrait for the artist because it is constantly changing, but the changes are usually extremely subtle. As John Singer Sargent once said, "A portrait is a picture with something wrong with the mouth."

## Observing the Mouth

When drawing the mouth, remember that the upper lip is made up of three parts, the lower lip of two, as shown in the drawings at top left. The line between the upper and lower lip should be broken, varied in weight and intensity, to avoid a strained expression.

In every part of the portrait you want to give the illusion that the image *might* move. Nowhere is this more desirable than the mouth. We must be extremely careful not to draw firm dark lines *around* or *between* the lips. The edges must be drawn or painted softly, particularly on women and children.

Note the way the corners of the mouth tuck into the adjoining cheeks. Pay a great deal of attention to these corners. Do they go up? Down? How dark are they? If you paint them *too* dark, the mouth will appear very tight.

In a small child the upper lip is frequently much larger and more protruding than the very small lower lip, for the lower jaw is undeveloped.

Study your mouth in a hand mirror. See how soft the lip tissue appears. The center of the upper lip projects, and the corners really recede as they go back into the cheeks. Turn your head slowly to one side. As you approach a three-quarter view, the far corner of the mouth tucks in and disappears. Turn slowly to the other side; watch as the other corner disappears.

Now raise your chin, putting your head back. See how the mouth curves around the teeth. The corners of your mouth point down in this perspective. Try smiling. What happens then?

Put your chin down on your chest and notice how the mouth curves around the teeth. The corners go up now; they go up even more when you smile. Throw your head back and look up at your mouth. The lower lip appears thinner than the upper lip. Conversely, when your chin is down on your chest and you are looking down on your mouth, the upper lip appears thinner than the lower lip.

# Step-by-Step: Drawing the Mouth, Full Face and In Profile

1. Studying your mouth in a mirror, indicate with a light line where you want the mouth to be on your paper. Look first for the corners of the mouth and place them.

2. The line between the lips comes next. Try not to draw this as one continuous line, but break it somewhere. This little break softens the mouth and prevents a tense expression. The viewer will mentally complete the line for you.

3. Now form the upper lip, developing it from the three oval parts. The light coming from the upper left or upper right throws the top lip into shadow. Add this tone.

4. While you're working on the upper lip, note the vertical indentation from the nose down to the lip and the shadow on the plane slanting back toward the cheek. If you're a man, you'll have facial hair growing in this area, which will tend to darken this part of the face.

5. Now look for and place the shadow under the lower lip as it travels down to the chin. Squint hard and study your mouth. Do you need to add tone to the lips? Perhaps to delineate the form of the lower lip? A woman wearing lipstick may need to add tone; a man might leave the lips as is.

Look hard for the highlight on the lower lip. Leave it the white of the paper, or lift it out with your eraser. Put in the dark accents you see in the corners of the mouth or between the lips. Tuck the corners of the mouth in well.

Try not to draw lines around the lips. The value difference between the lip tissue and the surrounding skin is hardly discernible in a black and white drawing.

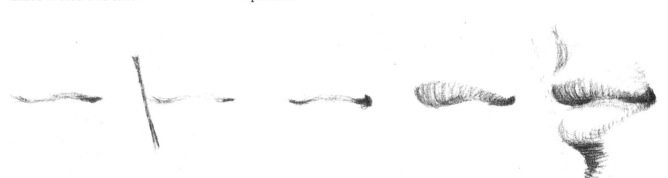

1. Now let's try drawing the mouth in profile. Holding a mirror at the side of your face and looking at the reflection of your mouth in a second mirror, block in the mouth by first indicating the angle of the line between the lips.

2. Block in, in a straight line, the angle of projection of your lips. Is the upper lip protruding more—or the lower?

3. Tuck in the corner of the mouth.

4. Darken the upper lip if it appears to be in shadow.

5. Add the shadow under the lower lip and at the corner of the mouth. Keep the edges soft where the shadow blends into the light. Is the lower lip darker than the skin surrounding it? Add this tone if you see it. (Ladies, remove your lipstick for

this problem.) Now, with your eraser, pick out the highlight where you see it. You'll find the mouth is there without lines circumscribing it.

# *Step-by-Step:* **Drawing the Mouth, Three-Quarter View**

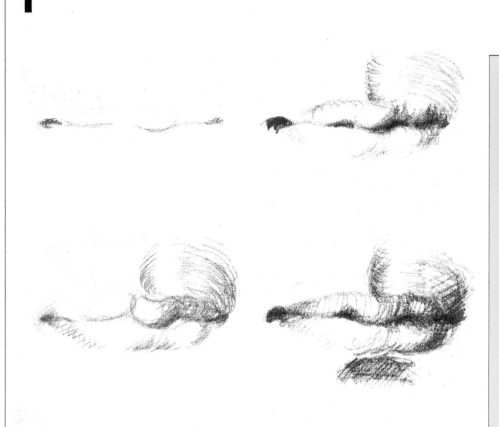

## Common Errors: Drawing the Mouth

*Handling the mouth too heavily.* Use a very light touch on any mouth. To avoid making the mouth look weak, search out small points where you can place an accent, such as the corners of the mouth, under the lower lip, or on the line between the lips. Very often, these accents in and around the mouth will produce the likeness you want. Above all, do *not* draw lines around the lips.

*Making the teeth too white, so they appear to protrude.* On the other hand, if the teeth are too dark they'll appear to be discolored or decayed. And too-strong lines between the teeth will also look like decay or spaces between teeth.

*Making the highlight on the mouth too glossy.* This will diminish the character of your portrait because it's too distracting.

1. Study your mouth in the mirror. Keeping your lines soft, draw the line between the lips, and break it somewhere.

2. Lightly block in the upper lip by drawing the three ovals. Squint hard. Where do you see shadow? In the vertical indentation between the nose and the upper lip? On the shadow side of the lips from the center to the far corner of the mouth?

3. Tuck in the corners of the mouth. On the far side, the side turned away from you, the corner may not be visible at all. Don't put it in if you don't see it!

4. Add the shadow under the lower lip. Is the upper lip in shadow? Should the corners of the mouth be accented with darks? If the lips are darker than the surrounding skin tone, darken them. Now lift out the highlight with your eraser.

# Handling Smiles and Teeth

Perhaps this is a good time to talk about teeth, while we are discussing the mouth. You probably didn't think you would be painting teeth! However, many people don't look natural with their mouths closed, and the teeth are an essential part of their likeness.

Just as the mouth curves with the front of the face, the teeth follow this same curve. The two front teeth are at least an inch ahead of the chewing molars.

Study the variety of mouths on this page. Try to see the teeth as a mass, not as separate bits like kernels on an ear of corn. Tuck the corners of this dental mass into the corners of the mouth well (see sketches below).

If you delineate the crevices between individual teeth, they will appear too prominent, as if the sitter had bad teeth and was ready for the dentist. The best way to indicate the individual teeth is to vary the color or the value *ever so slightly,* so as not to destroy the illusion of the teeth as one mass.

Look for the bottom edge design of the upper teeth. This line is often the key to an exact likeness (see sketches at bottom and at far right).

If the mouth is open, as it must be if we are to view the teeth, the upper lip will cast a shadow on the upper teeth.

Be careful not to draw it as a continuous line across the teeth. Better to indicate the fact that the upper lip overhangs the teeth by painting very subtle marks within the shadow to show the divisions between the teeth, but so subtle that the observer is hardly even aware of them.

Occasionally when having trouble getting a really good likeness, I've found I was ignoring the *lower* teeth. These lower teeth show more frequently than you'd expect when your subject is speaking or smiling. Start carefully observing the mouths of your friends and family when they're talking with you—and watch for their lower teeth.

Notice that the mouths depicted here are drawn with curving lines, expressing the full rounded forms of the lips. These curves describe protruding forms.

With a pencil, practice drawing all the mouths we've looked at so far in this chapter. Use curving lines, keeping some edges soft and placing dark accents where they really count. Then practice drawing mouths from magazine photographs. Remember, the more mouths you draw, the more confident you will become in your ability to portray them.

# Step-by-Step: Drawing the Ear, Full Face

Students think ears are more difficult to draw than they really are. Some dedicated observation will eliminate this fear. Whether ears are quite flat or protrude, it's convenient to think of them as flat oval disks set at the side of the head. The ear is made up of cartilage, not bone, and has virtually no movement, so it doesn't change as one's expression changes. On an adult, the ear extends in a vertical shape from the brow line to the base-of-the-nose line.

In profile, the ear begins at the halfway mark between the front and the back of the head and extends toward the back. It also slants backward slightly, sometimes paralleling the line of the nose.

The inner line around the top of the ear seldom follows the outer shape exactly. Don't forget that both ears usually line up with each other and are seen in perspective when the head is tilted.

## Observing the Ears

Oddly enough, although ears usually don't contribute very much to the likeness, when they're incorrectly placed they can cause you a great deal of trouble. And it's a very subtle kind of trouble, for no one is expecting ears to matter much. The face can be perfect, the ears beautifully drawn, but you'll sense there is something wrong. For students, the biggest problem seems to be aligning the ears with the eyebrow line and the base-of-the-nose line. Make sure you follow the curving eyebrow line when the head is tilting and hang the ears from that. Like the mouth, when the head is tilted back, the ears appear to be lower; head tilted forward, the ears appear higher.

Before you start to draw, sit up very straight, holding your head absolutely erect, and look in a mirror. Envision an imaginary line at the top of the ears and another at the bottom of the ears extending across the face. As you learned from the chapter on the proportions of the head, we have a rule of thumb that tells us the top of the ear usually lines up with the eyebrow, and the bottom with the base of the nose. But *your* ears may be positioned differently; look hard and decide.

Now tilt your head to the right or left and try to imagine the line across the bottom of the ears. It is *much* more difficult to get the ears properly placed when the head isn't posed straight up.

You will need a pencil, drawing paper, kneaded eraser, and mirror for this exercise.

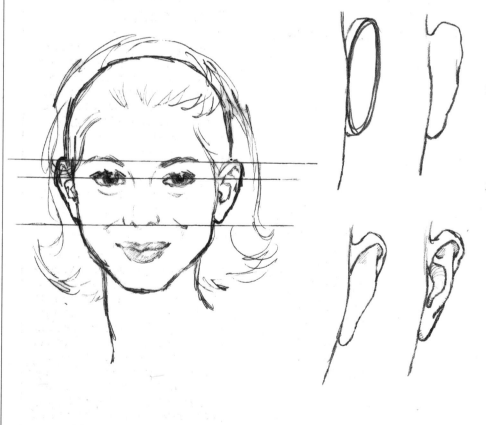

1. Block in the full-face diagram of the head using a light line to position the ears, top and bottom, where you see them.

2. Think of the ear as a flat oval disk and begin drawing your ears with that form on both sides of the head.
   Now refine the outer shape of the disks into the actual shape of your ear, as shown at near left.

3. Add the inner line curving around the top to form the rim or fold, called the helix, as shown at far left. Now, as shown at near left, define the bowl-like indentation of the ear and the small flap at the lower area. Draw the small flap at the front of the ear opening.
   Follow this procedure for both ears, and be sure to do both ears at one sitting. Does your hair cover part of your ears? Also, when you smile, do your cheeks cover part of your ears?

# Step-by-Step: *Drawing the Profile Ear*

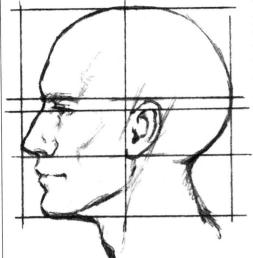

To draw your ear for this exercise, you'll need the two mirrors used for the profile view of the eye. As you sit up straight with your head erect, does the top of your ear line up with your eyebrow? Your eye? You will never get a good likeness in a profile if the ear is not correctly aligned with the other features, but many students don't realize this.

1. Draw a square profile diagram of the head as you learned in Chapter 1 and lightly position the ear as indicated (left). Study *your* ear and draw it where you see it. Does it align with the ear you just sketched?

2. Draw light lines indicating the top, bottom, front, and back of the ear (see the sketch below left). Then begin with the oval disk, slanting the top slightly toward the back of the head. Now refine the outer shape of the ear, top to bottom, as shown in the center illustration below.

3. Add the inner line inside the top of the oval as shown below right. Form the fold (the helix), and carry it down to the lobe.

4. Draw in the circular line describing the deep bowl; follow it down to the two quite rigid flaps which protect the ear opening—one at the lower back, one at the front toward the face. Add shadows and highlights. Now turn your head and draw your other ear. It is a different experience, drawing an ear from the opposite direction.

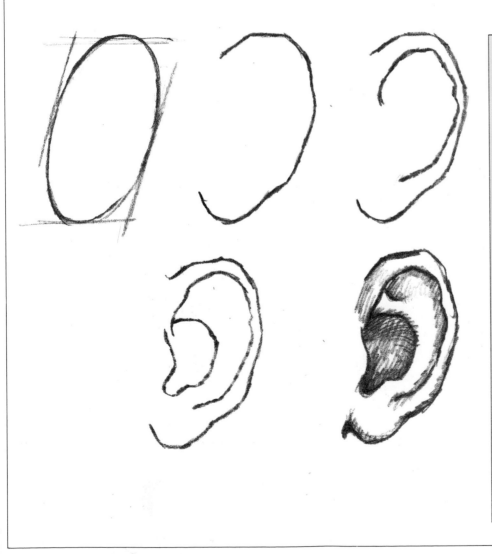

## Common Errors: Drawing Ears

*Carelessly drawn.* The ear is often overlooked too long in the process of drawing the head, and hurriedly stuck on in a rush at the end. Take your time and give ears the attention they deserve, checking the alignment with the eyebrow line and base of nose line.

*Not placed in proper perspective on the head.* Careful observation will ensure you're getting it right.

*Placed too high or too low.* This problem exists particularly when we are drawing children; the placement of the ear greatly affects how old the child appears, especially in the front view. If you are having difficulty getting the child the right age, check ear placement. When in doubt, line up the top of the ear with the eyebrow line. This alignment is not so easy to see as the child seldom sits still enough, but just knowing what to look for helps a lot.

Roberta Carter Clark, *Cookie,* oil on canvas. Courtesy of Mr. and Mrs. Harrison Jones II.

# DRAWING THE BODY

When we think of portraits we may automatically think of the head alone, but nearly every portrait you'll ever paint will include more of the subject's body than just the head. There will be the neck, perhaps the shoulders, frequently the torso, arms, and hands, and occasionally the legs and feet as well.

The material in this chapter will help you understand the construction of the parts of the body, how these parts interrelate, and how their construction determines natural movement. To get to know the way the body moves, it's helpful, and even fun, to draw from a jointed wooden mannequin. The adult-proportioned mannequin can be arranged in nearly any pose the human body will assume. These mannequins come in sizes from 1 foot to 26 inches high and stand upright on a wooden base. If you can't find them in your local art store, you can buy them from artist's supply catalogs.

# The Neck

The neck can be thought of as a cylinder, a very strong column rising from the sloping platform of the shoulders, as you see in the illustrations above.

Study the drawings at right. There are seven vertebrae in the neck, each capable of movement, like links in a chain. This allows the head to turn and twist in every direction except 360 degrees to the back. Notice that the neck isn't perfectly straight. It projects forward even when we are sitting up very straight.

The strength of the neck is at the back, where the trapezius muscles rise from well below the shoulder blades, and extend out to the shoulders and up to the base of the skull, as shown in the illustration below. These trapezius muscles hold the head erect.

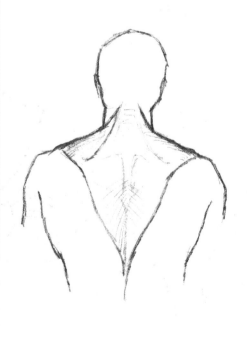

The neck, at the back, begins at a point on a level with the ear opening and the base of the nose. From the front, the visible neck begins at the chin and extends this same distance downward to the collarbone protrusions. Study the drawings at right.

Descending from behind the ears to a pit at the base of the front of the neck are two slender muscles called "bonnet strings" or sternomastoid muscles. These pull the head forward and back and allow the head to turn from side to side. Between these muscles, at the front, you will see a man's larynx or Adam's apple.

Notice that the neck can be stationary and still allow the head to nod forward and be thrown back, as shown in the drawings below right.

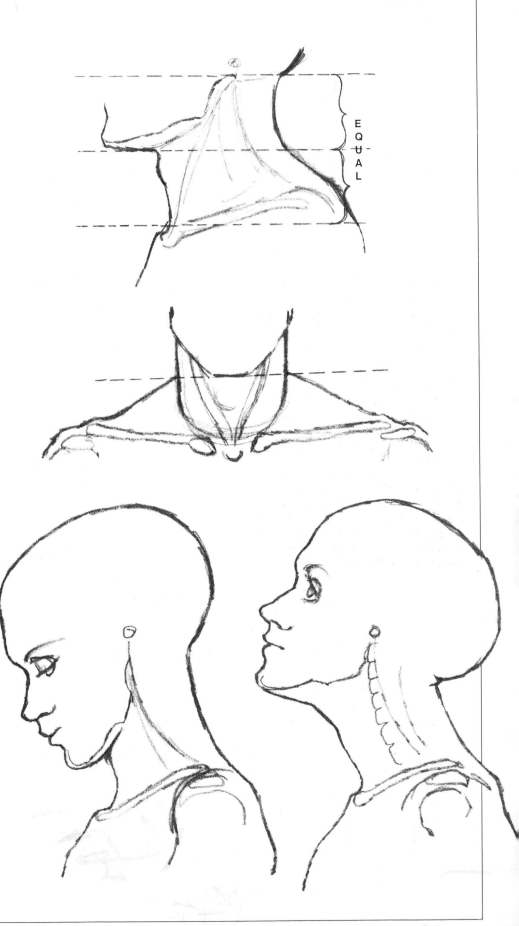

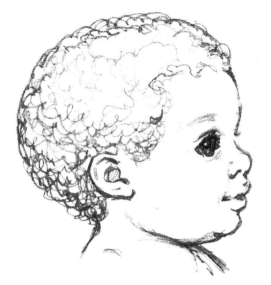

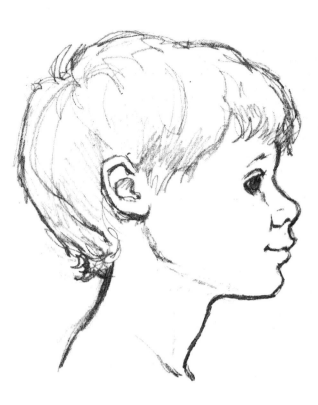

## Children's and Youths' Necks

Until a child is three or four months old, the neck is too weak to support the head, which is proportionately very large for the body. The neck in a newborn baby and up to age two is hardly visible as such, but may be indicated by creases in rolls of fatty tissue. As the child grows the neck becomes more perceptible and takes on a rather slender and delicate appearance.

When a boy of sixteen or seventeen becomes active in athletics, the neck thickens. As a portrait painter, you should watch for this, as the heavy, sturdier neck is a good way to indicate a young man growing out of boyhood. All professional athletes show great strength in the neck.

Michelangelo gave all his people sturdy necks, both men and women. There is something heroic about a very strong neck in a painted image.

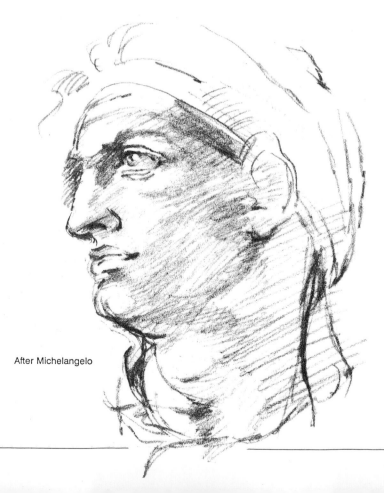

After Michelangelo

40

## Women's Necks

In painting women, the neck might be made to appear longer and attractively curved as an indicator of feminine grace and beauty. No woman was ever beautiful with her head slumped forward, scrunched down into her shoulders. Every beauty holds her head high, with neck extended and erect.

Many portrait painters have stressed the beauty of the "swanlike" neck and the way the head is balanced on it to convey an impression of elegance in their subjects.

### Common Errors: Portraying the Neck

*The neck too long or too short.* Poorly observed. Try to relate the neck to the chin, the collar.

*Too thick or too thin.* If the neck is too heavy, the figure may look stodgy. If the neck is drawn too thin, the figure may appear weak.

*Drawn as a tube with a ball on top of it.* The neck looks stiff and unnatural.

*No involvement between the neck and the shoulders.* Without the smooth flow from the neck to the torso the body lacks grace and movement.

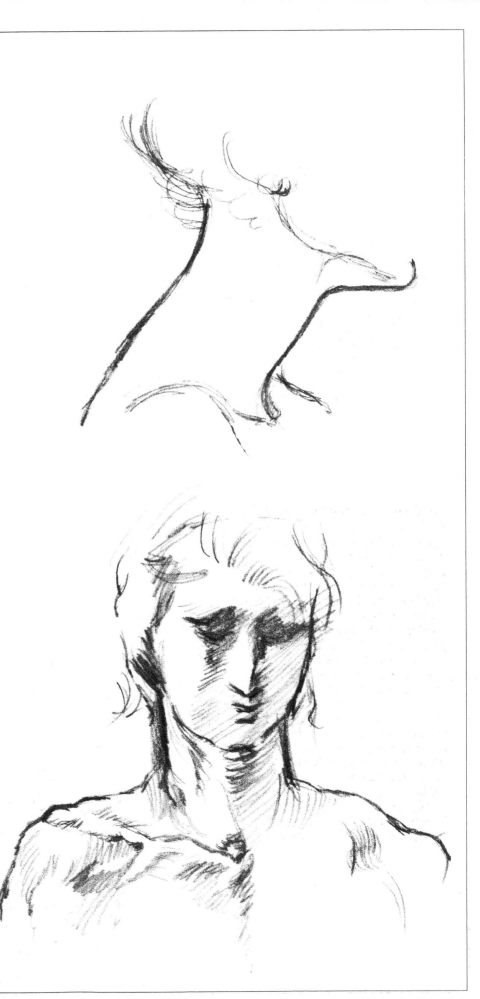

After Michelangelo

# Shoulders and Torso

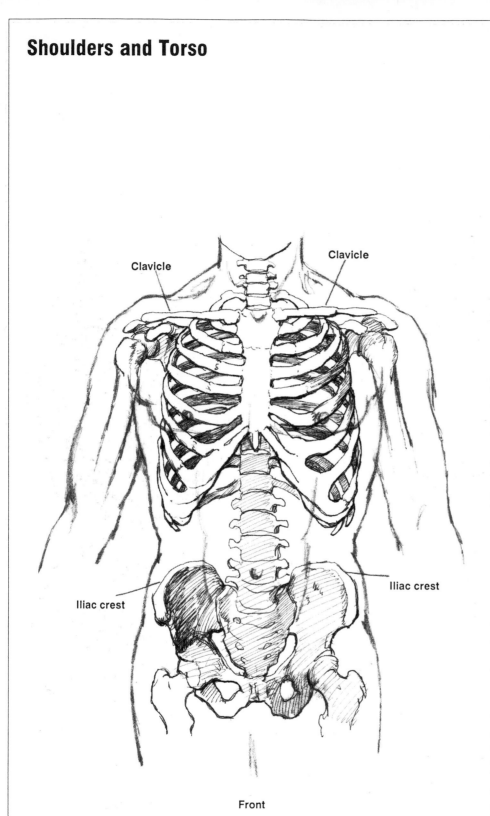

Clavicle

Clavicle

Iliac crest

Iliac crest

Front

The pit at the front base of the neck has two small bony protuberances rising on either side. These are the inner ends of the collarbones, the clavicles, which attach at this central point to the breastbone, or sternum. The opposite ends of these collarbones extend outward to the shoulders.

The shoulders appear as round and full forms. One shoulder can be raised independently of the other, but in most portraits the shoulders are at the same height or very near it, unless one elbow is leaning on the arm of a chair or something similar. As the elbow is higher, so is the shoulder.

The upper half of the torso is the cone-shaped rib cage called the thorax. This "cage" is constructed of the twelve curved ribs on either side which connect to the sternum in the front and the spine in the back.

The upper back of the torso is relatively flat, for there is a flat shoulder blade, or scapula, on either side of the spine partially covering the rib cage. The top edge of this scapula parallels the slope of the shoulder and is thicker at the outer corner where it forms the shoulder joint as a socket for the bone of the upper arm. As a person ages, the upper back becomes more rounded and less flat.

The torso is capable of twisting, bending from side to side, and bending forward and backward, but all this movement occurs only at the waist. The chest and the hips are relatively stationary.

The lower part of the torso is the pelvis, which is made up of the flat sacrum at the base of the spine and a hip bone on either side. The pelvis functions as one stationary unit and no part is capable of movement independently of the other two parts. The hip bones flare out at right angles to each other; each has a ridge at the top called the iliac crest which travels from the back to the front of the body. The lower front corners of these bones meet at center front and form the pubis, the lowest point at the front of the torso. At the outer edge of each hip bone is a socket fitted with the ball end of the femur, a neck-like extension of the thigh bone.

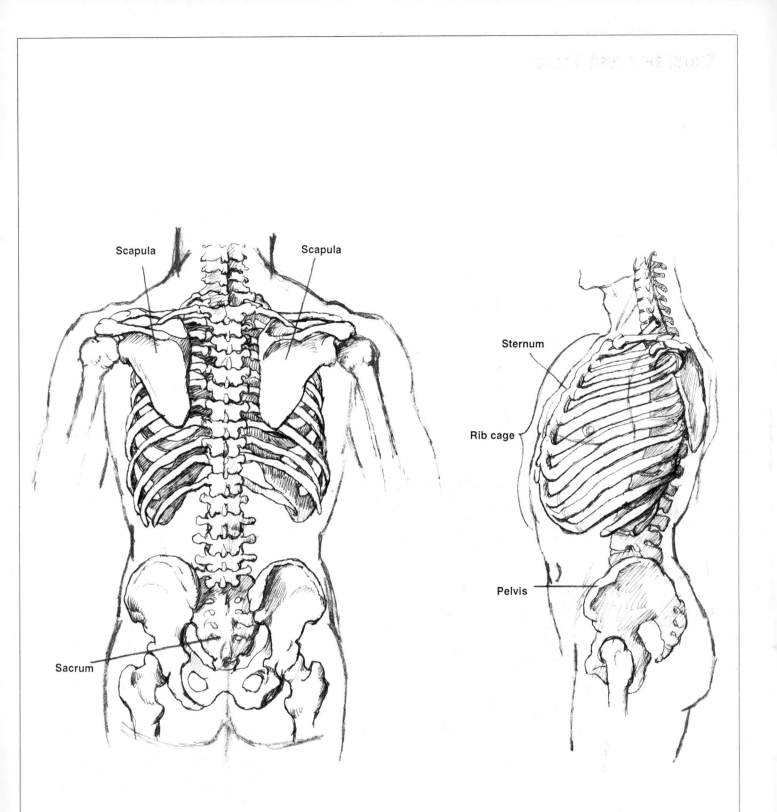

Scapula

Scapula

Sternum

Rib cage

Sacrum

Pelvis

Back

Side

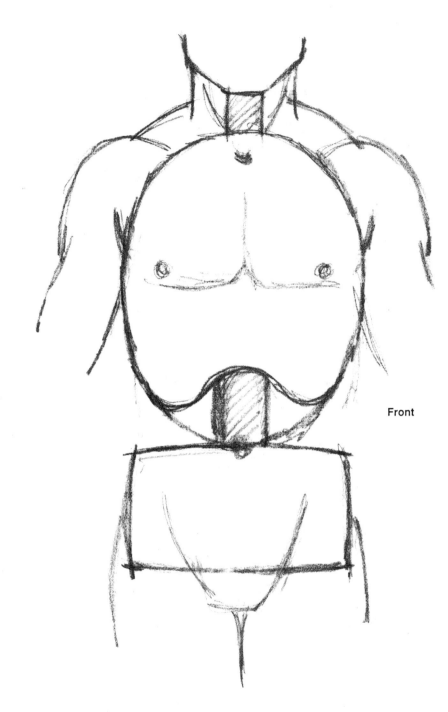

Front

## Common Errors: Drawing the Shoulders and Torso

*Body bending in all the wrong places.* The torso is not really a flexible sausage. There can only be movement front to back, side to side, and twisting movement *at the waist,* the area between the rib cage and the pelvis.

*Drawing or painting the figure's clothing awry.* The center front of the clothing *must* fall on the center front of the torso, the median line. This includes the vee of an open shirt; where collars button and men's ties knot; or where buttons go down the front of a garment. It's particularly easy to get things out of alignment on a small child's portrait, for children never do give you enough posing time.

*Failing to account for uneven weight distribution.* Remember, when the figure is standing with the weight on one foot, the shoulder line and the hipline can *never* be parallel, or the figure would fall over. (More on this later in this chapter.)

*Getting the proportions wrong.* When painting a portrait of a seated figure, it's all too easy to shorten up or visually leave out the part of the torso from the waist to the seat. Carefully measure head-lengths down to the chair seat, then to the knees. Imagine the body in a bathing suit, and block it in as you know, in your mind's eye, it must be. Then put the clothing on.

## Drawing the Torso

Stand up and raise your leg to the side, as if you were getting on a bicycle, and feel with your hand where the leg swings out. This spot, the hipline, is critically important to the artist. When drawing the full-length figure, this is where the body divides in half vertically — that is, the distance from the top of the head to the hipline is an equal measure to the distance from the hip-line to the soles of the feet. Also, when the arm is hanging straight down at one's side, this line aligns with the inner wrist. (See the diagram of the man, woman, and children on page 58.)

An artist visualizes this complex machine which is our body in terms of the most simple masses. Thus, blocking in the torso is accomplished quite effectively by drawing the thoracic area as

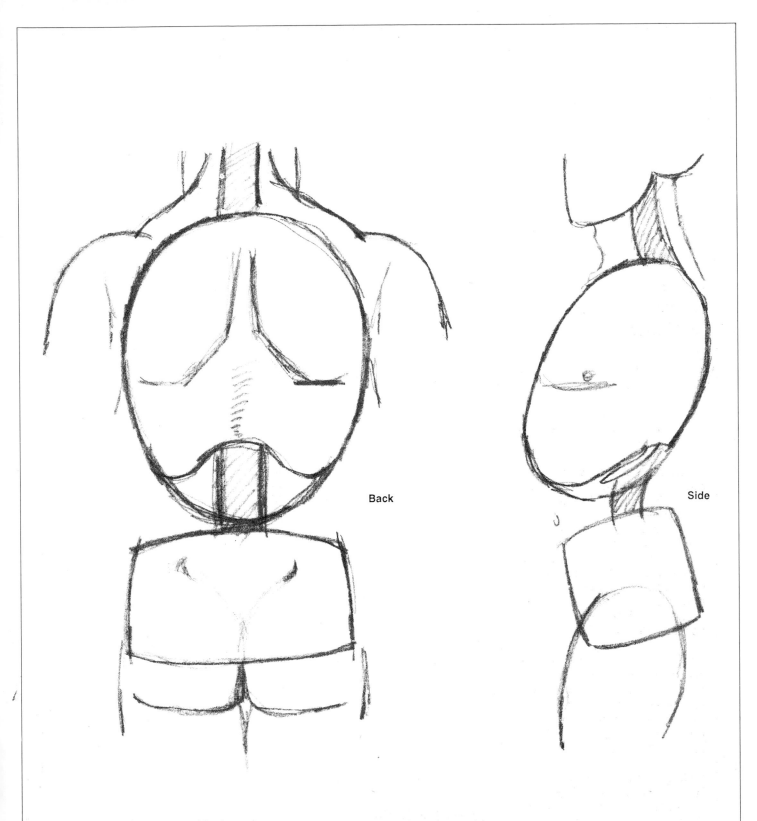

Back

Side

an egg, the pelvic area as a block, and connecting the two with the flexible spine.

Just as the vertical centerline and the horizontal center, or eyeline, are of critical importance when blocking in the head, so the centerline of the torso, both front and back, is extremely important in drawing your figure correctly. In anatomy, this is known as the *median line*. It's a good idea to use this line as a checkpoint if your figure drawing seems to be incorrect, particularly in the three-quarter view when your figure is in perspective.

And when you are painting portraits, the buttons of the shirt, jacket, or blouse must fall on this centerline, not on the edge of the garment.

# The Arms

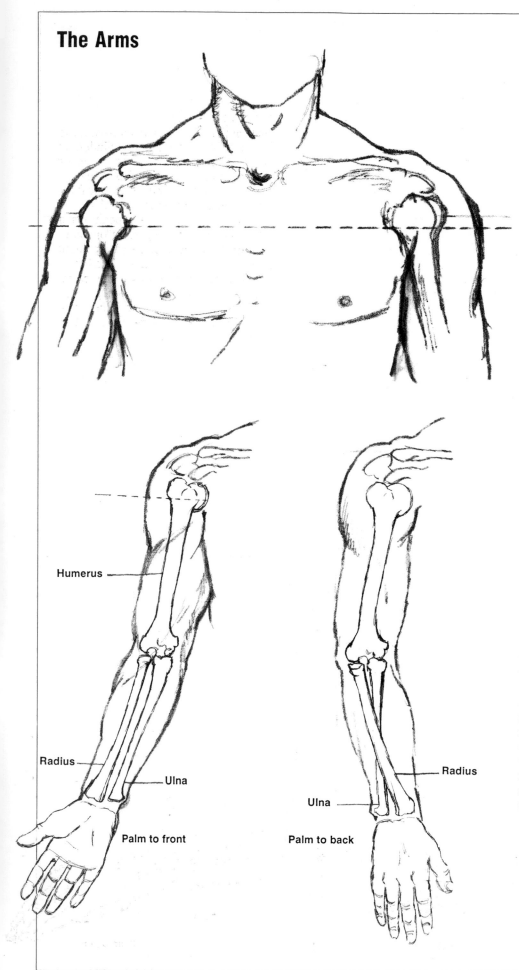

Humerus

Radius

Ulna

Palm to front

Radius

Ulna

Palm to back

By drawing a line across the upper chest through the mass of the deltoid muscles, at the heads of the humerus bones and slightly above the armpits, you'll discover the broadest part of the entire body. The shoulders are *not* broadest at their upper corners! Study the arm carefully; from this point of greatest thickness near the shoulders, the arm begins to taper until it becomes smallest at the wrist.

The arms are capable of radial movement in any direction at the shoulder joint. At the elbow, only side-to-side and forward movement is possible. The upper arm is round and is made up of only one bone, the humerus. Deltoid, biceps, and triceps muscles are prominent in the male. These muscles are less pronounced in the female.

The forearm is made up of two long bones, the radius and the ulna. It is heaviest near the elbow, where it is round. Two-thirds of the way down it tapers to a flat mass at the wrist.

Holding your hand flat, palm up, the ulna is on the little finger side. This bone is larger at the elbow and smaller at the wrist. The radius is the bone on the thumb side, and is larger on the wrist end, smaller at the elbow end. When you turn your hand over, palm down, the position of the radius and the ulna don't change at the elbow end, but midway down the forearm the radius twists over the ulna, allowing the hand to lie flat in this position as well. Try this; with your hand, you can easily feel the interaction of these two bones.

There is a sharper angle at the outside of the elbow joint, a rounder curve inside. When the arm is bent (hands resting in lap or elbow leaning on arm of chair), the point of the elbow is found under the *center* of the upper arm, not in a line with the back of the upper arm as shown in line $A$ to $A$ in the sketch at far right.

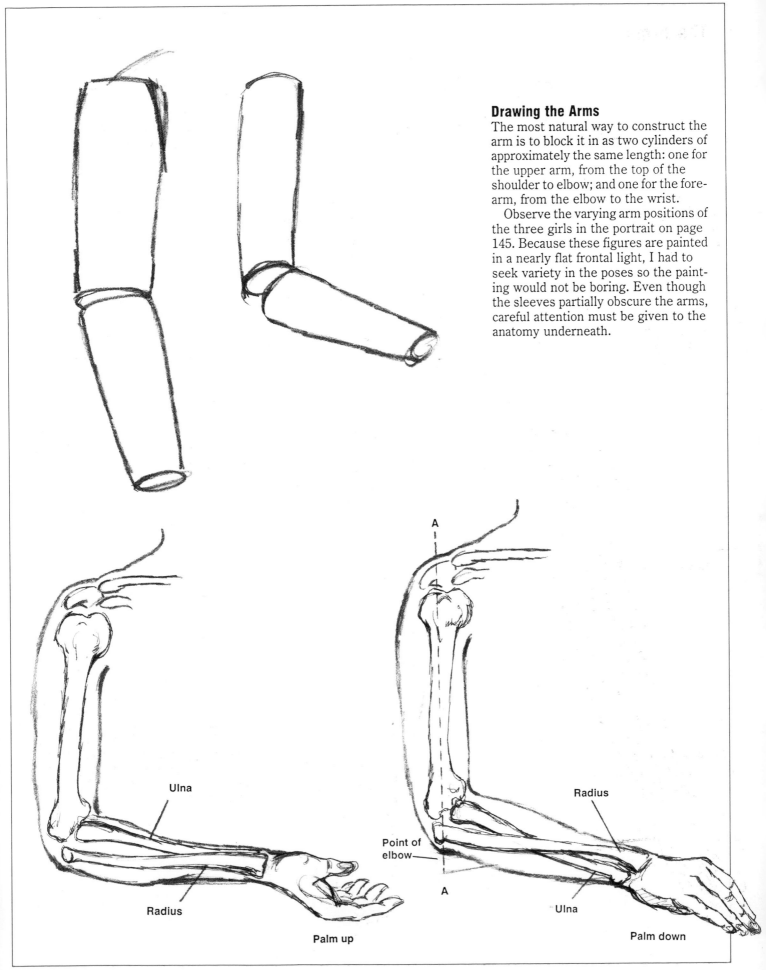

### Drawing the Arms

The most natural way to construct the arm is to block it in as two cylinders of approximately the same length: one for the upper arm, from the top of the shoulder to elbow; and one for the fore-arm, from the elbow to the wrist.

Observe the varying arm positions of the three girls in the portrait on page 145. Because these figures are painted in a nearly flat frontal light, I had to seek variety in the poses so the painting would not be boring. Even though the sleeves partially obscure the arms, careful attention must be given to the anatomy underneath.

Ulna

Radius

Palm up

A

Radius

Point of
elbow

A

Ulna

Palm down

# The Hands and Wrists

## Common Errors: Drawing the Arm

*Making the arm too stringy and without form.* This is really the only major fault in drawing the arm. The bare arms on a muscular man are easy to draw, but how many portraits of athletes will come under your brush in your lifetime? (Unless you specialize in circus people, dancers, or sports figures—wouldn't that be great luck?) Try to paint the bare arms of an eight-year-old boy. Now there's a task to test your mettle! And slender young women, too— not so easy. For one thing, the arms *do* look stringy, but you as an artist must add form and solidity.

*Note:* As you study that thin little arm, you really need something to go *across* the form. This is where your artistry comes in. Put the paint on across the form, the charcoal strokes as lines across the form, to indicate its roundness. This truly is the answer. *Never* paint an arm with up-and-down longitudinal strokes. Of course, the curve of a sleeve helps immeasurably, as does a watch or a bracelet, to make the arm appear round, so take advantage of them when you can.

Drawing hands takes a tremendous amount of practice. After all, if you're going to include hands in your portraits, you want them to be as well thought out as the head. Your sitter's hands express another facet of his or her personality. They add character to a man's portrait, grace and poise to a woman's portrait, and charm to a child's portrait. And if you can't put in the hands, you're forever limited to just head and shoulder portraits—not much fun!

Here are some facts about the hand and wrist: The wrist is a form similar to a flat block, approximately twice as wide as it is thick. The wrist rotates with the hand on the forearm, as discussed on the previous page.

When the hand is at rest, palm up or palm down, in one's lap or on a table, the front of the wrist, on the thumb side, is higher than the little-finger side. Prove this to yourself by studying your own wrist and hand.

When the arm lies flat, palm down, on a flat surface, there is always a hollow under the wrist. The arm and hand *never* rest on the wrist, but on the heel of the hand and the fleshy part of the forearm near the elbow.

The hand is made up of two masses: the hand itself and the thumb. There are four bones in the hand mass, twelve in the fingers, and three in the thumb.

### Blocking in the Hand

The hand is so complex a structure and capable of so many movements that most students are apprehensive about drawing or painting it. However, to the portrait painter, the hand is second in importance only to the head, adding so much to the character of the work that we absolutely must give it our best effort.

Let's set aside our fears and attempt to see the hand as a geometric form. If we look at it as a mitten with thickness, we can master it. This is a valid way to block in the hand in any medium— charcoal, oils, watercolor—and can be relied on to get you started on the hands in all the portraits you do for the rest of your life.

This first form below is a good beginning, but you'll never see a hand in this position—out flat—on real people, so we must explore further.

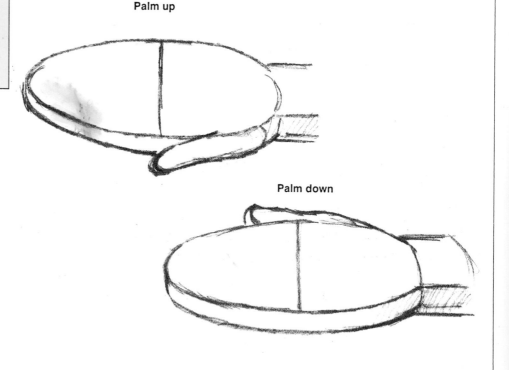

**Palm up**

**Palm down**

The knuckles (on the back of the hand) are halfway between the wrist and the end of the first finger, the index finger. Check this on your own hand. Let your blocked-in mitten bend at this point so that the "hand" appears more natural, slightly cupped. The middle finger is the longest and it determines the length of the hand.

**Equal distance**

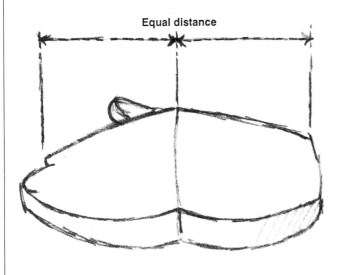

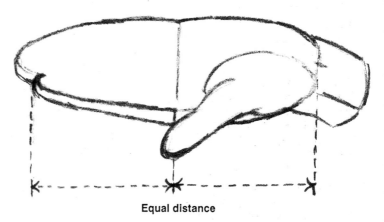

**Equal distance**

The finger section *A-B* is jointed twice more and can bend forward at these joints all the way to a tight fold, a clenched fist.

The hand section *B-C* is capable of movement at the wrist forward and backward and side to side.

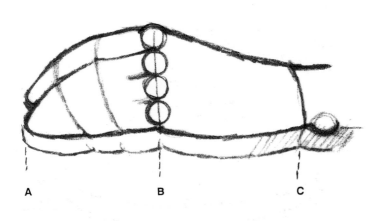

A          B          C

## Construction of the Hand

The first section of the finger, starting at the knuckle, is the longest of the three finger parts. The second section, in the middle, is shorter than this, but longer than the third section, the fingertip.

As none of the fingers are of equal length, none of these divisions line up across the finger mass. However, these segments—the longer section from the knuckle to the next longest to the shortest—are still the structure of every finger.

Each section of each finger is always *straight, never* curved. Even when you see the most graceful willowy hand movements, the fingers may curve, but each segment (called a phalange) is straight. Draw these finger sections with straight lines on the top side, and with rounded fatty pads on the lower, the palm side. Think of each segment as a cylinder and you will get the perspective right.

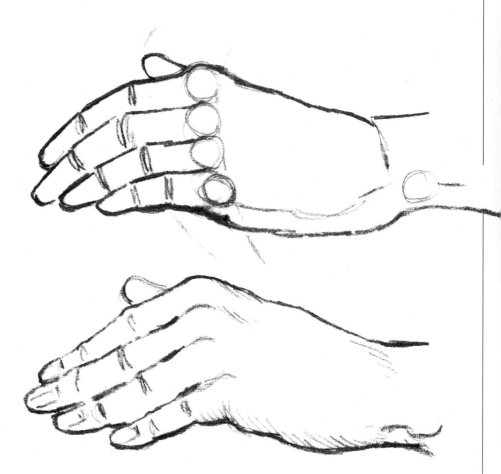

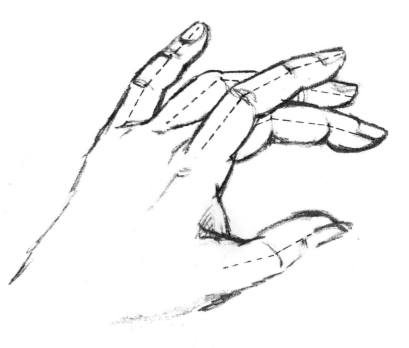

We have been studying the back of the hand. Now turn the hand over, palm up as in the illustrations at right. Looking at the fingers, you can see there are three parts to each finger — three fleshy pads, all quite *equal* on any one finger. Of course, since the fingers are not all the same length, the pads and the folds between them do not line up with each other across the hand.

You'd think the folds on each finger would match the joint divisions on the back of the finger, wouldn't you? Study your own hand carefully.

There is the fold at the third joint, the fingertip joint. Then the second section and the second joint. Then the third section and the first joint. On the palm side, this is where the fingers end and the palm begins. Now fold your hand at the knuckles — you are in for a surprise — the fingers do *not* fold at this third joint where they join the hand; the knuckle joint on the back corresponds with a *fourth* fold across the palm of the hand! *This* is where the finger action starts!

Look at your hand from the side to prove that the third fold on the inside is only halfway between the second joint and the knuckle joint on the back. Curl your fingers halfway closed and see this amazing fact for yourself, first from the thumb side, then from the little finger side. There is no movement where the fingers *appear* to attach to the hand, but at the knuckles further down in the hand mass. Knowing this will help you to draw hands in natural positions.

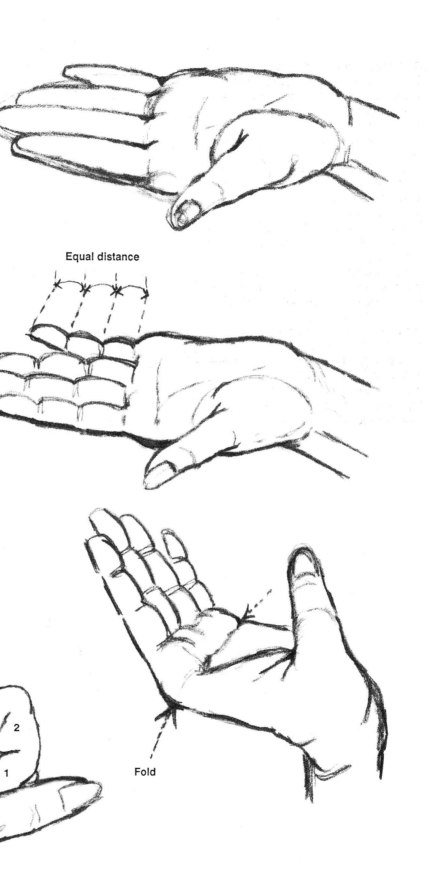

Equal distance

Fold

4  3  2

1

Fold

### The Cupped Hand

The hand is naturally cupped when in repose. We really have to *push* to flatten our hands on a flat surface. Cupped from fingertips to heel, the hand is also cupped from side to side. Knowing this will help remind you to *round* the form *across* the knuckles in any view.

The only time the hand is flat is when a conscious effort is made to extend the fingers.

### The Thumb

The thumb may be considered a long form with squared sides. It has three joints; the base joint is out of sight in the hand and connected to the wrist.

The fingers and the thumb fan out from the wrist. However, the visible joint where the thumb joins the hand is nowhere near the finger joints and is never in a line with them unless the hand is tightly closed, as when making a fist. The thumb dominates the hand, particularly when the hand is holding on to something.

The thumb appears most often at right angles to the fingers. You can check this easily: when you look at your hand palm down and see the fingernails in full view, you see the thumbnail in profile. Conversely, when looking at the thumbnail full view, you'll see that the fingernails are in profile.

### The Nails

Adding the fingernails helps considerably in conveying the form and direction of the fingers and hands. The nail starts halfway down the fingertip segment of each finger and the thumb. On a man's hand, keep the nails quite square; on a woman's hand, make them oval and a bit longer. Most portrait painters idealize the hands by making the fingers longer, and the fingernails in a woman's portrait look better if they are colored a soft pink or coral. Adding the highlight on the shine of the nails makes them almost like jewelry on a man or a woman. And on a small child, shiny nails make the tiny hands look very clean.

### Drawing and Painting Hands

As for color, the fingertips are always a warmer hue than the rest of the flesh. In fact, *all* the extremities—hands, feet, ears, and nose—are warmer, that is, pinker or rosier.

A child's hands are fatter, rounder, less defined, less "controlled" than an adult's. Although the forms of their fingers appear to be round, you will have greater success if you describe them with straight lines.

If you are right-handed, practice drawing your left hand in various positions: i.e., palm up, palm down, clenched, pointing, holding a letter or a flower. If you are left-handed, draw your right hand. The sketches on the next page will give you some ideas.

In general, it's safe to say you should try to block in *any* form with straight lines. Your work will be stronger and more solid. It's a simple matter to round off any area in the finishing—the *start* is what counts!

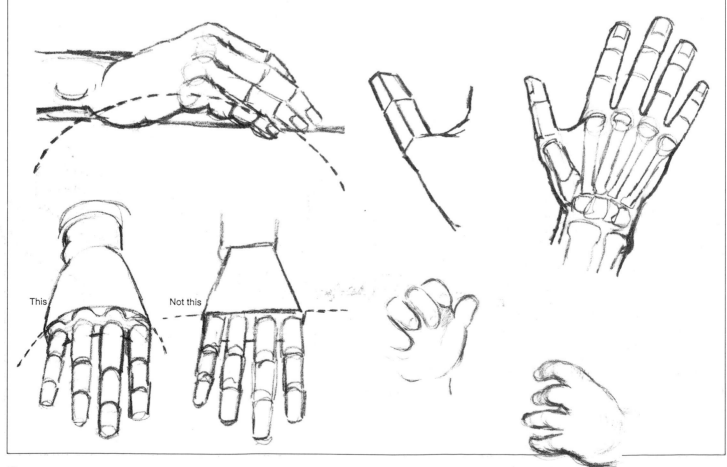

This

Not this

## Common Errors: Drawing Hands

*Hands too large or too small; out of proportion.* The length of the hand from its heel to the tip of the longest finger is considered to be the length of the face, from chin to hairline.

*The "bunch of bananas" syndrome.* Fingers appear to be hanging off a block-like form (which is the hand) rather than growing out from the knuckles.

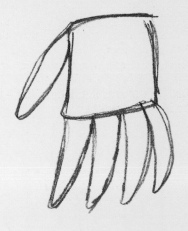

*Too much definition.* Draw the separate cylinders of the fingers, but when finishing, eliminate many of these lines and treat the fingers as masses with less articulation.

*Out of perspective.* Be conscious of your viewing position, and try to draw the finger cylinders in proper perspective.

*Awkwardly drawn wrist.* You can learn to draw every part of the human body in any position from memory—*except* the wrist. Keep it as a flat block and it will give you less trouble.

## Summing Up

By now you're probably thinking, "How am I going to remember all that?" No one expects you to remember it! I only hope one day when you're in the middle of a portrait and having trouble with the hands (all of us do, you know), you'll look back at this chapter and find the answer to the problem that's plaguing you. Most often the problem is in the basic construction and not the details. I can't stress this too strongly. I could give you the clearest, sharpest photograph of hands in the world, and you could spend days and weeks painting from it, but without real knowledge of how the hand is constructed and how it works, your painting will be lifeless and without substance. Remember, artists don't paint only what they see; they paint what they *know!*

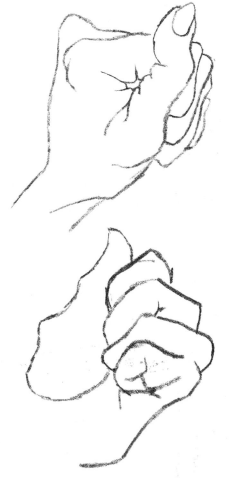

# The Legs

You won't often be asked to include legs and feet in a portrait of an adult, but if you decide to make portrait painting a career, one day you will most certainly be commissioned to paint a full-length portrait of your client. Even if the man's legs are covered by trousers and the woman's by a lovely gown, you still need to know what the body is doing underneath all that fabric. Also, to paint the standing figure you have to know how the weight of the body is supported.

The thigh—the form from hip to knee—is all one bone, the femur. The femur is the longest and strongest bone in the body. The femur is attached by a necklike form to the pelvis in a ball and socket formation. This allows the leg to move freely forward, backward, sideways, up and down.

As the thigh descends to the knee, it centers itself under the central weight of the torso. The knee is in a direct line with the hip joint.

The leg from knee to ankle, like the forearm from elbow to wrist, is made up of two bones side by side. The heavier bone is the tibia, and the narrower bone is the fibula. The narrow second bone, the fibula, allows the ankle to rotate, although we cannot flop our foot over 180 degrees as we can our hand.

Seen from the front, the inner ankle bone is obviously higher than the outer protuberance.

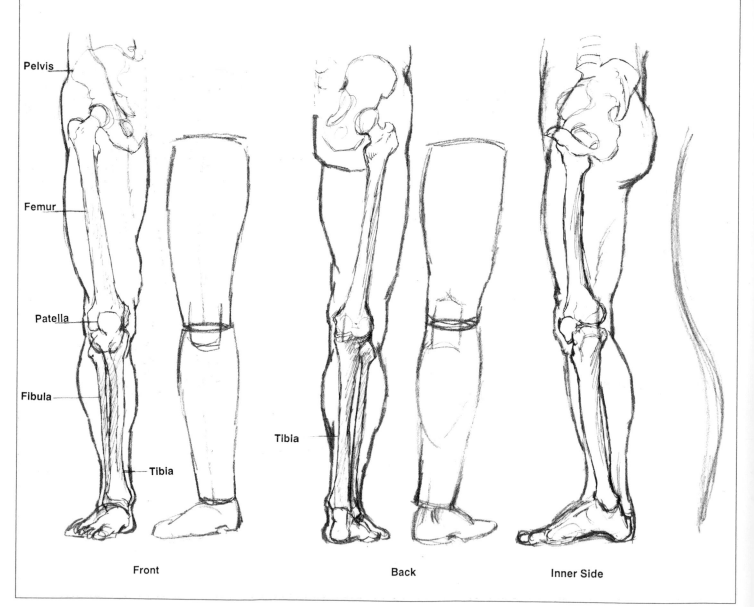

Front

Back

Inner Side

## Drawing the Leg

The leg in profile presents an elongated "S" curve. The kneecap (the patella) is held in place by extremely strong ligaments attached to the fibula below the shinbone. The leg resembles two cylinders of equal length, one from the upper thigh to the kneecap, and one from the kneecap to the inner ankle bone.

When a figure is seated with the legs bent at hip and knee, drawing the thighs is much easier by seeing them as cylinders in perspective and proceeding as suggested in these drawings.

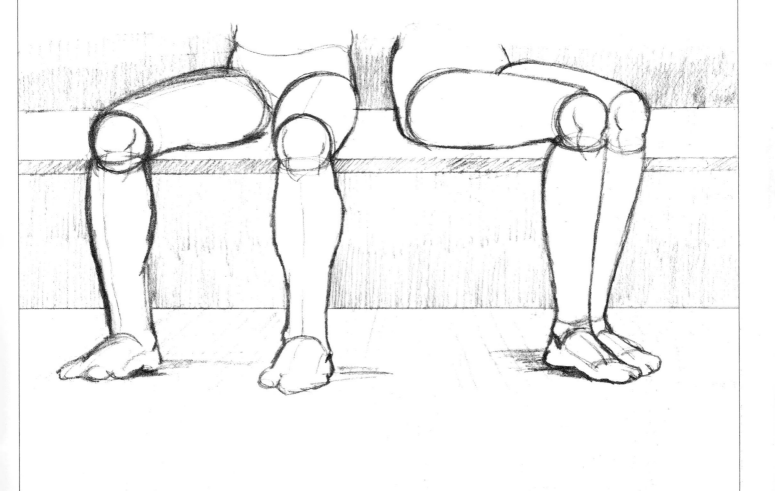

# The Feet

The foot is a wedge shape that flattens out at the toes. When a subject is standing, the outside of the foot, from the little toe to the heel, is usually flat on the ground. The main arch of the foot is on the inside, normally raised from the ground. This gives spring to the foot as it steps.

Notice that the big toe is often separated from the other four toes, rather like the thumb is separated from the other fingers.

When drawing the foot, try blocking it in with straight lines for strength and support. And block in the toes as small cylindrical forms. Learning to draw the toenails properly will help put the foot in perspective. This is important since all views from the front present the foot in perspective.

## Children's Legs and Feet

Though you may seldom be called upon to include legs in an adult's portrait, if you paint children you will have many opportunities to depict their little legs. The construction of a child's leg and foot is the same as the adult's, but there is less definition of muscle and the forms are more rounded.

An infant's foot is round, not flat, on the sole, as he has not worn shoes or walked enough to flatten the soles. The feet are fatter than those of an adult and the toes can be very tiny. Again, the small toenails help to establish the angle of the foot.

Many times you will prefer to paint a small child barefoot, even in fairly dressy clothing. The bare feet take away the over-formal look and remind us that the child is more free and natural than adults.

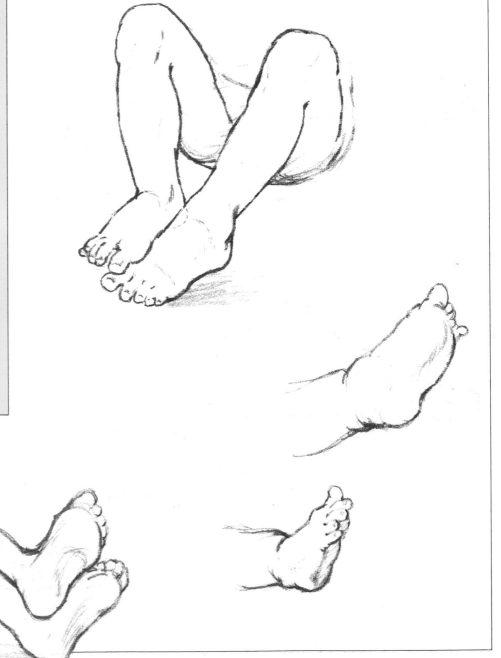

After Mary Cassatt

# Proportions of the Body

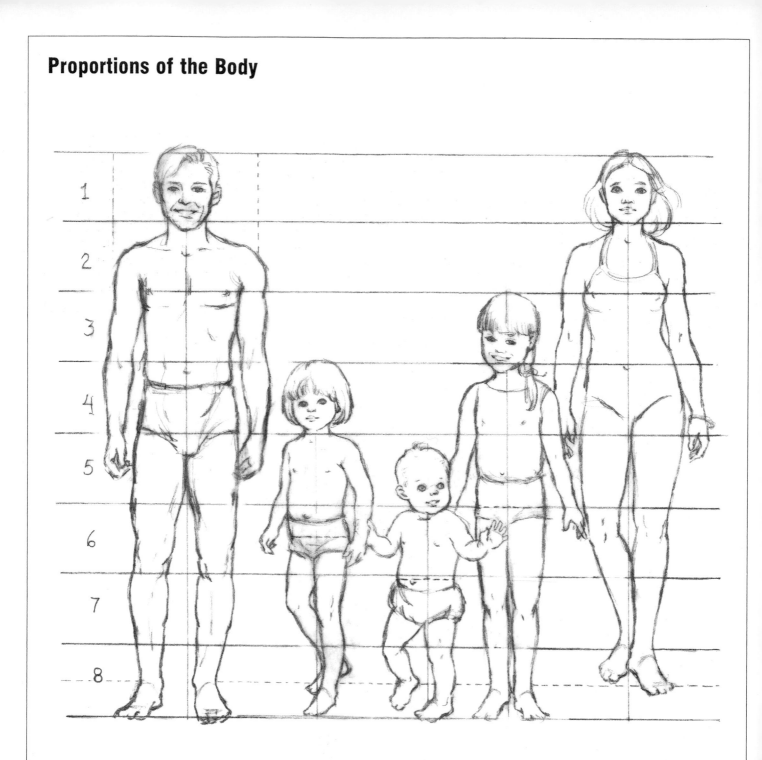

To get the proportions right, it makes sense to draw the large forms first, and then begin constructing the masses by means of light and shade and defining the larger planes. As you continue to work, the portrait will gradually get more and more refined, until eventually you arrive at the likeness and indi-viduality of your sitter. I know an experienced portrait painter who can begin with one eye and build the whole head and body around it, but don't make it this difficult for yourself yet. As a student, *always* draw the figure as a whole before you put in the details of the head, hand, foot, or face.

**Adults** Using the head length as a unit of measurement, the adult human figure is 7 to 8 heads high. The idealized figure is 8 heads high, lending a feeling of dignity and elegance. (*Never* make the head larger than it appears; this makes the figure look clumsy.) A good size for the average figure is 7½ heads.

In this illustration, the male and female figures are 7½ to 8 heads high. From the top of the head to the hipline measures 4 heads, and from this line to the heel measures 3½ heads. Study the diagram to see which parts of the figure can definitely be located by the head unit of measurement. Of course, the first head-length is the head; the second is the distance from the chin to the nipples; the third to just above the navel but below the waist; the fourth head-length takes us to the hipline. From this line it is 1½ heads to the knees. The center of the figure is about at the fourth head line, or just above that line.

In the male adult, the shoulders are approximately 2 head-lengths wide; this is the widest part of the male body. In the female body, the hips are often as wide as the shoulders.

When the arm hangs at the side, the elbow touches the rim of the hip bone, the iliac crest, and the inside of the wrist is on a level with the halfway point of the figure. The fingers reach a little below the center of the thigh.

**Children** In children the head is larger in proportion to the body. The central figure in the diagram at left, the one-year-old, has a head one-quarter the length of its body. The central point, indicated by the dotted line, is at the waist; above the navel may be easier to determine, as an infant this age normally has no waist.

The four-year-old (second from left) has a head-length approximately 20 percent of the body length, which, therefore, is 5 heads high. The central point is 2½ head lengths from the top of the head.

The eight-year-old child (fourth figure from the left) is about 6 heads high, and the halfway point is moving down nearly to the adult halfway point, the hipline. (The three children are in proportion to each other but not to the adult figures in the drawing. In actuality, their heads are smaller than adult heads, but drawing them in these sizes makes the proportions easier to see and to remember.)

**Drawing from Life** You can look at these diagrams and study your own body, but there's no substitute for drawing from the live model. If you can't find a life drawing class in your area, start one. Perhaps you can get members of your family or a classmate or friend to pose resting, reading, or even watching television! Portrait painting is really only an offshoot of life drawing—a sort of life drawing with personality superimposed.

Some students are interested in anatomy, the study of the skeleton and the muscles. Others don't have the slightest desire to know what goes on under the skin. But as a portrait artist, you need to know something about anatomy. If you want to study it in more detail, some excellent texts on anatomy for artists are listed in the Bibliography. Anatomy for medical students is a much more definitive study, but you don't have to master it in this great a depth. Even if you keep just this book near you while you are observing and drawing the live figure, you will see real progress in only ten drawing sessions.

Practice drawing people of both sexes, all ages, seated, standing, in a variety of positions. Most artists continue to draw from the figure throughout their lifetimes. To draw the figure well—to re-create its mass and its movement—is a highly desirable skill. And there isn't an artist alive who ever feels he draws the figure as well as he should.

> *Hint:* After deciding on a pose for your subject, get into the habit of measuring one head-length. Extend your arm, hold your brush vertically, and measure along the handle of the brush. Then measure the second, third, and fourth head-lengths to get a rough idea of just how much of the figure can be included on your canvas or paper.

# Weight Distribution

We have learned to block in the figure with jointed cylinders for arms and legs, a thoracic egg and a pelvic block for the torso, a mitten for the hand, and a wedge for the foot. However, there's more to it than that. We must also consider shoulder and hip construction lines from the very beginning of our sketch, for these lines tell us instantly how the figure is standing and how the body's weight is distributed.

## Using Construction Lines

The following construction lines are particularly helpful: the shoulder line passes from one shoulder to the other through the neck and is paired with a second line under the rib cage which *always* parallels it. The line at the hip is paired with a second line through the tops of the iliac crests of the pelvis; these two also *always* parallel each other. (See lines *A* and *AA*, *B* and *BB*).

Only when the body is seen standing perfectly erect with the weight distributed equally on both feet, are all the shoulder and hip construction lines parallel to each other.

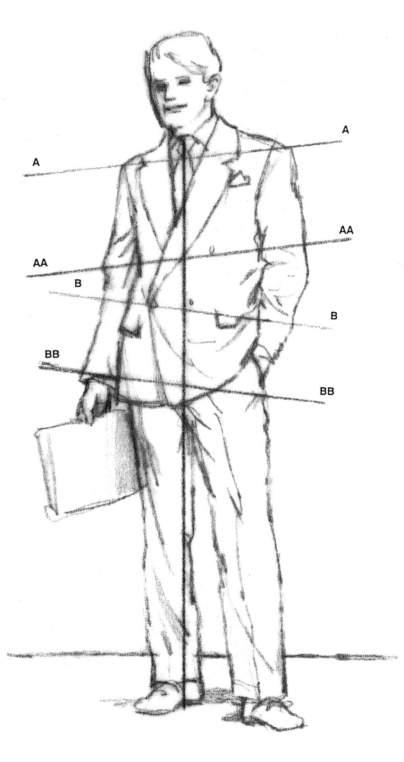

When the weight is shifted to one foot, say the left, as shown in this female figure, both the shoulder line and the hipline bend toward each other. The right nonbearing leg appears to be longer than the left supporting leg. The nonbearing leg can be bent, or extended to front, back, or side—it doesn't matter, for it isn't being used to hold the body upright, but just to balance its weight. Just watching for this shoulder-hip relationship will help your figure drawing look more natural.

Looking in a mirror, try it yourself. Stand with your weight on your right leg and raise your right shoulder. Uncomfortable! As you lower your right shoulder and raise the left, your body stands relaxed.

## The Plumb Line

When a subject stands with the weight on one foot, the inside of the ankle supporting the weight is in a direct line straight down from the pit of the neck. This holds true whether the body is viewed from the front, back, or side. This very important line is called the *plumb line.*

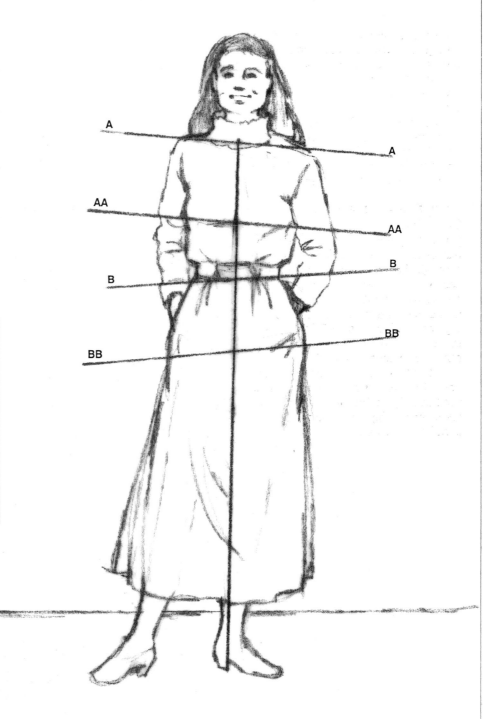

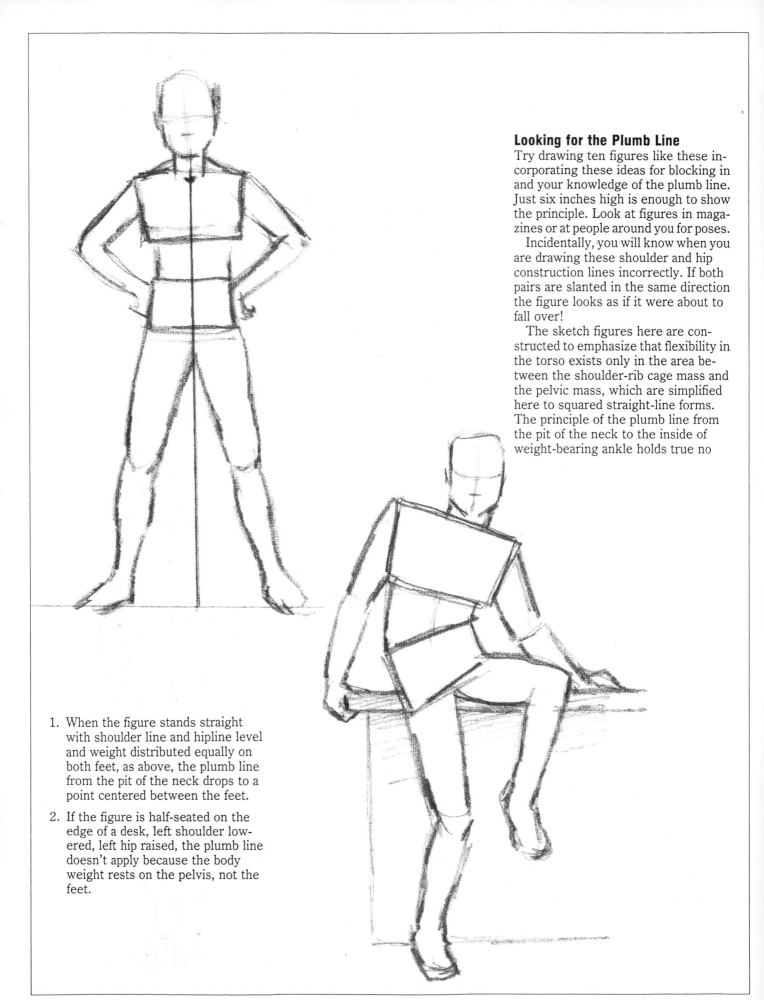

## Looking for the Plumb Line

Try drawing ten figures like these incorporating these ideas for blocking in and your knowledge of the plumb line. Just six inches high is enough to show the principle. Look at figures in magazines or at people around you for poses.

Incidentally, you will know when you are drawing these shoulder and hip construction lines incorrectly. If both pairs are slanted in the same direction the figure looks as if it were about to fall over!

The sketch figures here are constructed to emphasize that flexibility in the torso exists only in the area between the shoulder-rib cage mass and the pelvic mass, which are simplified here to squared straight-line forms. The principle of the plumb line from the pit of the neck to the inside of weight-bearing ankle holds true no

1. When the figure stands straight with shoulder line and hipline level and weight distributed equally on both feet, as above, the plumb line from the pit of the neck drops to a point centered between the feet.

2. If the figure is half-seated on the edge of a desk, left shoulder lowered, left hip raised, the plumb line doesn't apply because the body weight rests on the pelvis, not the feet.

matter which view of the figure is portrayed: back, front, or side. The center back and center front lines are lightly indicated on the figures on this page to show that they are independent of the plumb line.

If you practice sketching small figures like these for fifteen minutes three times a week, soon you'll be able to sketch people anywhere—in a bus station, at a party, at the beach—wherever people are standing about, waiting, or conversing. You will be able to sketch convincing figures from your imagination as well. Then when you have a new portrait client, you can do several quick sketches suggesting possible poses as a logical first step in the development of the portrait. Remember, you gain confidence as you gain facility.

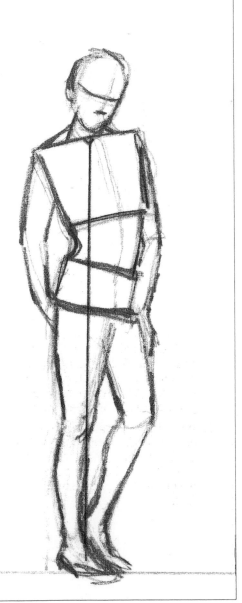

3. When the figure is standing (seen from the back, above) with weight on the left leg and foot, the plumb line runs from the pit of the neck in front to inside the left ankle. The left shoulder is dropped and left hip raised.

4. When the standing figure is slightly turned, with weight on the right leg and foot, the plumb line falls from the pit of the neck to inside the right ankle. The right shoulder is dropped, the right hip raised.

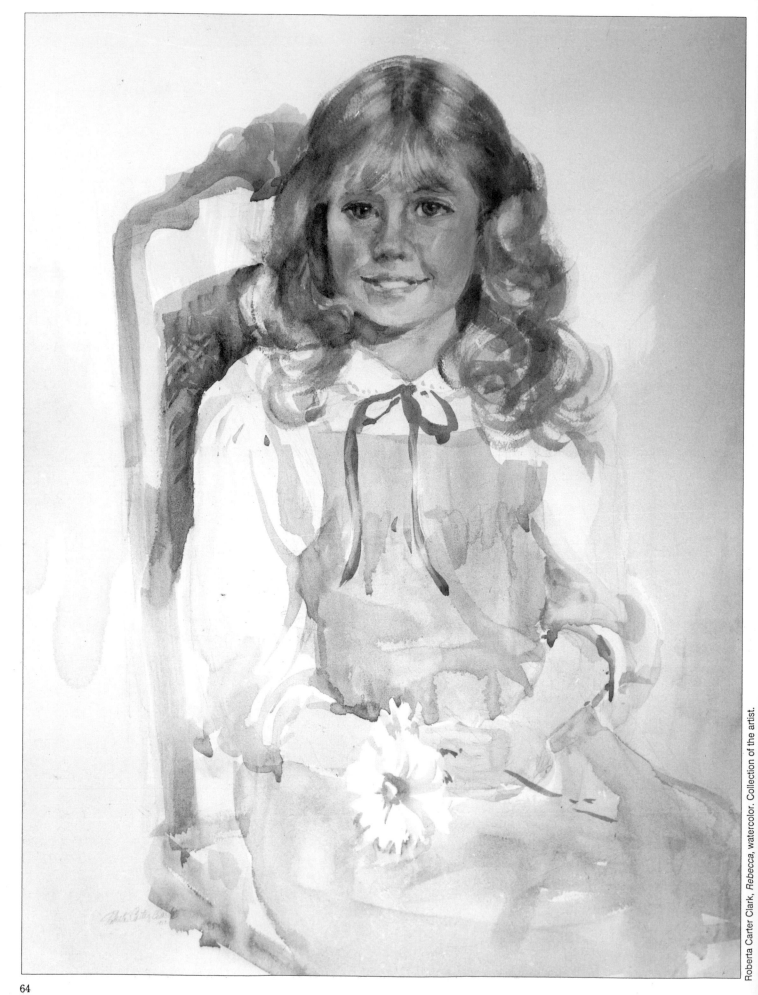

Roberta Carter Clark, *Rebecca*, watercolor. Collection of the artist.

# DRAPERY: CLOTHING THE FIGURE

Your rendition of clothing is a powerful tool for designing a portrait beautifully. It can add a great deal to the feeling of reality you wish to achieve.

Clothing is just fabric lying flat until someone puts it on the body. For all of us, our clothing means excess fabric, enough so we can move—bend, sit, crouch, walk. Since you will be painting many types of fabric, it's important to understand the individual characteristics of each one.

There are thin, fine, clinging fabrics like chiffon, which is sheer enough to reveal the forms within; silk; and satin, which is also shiny. There are medium-weight fabrics like cotton (crisp or soft); taffeta (crisp and angular); knits (used for T-shirts and sweaters); and woolens for men's and women's suits. There are heavy woolens for coats (soft but bulky); velvets (pile fabrics that absorb light to the extent they show no highlight but rather a rim light on the edges of the forms). There is fur (another pile material that can be flat and glossy like broadtail or longhaired like lynx). The list goes on and on.

# Observing Folds in Fabric

It's important to really notice the fabric in the clothing of people you see around you and study the differences. Mannequins in store windows and photographs in fashion and sports magazines are also good sources for study.

The weight and texture of the fabric controls the manner in which it drapes, wrinkles, or folds. The condition of the fabric—whether it is wet or dry, old or new, rumpled or pressed—also affects its appearance. Even though each fabric performs differently, we'll develop a method so that you can begin to understand what's occurring when you see a sleeve on the arm you are painting, or a scarf around that neck, for all fabrics make the same kinds of folds.

**Fabric Lying on a Form** Lying-on folds are just that—the fabric follows the form it's lying on. Spread out on a table, fabric looks flat. On a cylinder, or an arm or a leg, it hangs, but not quite straight down because it follows the form a bit before falling. Always look first for the areas of fabric that touch the form beneath.

**Fabric Going Around a Form** Look for instances where fabric appears to go behind a form and come out on the other side, such as a collar does around a neck. As we know from our anatomy work, the back of the neck is flatter and higher than the front of the neck, which is rounder and lower. This makes the front of a garment appear to dip down at the neckline in a round manner while the back of the collar or neckline lies higher and flatter.

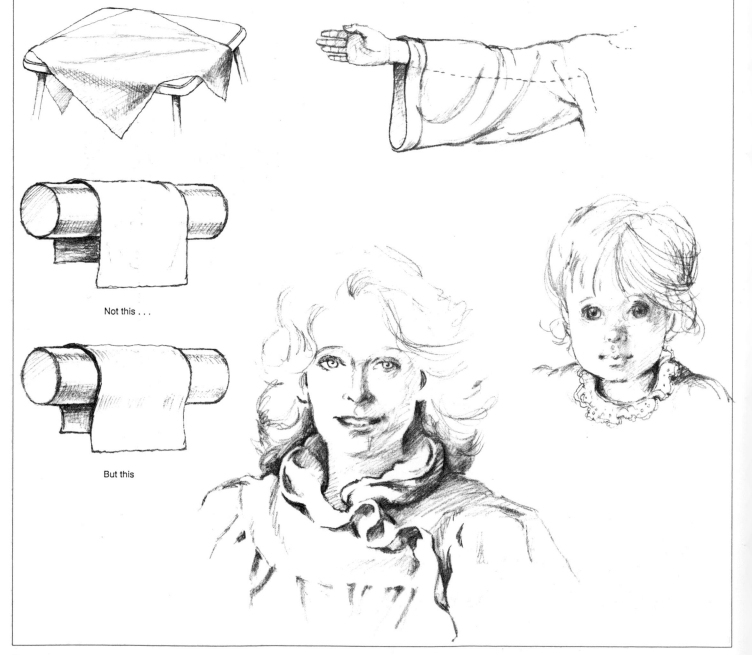

Not this . . .

But this

You could think of the folds on a cylindrical form — such as the arm, leg, or torso — as curtain rod rings around a rod. These folds are drawn mostly with curving lines. Just remember that without the rod, the rings would be lying in a heap, and without the arm the sleeve would be a floppy tube of fabric. Draw the arm first, with its gesture and movement; then lay the folds over the form like curtain rod rings.

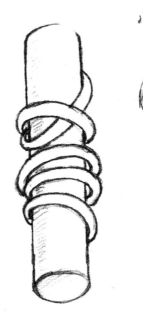

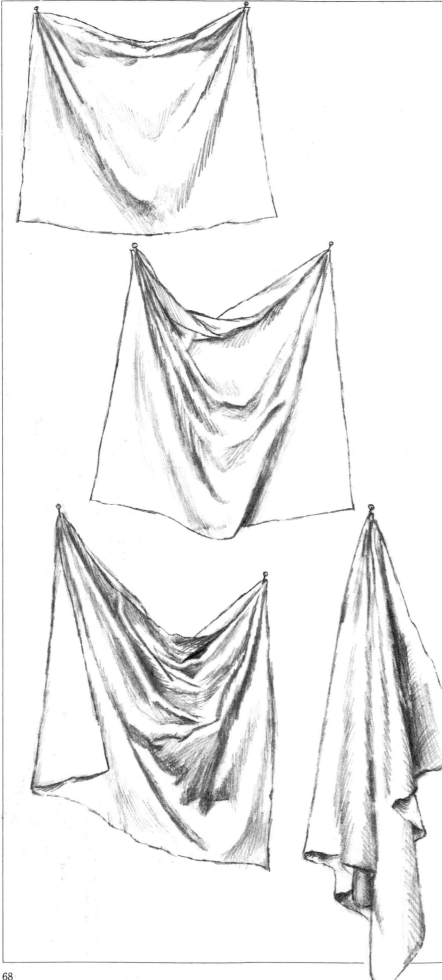

## Fabric Hanging

Hanging folds are affected by gravity and the weight of the fabric. These folds are drawn mostly with straight lines.

To study the way fabric hangs, get a piece of soft white cotton or cotton-blend fabric the weight of sheeting, about 48-inches square, and some pushpins, tacks, or tape.

Put the pins through the cloth at the two top corners and attach the fabric to the wall surface. As you move each pushpin with the fabric closer together, you'll see the fabric begin to drape a bit.

Leaving the pins at the corners of the fabric, move each top corner about four inches closer to the other, keeping the pins at the same height. You'll see the fabric now drapes into swag folds because the weight of the material is being pulled by gravity into triangular forms. Try to see the folds as forms with a halftone side, a light plane which is the top plane, and a shadow side. Use a spotlight if necessary.

Keeping the pushpins at the two top corners of the fabric, move one now to a spot on the wall about eight inches lower than the other. The folds are now off-center, and you are getting swag folds and hanging folds. Notice that the swag fold shadows are composed of broad triangular forms, while the hanging folds are more like "pipes" (organ pipes, that is).

Hang the fabric now using just one pushpin somewhere along the top edge of the fabric, but not at the corner. You will see there are no more swag folds, only pipe folds and excess fabric hanging as a jabot—a cascade of frills down the front of a shirt—might.

*Hint:* In all of these swag and hanging folds, the lines radiate from a hub, a point of suspension—in this case, the pushpin. Flip one corner of the excess cloth to the front to overlap the rest and observe what happens.

**Fabric Pulling** Pulling folds are action folds and are usually drawn in curved lines. In these drawings of seated trousers at right you can see the outside fabric stretches taut over the knee. The lines radiate from the smooth ball of the knee. The inside bunches at the front where the stomach meets the upper thigh, and again at the back of the knee. The fabric is stretched smooth over the buttocks. There are hanging folds below the knee where the fabric hangs free, and there's a lying-on fold where the trouser fabric hits the shoe.

In the standing trouser drawing below, you see gathered fabric puckering from the elastic waistband; puckered folds at the crotch; fabric pulled taut over the right knee, and bunched inside the knee bend; hanging folds where the trouser fabric hangs free from the left hip; and lying-on folds where the fabric of the right trouser leg follows the calf of that leg.

**Fabric Hanging from the Waist**

When drawing a skirt that's either gathered or pleated, the largest folds are at the center of the body; they become smaller toward the sides. The folds are in perspective.

In the drawing of the woman's skirt, the fabric is soft—maybe a silk crepe. The pleats and gathers fall very straight down from the hips and stay close to the body beneath.

In the child's skirt the fabric is more crisp and has more body—perhaps it's a cotton. The gathering of the skirt at the waistband pushes the stiffer fabric out and away from the body. In this drawing you also see one way of handling still another fuller ruffle of fabric. Note the small ruffle trim applied to the skirt as well.

# Step-by-Step: **Drawing Drapery**

This drapery study is helpful at any stage of your development. A knowledge of drapery is essential for portrait painters so that they can paint the clothing of sitters convincingly and design portraits with drama and conviction. You will also use this knowledge when depicting background drapery such as a cloth over a table or a curtain at a window.

**Preparing the Fabric** Take the 48-inch square of white cotton fabric and spread it out flat on a table or the floor. You'll need a yardstick and two markers with wide nibs, one colored and one black. With the colored marker make three parallel lines across the fabric dividing it equally into four parts. Make one line a solid line, one line of dashes, and one of dots. Turn the fabric in the

other direction and do the same with the black marker. The lines will cross each other at right angles.

**Making the Drawings** You'll want a middle-value toned paper large enough to make nearly life-size drawings of the fabric arrangements. The brown wrapping paper sold on a roll 36-inches wide has a pleasant tooth and will do the job well. You'll also need soft and medium-soft charcoal for the shadows, and white chalk or white pastel for the highlights. The brown tone of the paper will serve as the halftone. You will need a board large enough to support the paper, at least 30″ × 40″, and an easel, or you can tape the paper directly to the wall and work on it there.

Try making at least one study of each of the four hanging fold arrangements

on page 68. The lines you've drawn on the cloth will help you perceive what the fabric is actually doing. Every fold has a minimum of three surfaces, i.e., the top plane, the left side plane, and the right side plane. These planes will be easier to see if a single light source is used, such as light from windows on one side of the room or a spotlight.

Work hard to keep your drawings *simple!* It's so easy to get "lost in the folds" when your rendering becomes too intricate. If you begin to feel confused, get away from the work for a few minutes, or check in your mirror, observing the draped fabric and your drawing at the same time.

Spray your drawings with fixative when you're finished so they won't smear.

# Painting Drapery Without the Sitter

**The Stand-in** When Britain's Queen Elizabeth has her portrait painted, which is frequently, she must of necessity have another person pose in her place while the artist paints the clothing and the jewelry. This is an excellent method for getting the job done when a very busy person is your subject.

**The Lay Figure** Many portrait painters borrow the clothing from the subject and drape it on a "lay figure"—a life-size mannequin or a dressmaker's dummy—as a substitute for the real person. This not only relieves the client from all that posing, but the lay figure doesn't move, so the folds (and the light on them) are always the same.

Most lay figures in artists' studios are department store display mannequins and can be arranged to sit or to stand. Some even come with two sets of arms to allow more variety in the poses.

My own work is usually done from life in the home of the client. But to save my subject many hours of posing while I work on the clothing, I stuff the garment with a bed pillow and smaller pillows for the torso; when necessary I also use rolled towels inside the sleeves for arms. I then prop up my "figure" on the same chair as in the portrait and can work as long as I like on the folds and the pattern of the fabric.

**Interpreting Drapery** The Greek and Roman artists sculpted drapery as if it were wet fabric, in very vertical pipe-like forms. In the works of Albrecht Dürer and other artists of the Middle Ages, the fabric appears crisp, and the folds are squarish and angular.

Peter Paul Rubens painted drapery in large round forms and influenced the Baroque painters. Two of the best to study for drapery are the eighteenth century artists Giovanni Battista Tiepolo and Antoine Watteau. The sculptor and painter Giovanni Lorenzo Bernini, who worked in Rome from 1605 to 1680, made marble look like the airiest of fabrics billowing on the wind!

In the drawing below left, after Lorenzo di Credi, a Renaissance artist, the figure appears to be nearly flying in the wind. The motion and emotion in this tiny study are created solely by the handling of the drapery. We know the drawing is fantasy from the artist's knowledge and imagination, for no one could ever see fabric moving this rapidly, let alone draw it. But the illusion is complete. Try a portrait one day of a figure outdoors, hair and maybe scarf blowing in the wind. Wouldn't this be a challenging project?

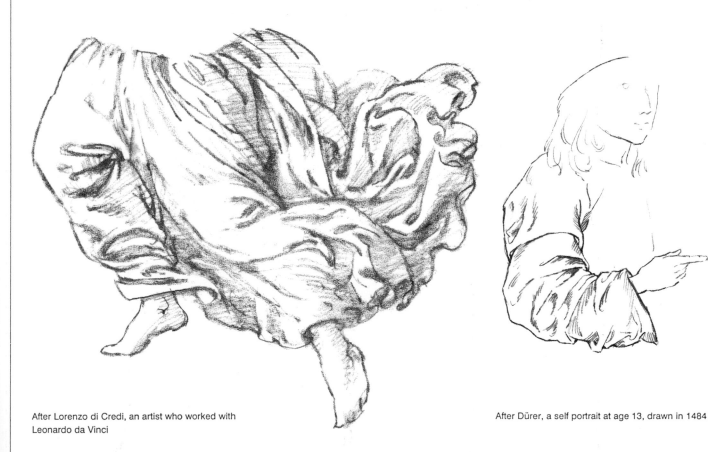

After Lorenzo di Credi, an artist who worked with Leonardo da Vinci

After Dürer, a self portrait at age 13, drawn in 1484

# LIGHTING FOR PORTRAITS

The way you pose your sitter in relation to the light source has a great bearing on the look of the finished portrait. When posing your model, lighting is the first thing to consider. I almost always use natural daylight or daylight supplemented by artificial light. I personally find it impossible to paint flesh tones at night when the only source of light must be artificial, though that doesn't mean all artists find this so. Of course, artificial light is fine for charcoal portraits, where color is not involved.

Before you begin to paint or draw, try having your sitter pose with several different lighting arrangements and in different positions. Usually one place and one pose will prove to be so obviously more interesting or beautiful than the others that you can hardly wait to paint it. Of course, that's the one to choose!

On the following pages you'll find examples of various poses of the head and ways of lighting it. Draw these photographed heads, then try to simulate these poses and lighting conditions on your own, with a model, and make light and shadow sketches of each of these. You will learn a lot from this. And here's your chance to draw forty-four more heads!

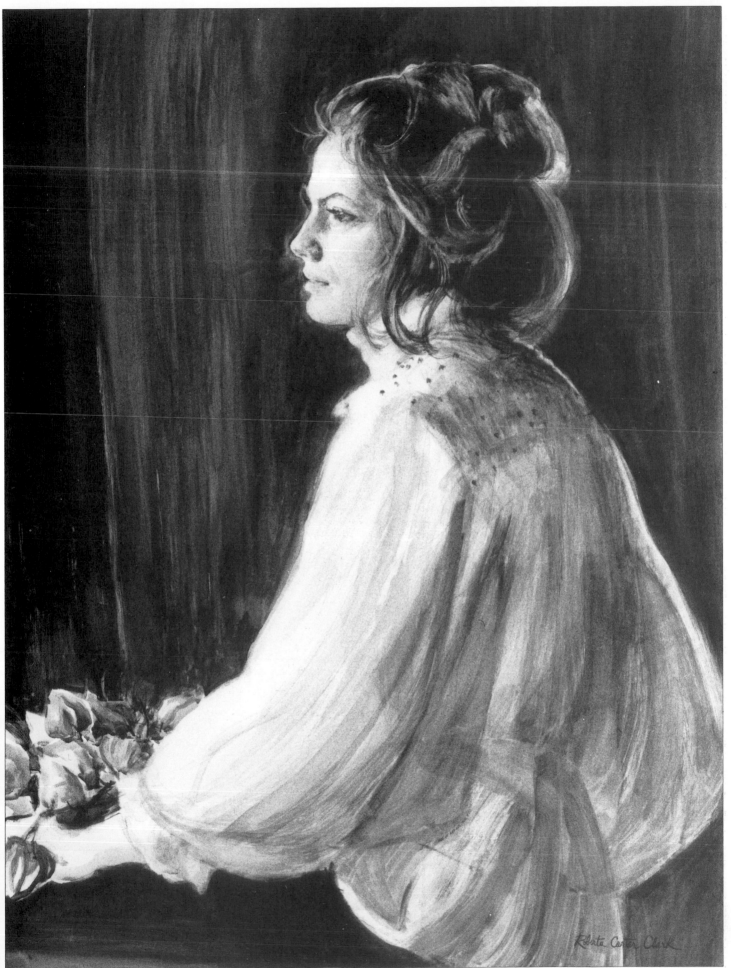

# Lighting the Front View

For this lesson you'll need someone to pose for you. Your drawing materials include paper, a soft pencil (perhaps a 6B), a kneaded eraser, and some sort of portable spotlight such as a clamp-on type or a photographer's light and stand, or even a table or floor lamp with the shade removed. A 200-watt light should be sufficient. Draw your model in the kinds of light discussed here. He or she should be looking straight at you.

*A word of caution:* When using artificial light as a supplementary source of light, be extremely careful not to get "crossed" lights—that is, one light coming from the left and another of the same brilliance from the right. Should you ever find yourself in this crossed-light situation, I'm certain your work will end in complete frustration. Remember, one source of light *must* dominate. Make sure the second light is not as bright as the primary illumination.

*Rembrandt lighting:* The lamp is at about ten o'clock, slightly to the front. A triangle of light appears on the cheek *away* from the light source. This type of lighting describes form very well.

*Overhead light:* This makes large dark holes for eyes and is most unflattering. Often an overhead skylight creates this effect. Very satisfactory, if you like a *spooky* effect!

*Sidelight:* One side of the head is in the light, the other side is in shadow. Highly dramatic, but unsuitable for natural-looking portraits.

*Backlight:* This creates a silhouette—it's what happens when the model is in *front* of a window. Backlight could be interesting to use if some light were reflected back into the face with a mirror or a piece of white cardboard.

*Three-quarter backlight:* This rim light effect is interesting for unusual faces, but too harsh for some. It's not for conventional portraiture.

*Bottom light:* Turns any face into a fearsome one—you really have to see it to believe it. Try it on yourself with a lamp or a flashlight.

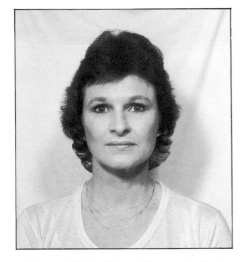

*Frontal light:* Since it's nearly shadowless, frontal light is excellent for people over thirty-five. The features are clearly described, but none of the aging characteristics are emphasized. It's also good for children, since it's best to aim for natural effects rather than theatrical ones when painting them. The eyes show very well in this light, as does soft, delicate modeling. If you stand with your back to a window, both the sitter and your canvas will be bathed in this frontal light, a good arrangement.

# Lighting the Profile

*Top front lighting:* Positioning the light at the front of the face and slightly from above, at about ten o'clock, is a good angle here.

*Rim light:* This general, overall light coming from the front makes for an interesting profile portrait. Moving the light source away from the face creates a softer effect.

*Back rim light:* This really describes good features. Unusual.

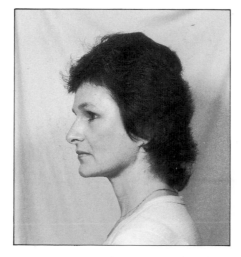

*Totally frontal light:* This light isn't very satisfactory for a profile portrait. The portrait always appears somewhat flat, as it shows only half the face and one eye. Frontal lighting flattens out all the forms even more.

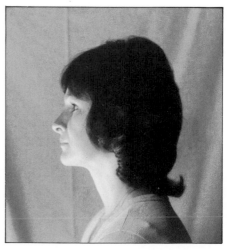

*Bottom light:* Scrooge and evil spirits once more!

# Lighting the Three-Quarter View

*Rembrandt lighting:* Creating a triangle of light on the cheek of the shadow side of the face is the most dramatic and most definitive of all lighting. Here are three versions of this time-honored lighting for portraiture.

With the model seated close to the light source we get a very intense light—too intense for most portrait clients but really exciting for the painter because of the distinct lines of demarcation between light and shadow areas. This lighting is excellent for the study of solid form.

Here the model is seated a bit farther away from the light source. We get a softer light, with less contrast, but still quite good definition.

The model is even farther from the light source here, giving us a very soft, quite diffuse light. More flattering for the portrait client, more difficult for the painter because of such subtle definition of forms.

*Frontal light:* This light diminishes all shadows; therefore, it is most flattering for women, and in fact for anyone past middle age. It's good for children as well, particularly since I feel that children's faces are best painted without heavy shadow areas.

*Rim light:* This light is good used as an accent light with the general overall light coming from the front. It is often seen when the subject is near a window on a bright day.

*Sidelight:* Sidelight from a window works well in a three-quarter portrait and is probably what you will use most frequently.

*Sidelight, face turned into the light:* This lighting in a portrait looks very natural. The nose and cheekbones are well defined by mid-value shadows. Notice the highlight is on the brow bone nearest us, also on her left cheek near the nose, as well as on the nose and the lower lip. Notice the cast shadow in the background in this photograph. Some artists use this to good advantage. Of course, it is seen only when the backdrop is quite close to the head.

*Sidelight, face half turned into shadow:* As the face turns into the shadow, naturalness is replaced by drama. Look how the right eye attracts us, while the left eye is lost in the shadow side. This lighting is not for everyone, but would be great fun to try in a portrait of yourself. (Usually clients like to see *both* eyes!)

If the head turns even more away from the light, the hair will be brilliantly lit but the face will be in shadow. It's extremely difficult to paint the entire face in shadow. In fact, I've seen portraits by the finest painters done in this lighting that didn't work out well at all.

# Lighting the Three-Quarter Back View

The only way to illuminate the face in this pose is with a sidelight, with the brightest light striking the features and defining them. This is a favorite view of Andrew Wyeth's. A portrait done from this angle always gives one the feeling that it is totally natural and unposed. It also conveys a feeling of great privacy for the sitter, for the viewer is not even considered—the sitter is lost in her own vision, her own thoughts.

*Sidelight:* This looks as if the model were seated beside a window, looking out.

*Top light:* Since the face is in shadow, you need to use a light background with this kind of lighting. I would guess this view in this light gives the ultimate in subtlety and mystery to a portrait.

*Backlight:* Some light here is also reflected into the face. This is what happens when the model is in front of a window, an interesting effect but tricky for the artist who must look against the light.

## A Final Word

After you've been working for some time, make a conscious effort to vary the lighting schemes in your portraits. Some painters use the same light direction in all their work, and this sameness has a tendency to make all the portraits look alike.

If you want the person to appear as if he were outdoors, try using a diffuse light. There are two ways to diffuse the light. It can be placed farther away from the subject, or a diffusing shield can be placed over the spotlight. In nature, the light comes from the sky but it is reflected in a hundred ways; it is a flattering light for people of any age. Almost all portraits with outdoor backgrounds and light were actually painted indoors. Try painting your subject in the open air just one time and you'll know why. The flickering of light through leaves constantly moving in the breeze, the lights and shadows on the face changing every half hour as the sun moves across the sky—all this makes your job extremely frustrating.

We all know that direct sunlight throws sharply defined lights and shadows on the face and also forces the sitter to squint! Brilliant sun is hard on the sitter and hard on the painter. However, if you decide you absolutely must try it—and you should—be sure to keep the sun off your canvas or paper when you are painting. It's impossible to judge the true color of things when the canvas is reflecting sunlight back into your eyes. The same rule applies to landscape painting. However, you must realize the more landscapes you paint outdoors, the more convincing the "outdoor daylight" in your indoor portraits will be.

# WORKING IN CHARCOAL

I recommend charcoal for your first portraits with a live model. They are simpler to do than a portrait in color, because you're working only with value (light and dark) and line. On the other hand, there's no color to "pretty up" the finished portrait, so your knowledge is visible for all to see. Above all, please don't dismiss charcoal as a trivial medium. It has been the sketch and study medium since prehistoric man drew his animals on the walls of the Altamira caves.

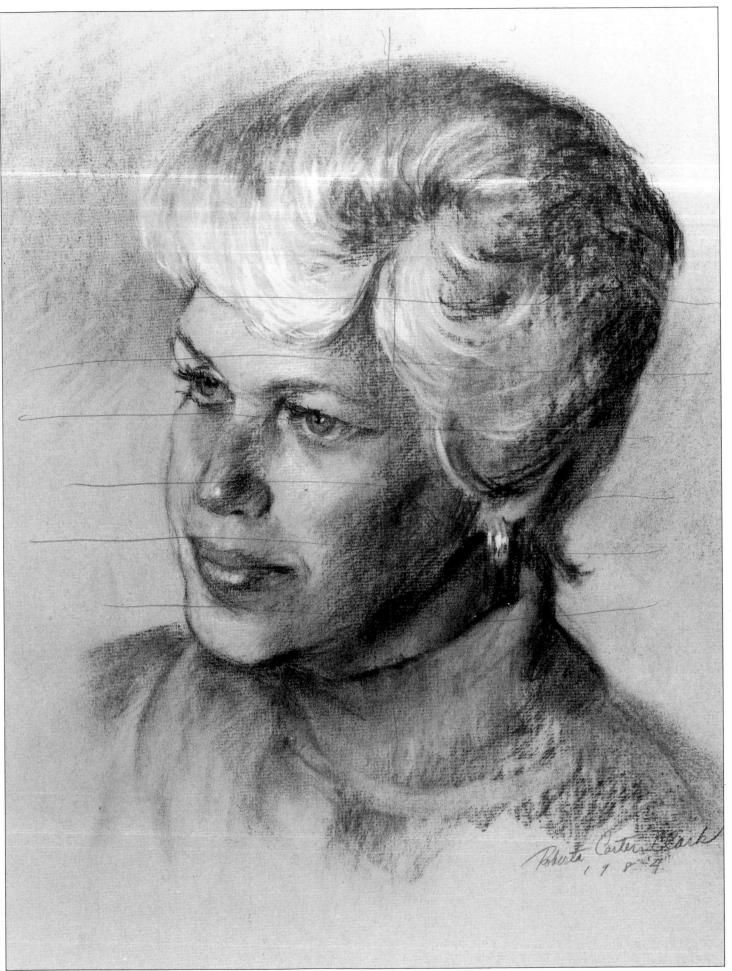

Value 1: White
Value 2: Light
Value 3: Mid-light
Value 4: Mid-tone or Medium
Value 5: Mid-dark
Value 6: Dark

# Values for Charcoal Portraits

It is obvious that charcoal drawings have no color; they are in black and white and many variations of gray. For portrait painters, these variations from white, through the grays, to black, are organized into a system of "values."

Some artists paint with a system of five values, some with nine values. Here we use a simplified system of seven values, which you see along the side of this page. White and black are not really used except as accents. Therefore we are working in a narrow range of 5 values: light, mid-light, mid-tone or medium, mid-dark, and dark. The seven values have been placed on the edge of the page so you can hold your own work alongside them for comparison. Squint your eyes and look through your eyelashes at both the chart and your work. It's much easier to determine value relationships with your eyes half closed.

## Bands of Value Across the Head

The rule of thumb when painting a head, whether in black and white or in color, is to have *three values in the light* and *one value in the shadow*. If the light is high and from the upper left, the lightest value — where the light is most intense — is the band across the forehead. The second lightest is the band across the cheeks, nose, and ear. Third lightest is the band across the chin and jaw. All these values are in the light.

## Light and Shadow on the Head

We would use values 2, 3, and 4 for the light on the head of a person with a light or fair complexion. Someone with a medium-toned complexion would still have three values in the light but all three would be pitched a bit lower. As the complexion becomes darker, however, the values become closer together; a very dark-skinned person may have only two values in the light areas of the face. The shadow on a fair person would be value 5½. The shadow on the face of a medium-toned and a dark complexioned person would be value 6 — dark, *never* value 7 — black.

## Highlights on the Head

The highlight on any area of the face is half a value lighter than the general value of *that area*. This means the highlight on the chin can never be as light as the highlight on the forehead.

The highlight on any area of flesh is *never* pure white. Pure black (or colors mixed to the value of black) is used only as accents. No shadow on any head is ever the black value, no matter how dark the complexion.

For changes in small forms such as eyelids, noses, and mouths, the top planes in the light are half a value lighter in light areas and half a value darker in shadow areas.

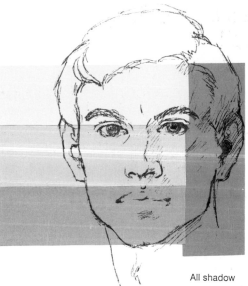

Value 2: Light

Value 3: Mid-light

Value 4: Mid-tone or Medium

All shadow
areas are value
5 to 6: Mid-dark
to Dark

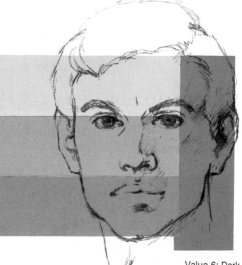

Value 3: Mid-light

Value 4: Mid-tone or Medium

Value 5: Mid-dark

Value 6: Dark

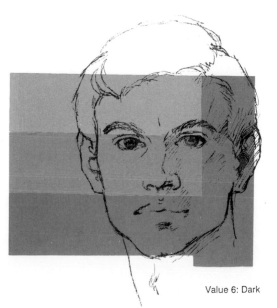

Value 4: Mid-tone or Medium

Value 5: Mid-dark

Value 6: Dark

Value 6: Dark

# Setting Up for Work with a Live Model

These are ideal working conditions and won't always be easy to arrange, but it's worth a try. If you're comfortable, the portrait will have a better chance of success, no matter what medium you're working in—charcoal, oil, or watercolor.

You should work standing. Do whatever you can to get the sitter's head up or down to your eye level. You could seat the model on a high stool or on a chair on a model stand. A model stand is a platform about 15 inches high and at least five feet square to allow room for the chair and a screen or backdrop.

**Background** The backdrop helps eliminate distracting and confusing shapes and colors behind the model. Later in your career, you'll choose a particular color, texture and pattern to enhance your sitter's coloring and costume, but for now use a plain, light colored fabric in a neutral shade draped over a folding screen or taped to the wall.

**Lighting** If you are working in a room with good daylight, move the model until you get the light you want on the face. If there's only artificial light, you may need lamps or a spotlight. Place the easel next to the model, as close as possible. The light should be the same on the model's head as on the work. Make sure the model doesn't cast a shadow on the portrait, and that the painting doesn't cast its shadow on the model.

**The "Looking Spot"** Mark a line on the floor about eight feet in front of the easel with masking tape. You will look at the model only from this spot, never when you are up at the easel. Squint so you see only the larger forms, no details, and make your decisions about what to do next at this distance—then step up to the easel and paint. Working this way, you'll get far less distortion in your portrait. In a class situation, step back a few feet, turn around, and check the painting often in a hand mirror. As a drawing aid, the mirror is very helpful, because it doubles the distance between you and your work and also reverses the drawing, giving you a new look at it. Leonardo da Vinci wrote "You should take a flat mirror and look at your work in it . . . and you will be better able to judge its errors than in any other way." Set your drawing or painting materials out on a table or taboret back at your looking spot, on your right or left, whatever side is most comfortable for you.

**Timing the Pose** Let the model rest for five minutes after every twenty or twenty-five minutes of posing. You need the break, too, to move around and look at your work from a different perspective. Set a kitchen timer and place it so that the model can see it—then you need not watch the clock. A word of advice: Try not to develop the portrait head when the model isn't posing; this can lead to disaster!

## *Understanding the "Looking Spot"*

Here we see the artist standing 8 feet back from the easel at the "looking spot." The model is seated on a high stool so that her head is on the eye-level of the artist. The paper or canvas is on the easel, and the crossbar of the easel is adjusted so that it is supporting the painting surface at the same height as the model's head. Having the paper or canvas at the same level as the head of the model allows the artist to visualize the head on that surface. The easel is placed just next to the model and on the same plane, meaning not in front of the model nor behind the model.

You will walk back and forth from the "looking spot" to the easel many times in the course of the portrait drawing or painting.

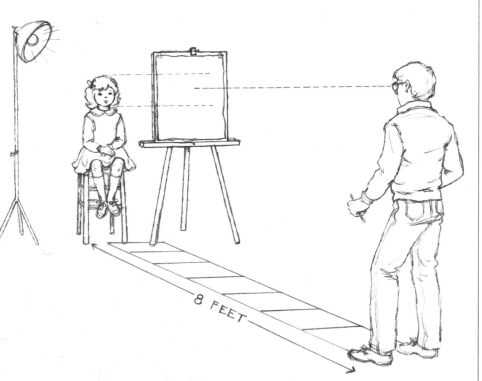

8 FEET

# Step-by-Step: **Charcoal on White Paper**

**Materials** For this exercise you will need white charcoal paper. The paper needn't be heavy, but it must have some "tooth" (texture) to it; smooth paper doesn't accept charcoal well. Strathmore 500 charcoal paper is widely available, good quality, and is 19″ × 25″, a good size for a life-size portrait head. Other good charcoal papers are Canson Ingres, and the heavier and slightly more expensive Canson Mi-Teintes. You'll have better results with two extra sheets under the working sheet to act as a pad.

You'll also need: two sticks each of medium and soft vine charcoal; charcoal pencil (soft or 6B); kneaded eraser; drawing board (a rigid surface is important here—use a wooden or Masonite board 19″ × 25″ or larger); tacks, masking tape, or clamps (to fasten your paper to the board); easel; old towel or paper towels to wipe your hands; hand mirror; spray fixative; and a kitchen timer.

**Preliminaries** Tape or clip the charcoal paper to the board. Break off a two-inch piece of soft charcoal, and holding it on its side, cover the entire sheet with long broad strokes. Then smooth the charcoal with your fingers so the whole sheet has a middle tone (about value 4). Rub it in enough so it won't disappear when you blow off the excess charcoal dust. It need not be an even gray, just not too streaky. Indeed, some tonal variety adds to the interest. If the overall tone is too dark the lines of your drawing won't show clearly and your work will look messy. Yes, your hands will be very dirty; wash now before proceeding.

Set up for work as described earlier, and set the timer for twenty-five minutes. Pose the model looking straight at you, full face, head not tilted. Have the light at the upper left front, similar to Rembrandt lighting.

**Blocking in the Head** Adjust the easel so the center of the paper is the same height as the model's head. Step back to your looking spot and try to visualize the head on the paper. Then walk up to your paper and make a mark for the top and bottom of the head. Hold the charcoal loosely at the end, not tightly like a pencil. Draw with your whole arm, swinging from the shoulder, holding the charcoal at arm's length. This will prevent your work from getting too tight too soon. Try to work life-size: 8¼ inches for an adult female head and nine inches for an adult male head.

Lightly and quickly, draw the oval of the head, then the neck cylinder. Lightly put in the horizontal eyeline midway down, then the vertical center-line.

*Hint:* If you have to change something in a charcoal drawing, don't erase. Just tap the drawing with your clean finger and lift off the mark, then re-draw the line where you want it. Changes can be made easily in soft charcoal.

## Portrait Demonstration
**I rub soft charcoal over the white paper to a value 4 mid-tone and smooth it in with the fingers a bit.**

Add the brow line and place the nose approximately halfway between that line and the chin. Of course, you must study the model when drawing the features, but the information gained from working with the diagrams and egg heads should also help you to get the features in the right places.

**Looking for Darks** Step back to the looking spot and squint, studying the model's head for the most obvious feature, which will usually be a dark value. It may be the hair, or the shadow on the side of the face, the eye sockets, the area alongside the nose, or the shadow under the chin on the neck. When drawing or painting we always begin with the part we are most *sure* of; this is the easiest way. Add this most obvious area to your block-in.

Work with the piece of charcoal on its side (not its tip) for a broad effect. Usually the eye shapes go in next—the whole eye cavity. They should be just dark ovals now. You're not *drawing* the eyes, just *placing* them. Remember, shadow is the area where direct light

does not strike the form. Add the other shadows, squinting all the while. Don't try to perfect any features yet. (We just need to know where the darks go; we can't have lights later without darks now.)

Check your shadows by looking back over your shoulder in a hand mirror, comparing the model and the drawing. Look for and correct distortions, particularly any lopsidedness. Remember your centerline. Double-check that one side of the face is not wider than the other, a common fault.

Then turn around and compare the model with your drawing, squinting hard. With your fingertips, tap out the areas that have become too dark. Now you're beginning the modeling of the head. Wipe your hands clean before tapping out the charcoal or you'll end up just moving it around! *Don't rub*, just tap. You now have a head with halftones (the gray tone rubbed on the paper) and shadows, but no lights.

**Looking for Lights** From here on, begin to define the lights and thereby refine the shadow shapes, using strokes that follow the form if you can.

Where do you see light areas? On the light side of the forehead? Surely on the light side of the hair. Under the keystone area at the bridge of the nose? On the cheekbone? The area between the nose and the upper lip? Perhaps the lower lip catches the light, and part of the chin and neck. Squint, and you'll discern those lights. If the model is wearing a white collar, lift that out now with your fingertips or a kneaded eraser. It will help you to judge the values on the face and head. Try not to get darks in the lights or lights in the darks.

To get really clean light areas, lift them with a clean point of your

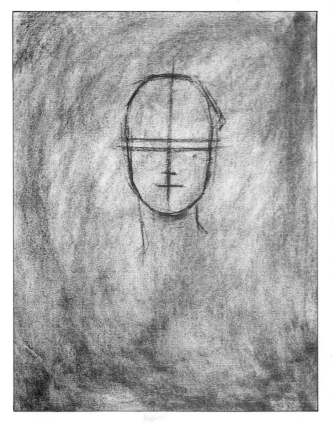

*Portrait Demonstration*
**The head is placed on the paper, egg-oval drawn, also the eye-line and the central vertical line. Brow line, nose, and mouth are marked. Head is considered "blocked in."**

kneaded eraser. You really do have to *lift* — rubbing will only smear the charcoal. After each touch, when the point of the eraser is dirty, pull the eraser into another point. If you keep the eraser in the warmth of your other hand, it will remain pliant. Theoretically, the eraser should eventually become black all the way through, but in actuality you will be able to find a clean spot in it even after dozens of drawings. It takes years to wear out one of these kneaded erasers.

Your head now has lights, shadows, and halftones. You have not yet attempted to finish the eyes, nose, or mouth.

**Working Out the Features** I can tell you how to draw the features, but I can't tell you in what sequence to do them. We will start with the eyes, followed by the nose, the mouth, the ears, the hair. This is not, however, the way a portrait is done. No one finishes the eyes first, then the nose, then the mouth. You have to work over the entire head. Working on the eye socket, you see how that helps you to define the temple. And working on the inner corner of the eye leads you to the structure of the nose bridge. This may in turn lead you to the bony part of the nose and then the tip of the nose, which leads you to the cheek, to the mouth and the chin. Then the artist returns to each area, refining with ever more subtle adjustments until all the parts come to a finish at once and the portrait is done.

To be truthful, one feature will lead you to another, but I can't write a book that way. It would be far too long and confusing. And so, for the sake of clarity, I will cover the features one by one.

Before you draw, it seems sensible to read through the following material from eyes through hair and then refer to it as you need it. Drawing a charcoal portrait is just like any other activity. The first time you'll be awkward and may return to the information frequently, but as you get to your eleventh and twelfth portraits you'll develop your own rhythm and sequence, and will only have to refer to these pages when you get stuck.

Work in any order you like, just so that you develop each feature as well as you can and relate each one to the others. Remember, every approach is valid and will produce excellent likenesses.

**The Eyes** The entire eye area is now dark. With a pointed end of the medium charcoal, draw the upper and lower eyelids as they follow the round form of the eyeball. Then put the fold in the upper eyelid, if you see one, and draw the iris, working on both eyes at once. Please don't try to finish one eye and then go to the other. It's more difficult — and they may never focus!

## Portrait Demonstration

**After squinting, darks are added first in the hair, then the eye ovals, alongside the nose, the upper lip, under the lower lip, and on the neck.**

Molding the kneaded eraser into a point, lift out the whites of the eyes where you see them out of the mid-tone and darks. Remember, the whites of the eyes are not *white*, for they are shadowed by the eyelids. If you make them too white, the eyes appear to be staring.

Now add the dark pupils and any other darks you see in the eyes. Pick out any light area on the upper and lower eyelids, then work out the shadow between the inner corner of the eye and the nose, watching for a light at the area near the tear duct. Look for the shadow under the lower lid.

Perfect the eyebrow, looking for a light spot as it follows the bone over the eye socket. Remember the eyebrow is made up of tiny hairs; draw it in many short strokes. Look at the model's eyes up close and study the eyelashes and add a few of them very delicately—not a whole series of tiny lashes like a centipede's legs.

Lay your stick of charcoal horizontally across the eyes on your drawing to be sure they're level. It's only too easy to get them out of line when you're working on them bit by bit.

Then, form your kneaded eraser into a clean point and deftly pick out the highlights in the eyes, at about ten o'clock if the source of light is at upper left, about two o'clock if at upper right, or where you see them. This highlight should be *small*—a great white spot cheapens your work. You *have* to do this last, because the focus of the eyes is achieved by minute adjustments between the pupil, the iris, and the highlight, and you can't handle this with any real finesse until the head is virtually complete. Putting in this highlight is the most fun of the entire portrait! It really brings it to life.

---

*Hint:* If the highlight you've drawn in an eye isn't right the first time, darken the area and try again. These highlights should be quite sharp and clear to indicate the wetness of the eyeball. It will never look right if you keep dabbing at it with the eraser. Clean and careful does the job.

---

**The Nose** You've made the nose mark halfway between the brow line and the chin. Studying the model, decide if the nose is shorter or longer, and correct it. Sketch in the triangular shape of the nose, the top and side planes, the ball, and the wings on either side, studying the model all the while. As you worked out the area of the tear ducts of the eyes, you may want to work out the bridge of the nose. The side of the

*Portrait Demonstration*
**The lights are picked out with the fingertips or a kneaded eraser. Darks are more defined. Halftones are made visible.**

bridge away from the light may be very dark, so do nothing there. But there should be a light on the bridge of the nose just below the keystone area where eyeglasses rest. Is there light on the bony part of the nose? Does the light on the side plane spill over onto the cheek? Squint hard and you'll see these lights. Lift them out with a clean point of your eraser.

Add dark to the underplane of the nose and the nostrils. This leads us to the small indentation from the center of the nose down to the bowed center of the upper lip. Is this visible on your model? Is it shadowed? Add this and the rounded shadow side of the "muzzle" area, the skin that travels over the upper teeth and curves around to meet the cheek.

**The Mouth** Hold your charcoal vertically at arm's length and line up the corners of the mouth with some part of the eyes, as in the illustration. Are the corners of the mouth directly beneath the pupils? Place both corners, and then the center of the upper lip. Don't forget to break the line between the lips. Put in the shadow in the corners of the mouth if you see any. Add the shadow under the lower lip, and the upper lip, which may be entirely in shadow. With the clean point of your eraser, lift the lights where you see them: just above the upper lip, on the light side of the rounded "muzzle" area, and on the lower lip—anywhere else?

**The Ears** Sketch in marks to indicate the top and bottom of the ears, the top of the ear at the brow line. Draw the flat oval disk of each ear at the same slant as the ears on your model. Refine the disk shapes into better ear shapes. Put in the line forming the fold at the upper rim, the helix, then the bowl, the two small flaps—whatever is visible, and the earlobes.

Look for darks in the ears. The ear on the shadow side of the head may be totally dark, with no detail discernible. Study the lights and pick them out with a clean point of your eraser. There's usually a bright light on the helix and on the lobe. You may see others.

**The Hair** Hair should be treated as a mass, not as lines. Lay the charcoal on its side and block in the darks. Blend the edges in at least two places where the hair meets the background, so the head doesn't look cut out and pasted on the background, but integrated with it and the air around the head. The edges where the hair meets the face are also extremely important: soften them with your fingers. You don't want the hair to look like a wig or toupee! Then squint and decide where the highlights are lighter than the halftone of the paper, if there are any, and lift them out with the eraser. Watch how the hair flows, how it falls; let your lights describe this action.

The most important aspect of hair is its *texture*. The hair on an average head consists of thousands of filaments. Nothing about hair is at all like the skin over muscle over bone that makes up the face and the body. Think of ways you can show the special properties of hair—the softer edges, linear movement, and design found in waves or curls, or its sheen. Your treatment of the hair can even help express the personality of your sitter; a person with every hair in place is very different from one with loose, flyaway hair.

**Hold the charcoal vertically to align one feature with another—here, the corner of the mouth with a part of the eye. A brush or a pencil may be used when working in other mediums.**

*Hint:* In putting in the features, no matter what the medium, work back and forth between the lights, darks, and halftones, continually refining the drawing.

**Finishing Touches** You now have a head with darks, halftones, lights, and well-developed features and hair. The head is integrated into the background. Look at your model very, very hard now, with your eyes wide open. Search for a few selected places where absolutely no light can reach, and firmly put in small dark accents with your charcoal pencil. These add sparkle, as do the highlights; check and add any highlights you've overlooked.

Look for reflected light under the chin or on the side plane of the lower jaw on the shadow side and lift these with your eraser. Reflected light can never be lighter than the halftone, and *never as light as your lights*. If it were, it would destroy the solid feeling of the head.

Add the collar, clean up the background with your fingers where you may have left smudges, and you're finished. You've spent at least an hour on this drawing. Anything over two hours is too long—you lose your ability to make judgments after so long a period of concentration.

Wait a day before you look again at this drawing and judge it. Correct any errors you see then, and spray it with fixative to keep it from smudging.

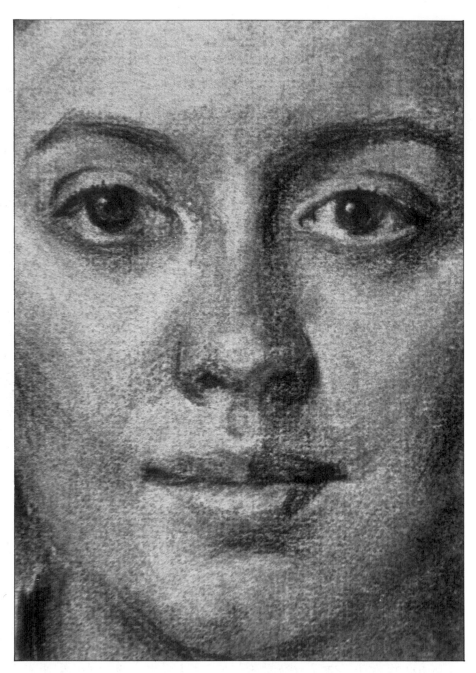

## Portrait Demonstration

(Detail) Notice the degree of finish and the rough texture, or "tooth," of the Strathmore charcoal paper. Can you see how softly the linear elements defining the eyes and the mouth are handled? Can you see where the kneaded eraser has picked out the lightest lights and the highlights? And where the darkest accents are placed? We all know no portrait is ever perfect, and this close-up makes me painfully aware of an error. I think the nose tip is pulled over to the right a bit too far—do you agree?

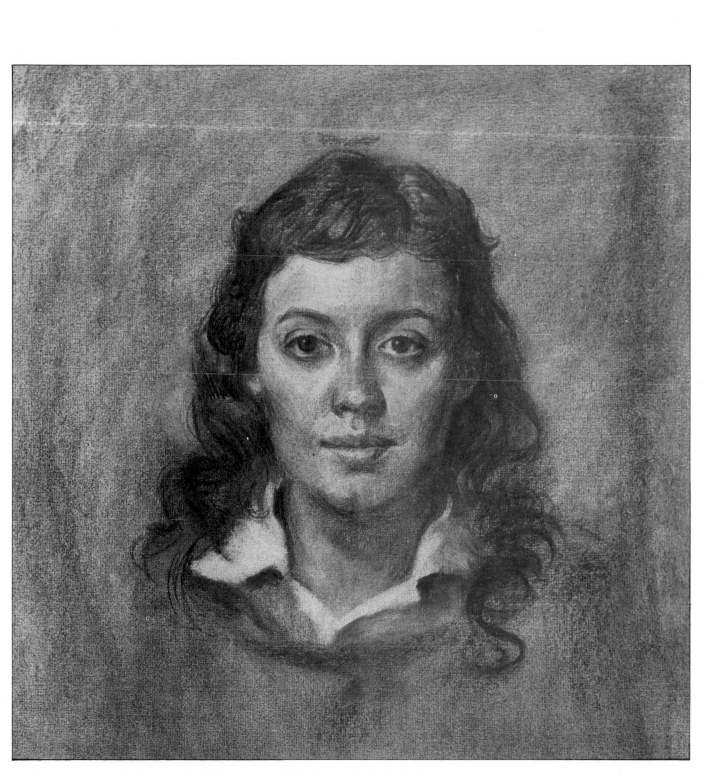

*Wendy*
Charcoal on white paper: 25" × 19"

## Portrait Demonstration

(Finish) Now the features are worked out. Highlights (where the eraser has lifted the charcoal and left clean white paper) and accents (deepest spots of dark) have been added. The hair edges are integrated into the background in places. Reflected lights are tapped out with the fingertips, making sure they are no lighter than the halftones. After careful checking in the mirror, I decide the portrait is finished.

# Step-by-Step: **Charcoal on Tinted Paper**

We will be using the same materials as before, but working on a mid-tone gray paper, rather than white. Add a stick of white Nupastel to your supplies for bringing out the light areas and highlights.

Perhaps you would like to try a portrait in more of a profile view now. You will find the procedure is the same, but the drawing problems are quite different. Have your model turn his body to one side, but adjust the head so you can just see the other eye; this view is much more interesting to draw than a flat profile. If you're right-handed, it's easier to draw the model facing to his right (your left), and vice-versa. Also, be sure he is facing toward the light, not into the shadow.

In this charcoal technique we do not tone the paper; the tint of the paper *is* the halftone.

**Placing the Head on the Paper** Set the timer for twenty-five minutes and have your model pose.

Step back to your looking spot, squint, look through your eyelashes, and study the head, looking from model to paper and back again. Try to visualize the head on the paper. Decide where to place the top of the head, how it slants, and the size of the head. Then step up to the easel and, with your soft charcoal held lightly, make a mark for the top of the head, the bottom of the chin, the outside edge of the face, and the back of the head. Try not to draw the head larger than life-size.

Placement of the head is important; you don't want the head too close to the top edge, and you don't want it in the lower half of the paper either. There are no absolute rules. Later, after doing several portraits, you may want to attempt less conventional placements—even allowing the head to run off the top of the paper. We just have to learn to walk before we can run.

**Blocking in the Head** Now that you have the general dimensions, draw the oval shape of the head within them, studying the model. Look carefully to determine the angle of the head. Is it tilting up and back, or down, or is it

straight up? When you decide, draw the eye-line halfway down, making it an ellipse, if necessary, to conform to the tilt of the head. *This line is the most important factor in establishing the position of the head.*

Add the brow line parallel to the eye-line. Sketch in the vertical line in the center of the face and mark the base of the nose halfway between brow line

and chin. Add the vertical line at the side of the head and place the ear just behind it, aligning the top of the ear with the brow line and the bottom with the nose line. Place the mouth line. Indicate the hair mass. Then place the angle of the neck cylinder, front and back, and then the collar line. You now have a blocked-in head.

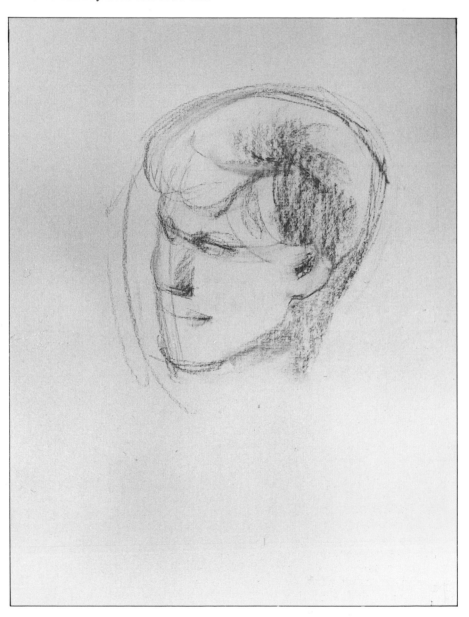

## Portrait Demonstration

When placing the head in the picture area, be sure that the top of the head isn't too close to the top edge of the paper, more "air" is given on the side from the face to the margin, and less at the back of the head. The nose falls slightly above the vertical center of the paper, approximately midway from top to bottom.

## Looking for Large Shapes and Darks

Step back, squint, and look for whatever shape appears most obvious. In this near-profile it's most likely the hair mass, for in this view, the face occupies a relatively small area. Indicate the hair shape. Is it dark? Now look for shadow areas in the face. First the eye socket, then the underplane of the nose, and possibly a side plane of the nose. Then another side plane at the cheekbone, the side of the face from the temple down to the jaw and chin. Lay these areas in with the side of a small piece of charcoal. Is there dark on the neck? Anywhere else?

## Adding Lights, Refining Angles and Proportions

Again step back. You can't define the lights without careful attention to the edge of the face, so hold up your charcoal at arm's length so it appears to lie along the outside edge of the model's forehead. Then walk up and add this line to your drawing. Step back and repeat this process for the line of the angle of the nose, the cheekbone to the lower jaw, and along the jawline to the center of the chin. Lay all these angles in lightly. (Most artists begin with all straight lines for these indicators.) Look in the mirror at the model and at your blocked-in head at the same time to check for accuracy. Use your kneaded eraser, but try brushing the incorrect lines off with a paper towel first, or tapping them off with your finger, then blowing away the charcoal dust.

## Working out the Features

We have defined the outside shapes of the nose, forehead, mouth, chin, and neck. Now we'll move within the head shape. Looking at the model, hold your charcoal stick horizontally and sight-check the alignment of the top of the ear with the brow line. Is the top of the ear higher or lower than the eyebrow? Draw the ear, using medium charcoal now for more precise drawing.

Draw the eye shape, the brow, then the bridge of the nose, the hollow at the inner corner of the eye, and the nose. Check, holding the charcoal ver-

tically and at arm's length, how the wing of the nostril lines up with the inner and outer corner of the eye. See how far the mouth and chin project beyond the nearer brow, and sight other vertical alignments such as the corner of the mouth and the eye. Check both the model and your drawing in the mirror for all these relationships.

Finally, refine the shape of the hair and any collar area.

You now have a head with a carefully drawn near-profile silhouette, darks, and halftones. Indeed, there's nothing *but* darks and halftone, for the whole paper is the halftone.

## Putting in the Lights

Now, with the white Nupastel in hand, squint very hard and decide where the lightest areas are—lighter than the halftone gray of the paper. Then *erase* all charcoal from areas where you want the whites *before* you place them. (You may want a few lights in the hair, for example.) Lay in these areas very lightly at first, and don't put in too many or you'll destroy the form of the head. You must be *sure* if the area is light, halftone, or dark shadow. Don't get any whites in the charcoal shadows or charcoal in the white pastel areas—your drawing will be really muddy.

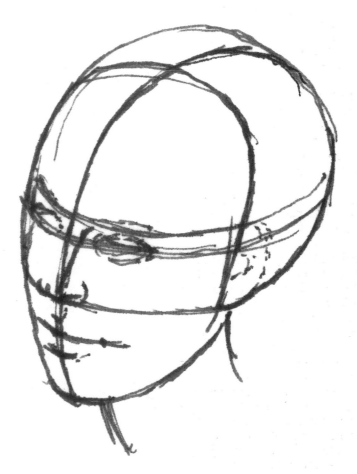

## *Portrait Demonstration*

**The head of my model, Anne, is almost in total profile and tilted. This makes the eyeline a downward ellipse and the central vertical line a way around to her right. The ear line is a quarter of the way around the head to her left side.**

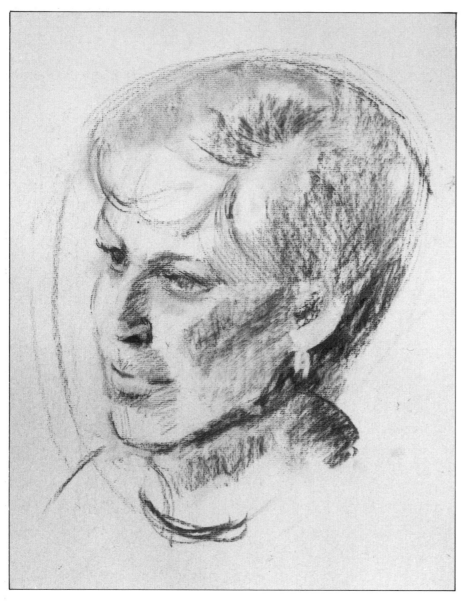

**Adding the Highlights** When we were working on white paper, we let the white of the paper serve as our highlights. Now we're using tinted paper, and we've laid the light areas in with a gentle touch, but put the highlights in firmly now with the point of the white Nupastel.

Search out the highlights on the model's head—maybe at the bridge of the nose, on the cheekbone, the tip of the nose, and on the lower lip. Enjoy adding a crisp light in the eye *only* if you see one.

---

*Hint:* Highlights are great fun to put in and add considerable vivacity to the portrait; keep them small and bright. The highest light is often on the forehead as it is closest to the light source.

---

**Dark Accents and Reflected Lights** Accents could be in the iris and pupil of the eye, a dot or two in the nostril, the corner of the mouth, and in the hair. Look for reflected light under the chin and lift it out with your kneaded eraser (*no* white pastel here). Add the darks and lights of the collar. Clean up any fingerprints in the background with the eraser. You could leave the tint of the paper as your background or develop it with shadow. Having a darker background behind the light side of the face throws the head into relief.

*Portrait Demonstration*

**With much squinting, the direction of the light is noted and the resulting shadow shapes are laid in. Angles of the features are considered. Each feature has its own distinctive shape and direction. Still, they must all work together.**

This drawing should take one-and-a-half to two hours, or four posing sessions. Put it away so you can look at it tomorrow with a fresh eye; correct it then, if you need to, and spray it with fixative.

## Comparing the Portraits

My portrait of Wendy (on page 91) is what's known as *painterly*—it looks as if it were done with a broad brush rather than a pointed drawing instrument. The lights, shadows, and halftones are quite developed, giving it a feeling of solid mass. Line does not play a large part in this work.

This portrait of Anne, on the other hand, is more *linear* and less "round" or sculptural. This may be partially because Anne is in a semiprofile pose, which can look quite flat. However, many artists believe it's easier to get a good likeness with a profile. Putting a darker background behind the face sometimes helps throw the head into relief, but a sharp contour line around the face and head may make it look pasted on the background. Varying the weight of your profile contour line, making it lighter where direct light strikes the form and heavier on the shadow underplanes, should help the head to appear more rounded. Softening the edge of the hair shape in at least two places and allowing it to blend into the background also helps.

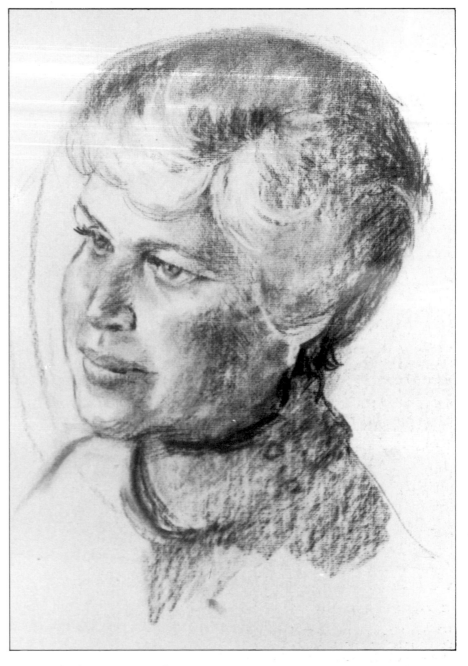

## *Portrait Demonstration*

I refine the features, and the head and hair shapes. Small darks are added and lights lifted out. I was so busy working on the features that I lost the likeness—very easy to do when looking at the parts and not the whole. It looks like a round-faced, even chubby, person; not like Anne. Did she move her head a bit? Did I change my viewing position?

I decide the neck edge of the turtleneck sweater is too straight and force the line to become a rounded ellipse like the eye and brow line. Notice how the right and left eyes differ.

*Anne*
Charcoal on gray paper: 20″ × 16″

## Portrait Demonstration

(Finish) After considerable effort, Anne's character begins to emerge again. The delicacy of her head is a very important part of the likeness. I've done and redone the line defining the far side of the face, a very tricky area in a head turned away this far. After much checking in the mirror, I lift out the charcoal and put in the highlights with white Nupastel. I add a few dark accents in the pupils of the eyes, at the bridge of the nose, in the corners of the mouth, under the chin, and behind the earring. The expression is true now.

I decide the turtleneck is still too heavy. I really don't like turtlenecks for portraits very much. They cover the neck right up to the chin and, to me, separate the head from the body. I change it to suit myself. A slightly darker value is placed behind the white hair at left and also at right to make it look as if the tone is behind the head, giving the illusion of a three-dimensional head.

Two hours and fifteen minutes have passed, five posing periods. I sign and date the drawing and spray it with fixative.

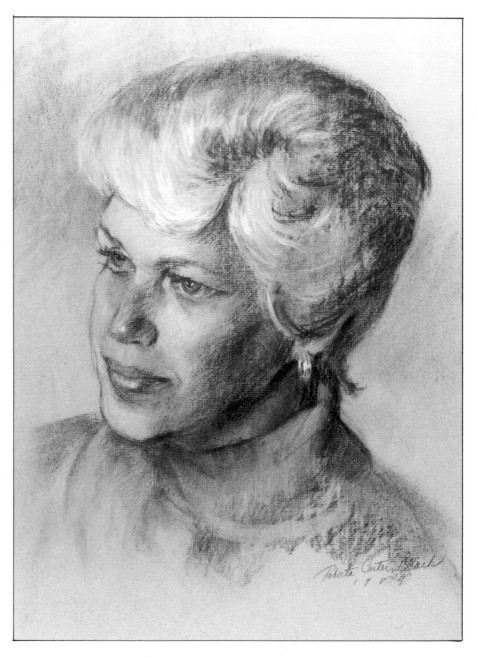

## Portrait Demonstration

(Detail) Note how softly the edges are handled; there are no hard lines defining the far side of the face, and there are none around the mouth. The white highlights are kept to a minimum.

# Other Approaches to Charcoal Portraiture

The painterly approach of Wendy's portrait and the more linear approach of Anne's portrait are not the only two ways to handle charcoal. Other artists use the medium differently, as you will see in the examples that follow.

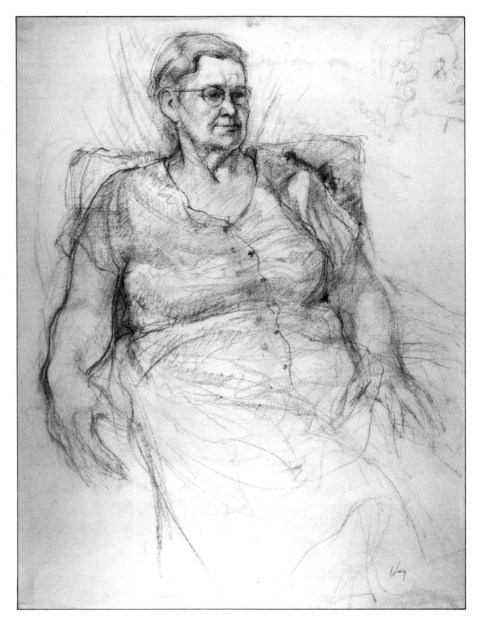

Ronald L. Wing (1929- )
*Paul's Mother*
Charcoal: 24" × 20"
Collection of Roberta C. Clark

The emphasis here is on line rather than values. Almost all the definition in this work is in the light side of the body, with an absolute minimum of description telling us all we need to know. You can see where Wing changed his mind about the center front of the dress. I think the line he chose describes the torso better, don't you?

The head is beautifully done—the ear is marvelous—but the solid form of her right arm—the extremely subtle foreshortening and the distortion that makes the wrist and hand project—proves Wing is a sensitive artist.

In Degas's masterful black chalk drawing for a portrait of his friend Manet we again see a more linear approach, but also an interest in pattern. The dark beard, hat, and shadow under the sleeve keep our eye moving over the entire figure. Every part of the figure—from the set of the shoulders, to the hand, to the heel of the shoe—has received careful attention, with only slightly more given to the head. Note the descriptive strokes going across the form on the head and face. There is no flash or dash here, just a sure and competent drawing by a true genius exploring an idea. You can see where he changed his mind about including the walking stick and a different view of the hat. Notice too how Degas has handled the hair as it grows from the scalp, and the beard and moustache as it grows from the face. The beard never looks woolly; it looks like hair.

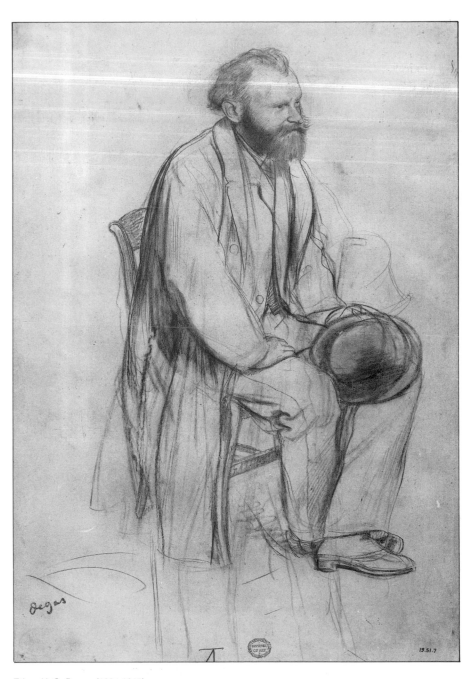

Edgar H. G. Degas (1834-1917)
*Study for a Portrait of Edouard Manet*
Black chalk: 13″ × 9⅛″
The Metropolitan Museum of Art, New York
Rogers Fund, 1918

Lilian Westcott Hale uses charcoal in a highly personal way, building up the figure in countless vertical strokes. With admirable restraint, she consistently says more with less. The dress is simple and the hair not overly defined but kept as a textured mass. Notice how she emphasizes the little girl's fragility through the delicate shadowing and also by the shock of the very black background against the child's fair hair and skin.

The small hands add so much. Aren't they wonderfully child-like? Although the child's dress suggests this portrait was drawn in the thirties, the way Hale has allowed the head to go out of the picture, the positioning of the figure, and the contained dark shape on the paper give hints of a more contemporary approach to children's portraiture.

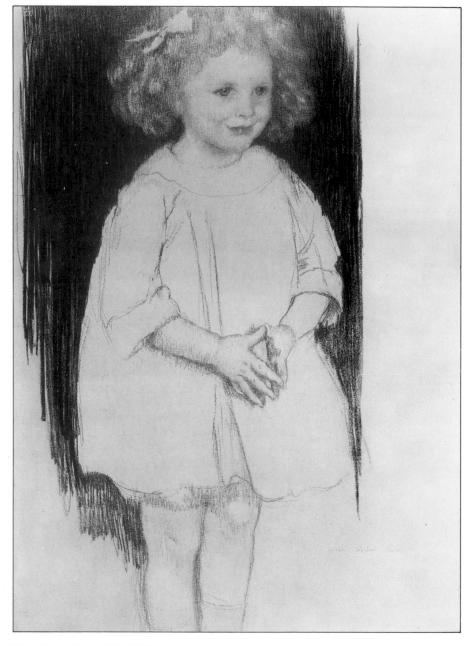

Lilian Westcott Hale (1881-1963)
*Little Girl*
Charcoal: 29⅛" × 23"
Private collection
Photograph courtesy of Hirschl & Adler Galleries, New York

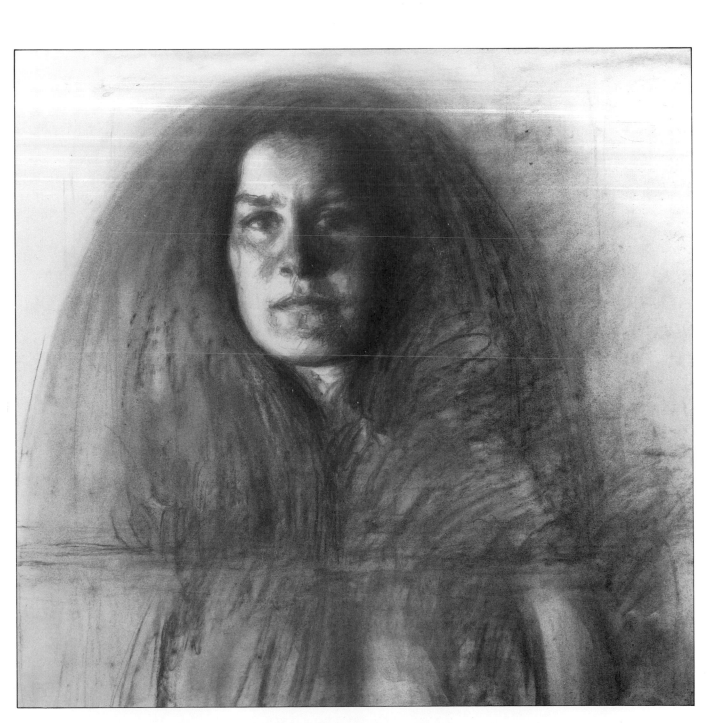

Sidney Goodman's unconventional approach to charcoal portraiture comes more from the unfinished quality than from the actual drawing style. The head is treated in a painterly manner, and the values in the face and hair are strong and extreme!

What makes this portrait contemporary? Is it the focus on the face and hair, allowing the outside contours to be less defined? Is it the way the hair is generalized into a compelling shape? Notice he held the edge of that half-oval shape against the background on the light side of the head and allowed it to diffuse into the background on the shadow side.

Goodman considered ending the portrait at the horizontal marks just below the shoulders but changed his mind and decided not to trim it away. When I look at this portrait, I feel the strength of the characterization, almost a sense of confrontation with this young woman. Goodman has made her anything but remote or detached.

Sidney Goodman (1936- )
*Portrait of P (1978)*
Charcoal: 24″ × 29″
Courtesy of Terry Dintenfass, Inc., Gallery, New York

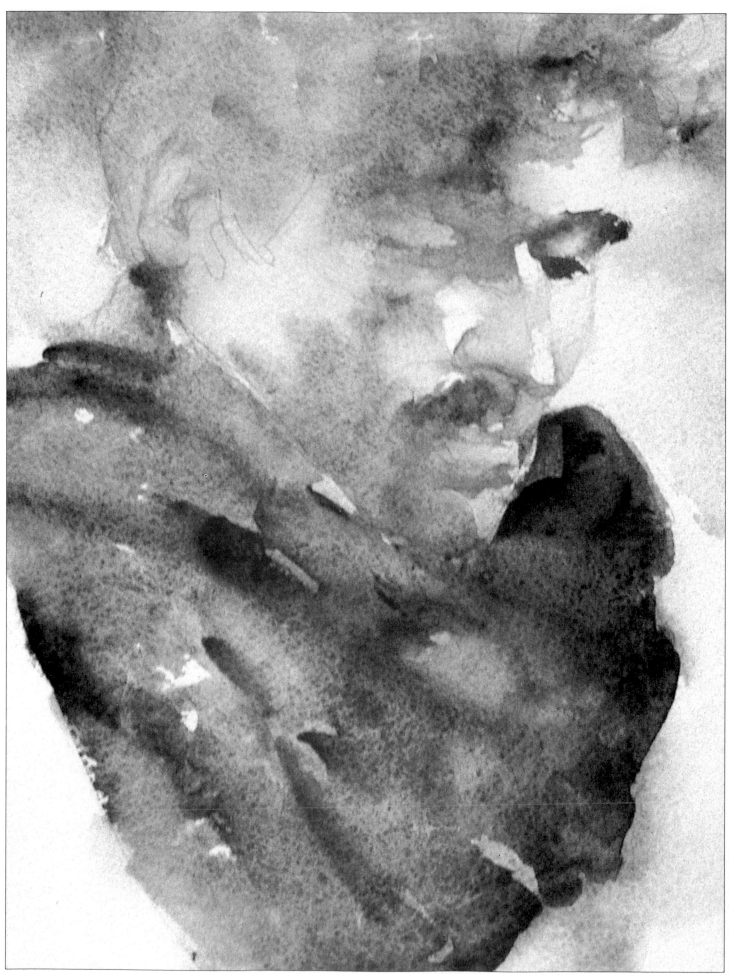

Roberta Carter Clark, *Meditation*, watercolor. Collection of the artist.

# USING COLOR

You'll need to know something about color before moving on to paint portraits in oil and watercolors. What you've learned from charcoal portraits will be useful. You now know about modeling the form, distinguishing the lights from halftones and darks; you are aware of soft and hard edges, and ways of handling texture. But when we work in color we add another facet to the problem. Of course, we also add excitement!

The perception of color is such a personal experience. Each of us sees colors differently, influenced by associations from as far back as childhood, by preferences for what we think is beautiful, by the sharpness of our vision, and by the possibility of some color blindness. Our reaction to color is psychological and even visceral—there can be no question that color affects the emotions.

In this chapter we will develop a vocabulary so we can discuss color intelligently in the ensuing chapters on color techniques. You'll find four projects here that use color in ways to help you understand it better and feel more confident about mixing the colors you want. Then we will be ready for flesh tones and hair mixtures.

# *Step-by-Step:* **Color as Hue**

Hue is the *name* of the color: red, yellow, orange, purple. These words describe a *hue*.

Red, yellow, and blue are considered *primary colors.* To mix any color you must start with one or two of these three, for you can't mix red, blue, or yellow by combining other colors.

We are going to make a color wheel, which will give us the know-how to mix the three primary colors into fifteen more, plus a neutral gray. We'll learn to find harmonious or dramatic color combinations and how to neutralize one hue with another.

**Materials** You will need lemon yellow, alizarin crimson and cobalt blue oil paints in tubes, plus the following materials: a disposable paper palette, 12″ × 16″, for oils; a ball-point pen; a flat square brush (called a bright) about ¼″ wide — not bristle, but softer — synthetic sable is fine; palette knife; gum turpentine or odorless paint thinner in a homemade brush washer (see instructions at right); paper towels; and Winsor & Newton Liquin Oil Painting Medium.

*Note:* For all the charts in this chapter done on the disposable paper palette, we will add a few drops of Winsor & Newton Liquin Oil Painting Medium to our paints to speed the drying process, which will be about two days under normal drying conditions.

## Making a Color Wheel

Squeeze out about an inch of oil paint of each color along the top edge of the paper palette: lemon yellow (left), alizarin crimson (center), and cobalt blue (right). Carefully tear off this palette sheet and tape or clip it onto a white paper or cardboard. (You'll be mixing color on this sheet throughout this chapter.) Using a ballpoint pen, trace this color wheel illustration onto the *next* top sheet of the paper palette. You'll be painting on this sheet: The waxy surface is perfect for oils — they spread easily and look beautifully clear, like stained glass, and the oil from the paints won't leave the oil stain you'd get on paper.

With the flat brush, paint the primary hues in the designated areas on the

## Making a Brush Washer

An excellent brush washer can be made by taking an empty tuna fish can, punching nail holes all over the bottom of it, putting it upside down in an empty one-pound coffee can, and filling this can about one-third full with turpentine or odorless paint thinner. All the sediment filters to the bottom of the coffee can, so the turpentine on top is always clean. Hammer the nail holes from the outside in, that way the rough metal edges are on the inside and your brushes will not be ruined. Keep the plastic lid on the coffee can when you're not using it so the turpentine doesn't evaporate. You can use the same cans for months, depending on how often you paint, until the turpentine no longer clears upon standing or the dirty paint sediment oozes up from under the holes. Then just throw the whole thing out and make a new brush washer. No cleaning out the mess! The brush washer is also good for painting outside your studio; just don't spill it! (A word of caution: the coffee can must be metal or it will leak.)

*Washing your brushes with soap.* No matter how clean your brushes

are when you have rinsed them in turpentine or paint thinner, you still should wash them with soap and water at the end of every painting day. Wet the brush, scrub it into a cake of soap, then scrub the bristles in the palm of your hand. Rinse in warm water, squeeze out the excess water and shape the brush with your fingers and lay it flat to dry overnight. If you can get into the habit of washing your brushes, they will last longer and respond better.

color wheel you have traced. Remember to wash the brush clean in turpentine before each new color, wiping it on a paper towel until no color comes off. You can mix your paints with a palette knife if you wish; just wipe it clean between colors. Add only a drop or two of Liquin Medium to make the paint easy to apply; it should be thick and buttery so it covers well.

When you've done the primaries, paint in the secondary hues. For green, start with lemon yellow and add cobalt blue a bit at a time; you'll have to make several mixtures to get a green not yellowish, not bluish, but halfway between. Again starting with lemon yellow, add touches of alizarin crimson

until you arrive at an orange which is halfway between yellow and red. Repeat this procedure adding alizarin to cobalt blue for a purple hue halfway between the two. Paint the three secondaries in their spaces. Do your best to keep the edges of each hue from mixing with its neighbor.

Then mix the tertiary hues. Put a bit of alizarin crimson into the orange mixture and mix until you get a red-orange (halfway between red and orange). There will be five more tertiaries to mix: yellow-orange (lemon yellow plus orange), yellow-green (add green to lemon yellow), blue-green, blue-purple, and red-purple. Paint each mixture in its proper place. Then mix the

quaternary hues from the tertiaries: russet, dark orange, citron, dark green, olive, and dark purple, using the same procedure.

When you're finished, mix together whatever is left on your palette for a neutral no-color and paint this in the center circle.

After it dries, tape your color wheel to white paper or board so the colors will appear more solid, then tape the wheel on the wall of your studio or inside the lid of your paint box where you can see it and use it often enough to commit it to memory.

**Working in Watercolor** Trace the color wheel above and transfer it onto watercolor paper. Squeeze alizarin crimson, lemon yellow, and cobalt blue (from tubes) onto a watercolor palette or a dinner plate, leaving room for more colors to be added later on. Fill in these primary hues first, then the secondary hues, mixing carefully to get a green halfway between yellow and blue, an orange halfway between yellow and red, and a purple halfway between blue and red. Allowing each wash to dry before applying the one next to it, mix and fill in the tertiary

and quaternary hues. Finally, mix yellow, red and blue for the neutral gray in the center.

*Hint:* Notice that the more hues you mix together, the less clarity and brilliance you have. Remember this later when you are painting portraits. Try then to get the hue you want by mixing only two colors (not counting black or white) or possibly three. Any more will give you mud, and the color in your paintings will lack impact.

# Step-by-Step: **Color as Value**

The word *value* used in describing color means the lightness or darkness of the hue. In this study we do not change the hue; we change only the *value*. If we say *pale pink*, we're speaking of a light-value red; if we say *maroon*, we mean a deep-value red. Whether we say *sky blue* or *navy blue*, the hue is still blue, just the value is different. To lighten the value, i.e., *pale pink* or *sky blue*, we add white. To make the deep value red—*maroon*—and the deep value blue—*navy blue*—we add black. But adding black sometimes changes the hue; for example, black added to yellow does make it darker but the yellow changes hue and becomes green. To make yellow darker and *not* change its hue we must add raw umber. (We call a deep value yellow *brown*.)

In our Color-as-Value Chart at right, you see titanium white at value 1 become progressively darker toward black at value 7 as you move across the top row of squares from left to right. Each color also has its own row of squares (horizontally) and is painted in progressively darker values between value 1—white and value 7—black.

Each of these colors at full strength has its own intrinsic value built right into it. The position of the color on the

chart is predicated upon this value; for example, lemon yellow is value 2—light, and cadmium yellow orange is value 3—mid-light. Cadmium red light is value 4—midtone, while alizarin crimson, ultramarine blue, and viridian green are all value 5—mid-dark. Raw umber and burnt umber are value 6—dark.

## Making a Color-as-Value Chart

By completing this chart, you will learn how to make any of these pigments lighter or darker without changing its hue. Working with this chart will greatly increase your awareness of value and your sensitivity to value change, of major importance to a portrait painter.

As with the preceding color wheel, you'll be saving the chart you make for reference.

**Materials** We will continue using oil, with more colors added. The rest of the materials remain the same: titanium white; lemon yellow; cadmium yellow orange (by Grumbacher; if Liquitex, use brilliant orange, value 7); cadmium red light; alizarin crimson; ultramarine blue; viridian green; raw umber; burnt umber; and ivory black.

**Procedure** On your paper palette, squeeze out about two inches of titanium white and about an inch of paint in each of the nine hues in the order in which they are given: White in the upper left corner of the palette, then lemon yellow, cadmium yellow orange, cadmium red light, and so on across the top to black in the upper right corner. Don't crowd the colors on the palette: We do not want one color to touch another. Carefully tear off this top sheet with the paint on it and set it to one side. You'll mix your colors on this sheet.

As we did in the Color Wheel project, slip this chart at right under the new top sheet of the paper palette; you'll be able to see the chart squares through the translucent palette sheet and trace them with a ballpoint pen.

Paint lemon yellow in its designated square under value 2—light, then cadmium yellow orange in its designated square, then cadmium red light, alizarin crimson, ultramarine blue, viridian, raw umber, burnt umber and black, each one pure, clean and unadulterated, in its square as printed on the chart.

Starting with lemon yellow at the top, you will see that it is already only one value away from white, so we need not do anything about mixing it to a *lighter* value. We must concentrate on mixing lemon yellow with raw umber to the darker values—3, 4, 5, and 6, in graduated progression toward value 7—black. Starting with the yellow, we mix raw umber with it, first in *tiny* amounts, then more and more, darker and darker.

Squint very hard to compare your lemon yellow-raw umber mixtures with the gray values at the top of the chart. Do you have a value 3 mid-light and 4, 5, and 6? If not, adjust your mixtures lighter or darker until you feel they are as close as you can get them. Paint the four lemon yellow values in their allotted squares on the top line.

It is not easy to mix color exactly to a precise value. *You have to squint hard to match a color value to a gray value.* This is excellent practice for your future portrait paintings where you must constantly keep judging color as value.

Try to paint each square a flat, even hue rather than streaking it with light or dark. And paint it out to the edges of the square, not just a blob in the center.

---

To lighten any of the oil colors, we add white. To darken a color (lower its value) without changing its hue, we need to know the following:

Lemon yellow is lowered in value by the addition of raw umber.

Cadmium yellow orange is lowered in value by the addition of burnt umber.

Cadmium red light is lowered in value by the addition of burnt umber.

Alizarin crimson, ultramarine blue, and viridian (green) are all darkened with black.

Raw umber and burnt umber are darkened with black.

| VALUE 1 White | VALUE 2 Light | VALUE 3 Mid-light | VALUE 4 Mid-tone | VALUE 5 Mid-dark | VALUE 6 Dark | VALUE 7 Black |
|---|---|---|---|---|---|---|
| | | | | | | |
| Titanium White (Pure) | Lemon Yellow (Pure) | | | | | |
| | | Cadmium Yellow Orange (Pure) | | | | |
| | | | Cadmium Red Light (Pure) | | | |
| | | | | Alizarin Crimson (Pure) | | |
| | | | | Ultramarine Blue (Pure) | | |
| | | | | Viridian Green (Pure) | | |
| | | | | | Raw Umber (Pure) | |
| | | | | | Burnt Umber (Pure) | |
| | | | | | | Ivory Black (Pure) |

Moving on to cadmium yellow orange, we find we must mix this hue with enough white to make a lighter value corresponding to value 2 — light. Start with white and add a small amount of yellow orange to it until you reach value 2. We know that this hue is darkened with burnt umber. Starting with yellow orange, add burnt umber bit by bit until you feel you have a value 4, midtone, value 5, and value 6. When you feel they are correct, paint them in their corresponding squares on the line with yellow orange, just below the lemon yellow-raw umber values 4, 5, and 6.

Now the top row of lemon yellow values from 1 to 7 is complete, as is the second horizontal row depicting the seven values of cadmium yellow orange. Aren't you already a little surprised at the very beautiful color value mixtures you have made?

Continue downward, row by row, with the other pure colors you have painted on the chart. All are *lightened*

*Hint:* If you would like to make this color-as-value chart using watercolor, trace and transfer the chart onto white paper. The same colors used in the oil chart will lower the values of the watercolor hues (darken them). See the shaded box on page 106. To make watercolor *lighter* in value, of course, you must add more *water* to the color rather than white pigment.

by white. Check the shaded box on page 106 for the pigment that darkens each respective color.

This chart, with all its subtle value gradations, will take some time to finish. Try not to rush it.

When you have finished, you will have each of our colors mixed to value 2, light — in a vertical column beneath the value 2, light gray square. They will all be very pale, their lightest. Under the value 3 mid-light gray square, you will have every color mixed to value 3, and so on under values 4, 5, and 6.

You will have an extremely beautiful Color-as-Value chart, and you will know a great deal about changing the value of a color without changing its hue. This chart is really helpful when you are searching for color harmonies.

**Value and the Naming of Colors** For auto manufacturers, interior designers, and paint salesmen — and the dozens of other professionals who deal with color but are not artists — the *name* of the color changes all the time. The words "pink," "rose," and "wine" are used to designate differing values of red. To the artist, "pink" is still a light value red. "Rose" is a middle-value red, and "wine" describes a deep-value red. To the artist, the hue has remained the same; only the value has changed.

More examples of these non-artist's color names and artist's hues are:
*Peach* is a value 2 — light orange.
*Rust* is a value 5 — mid-dark orange.
*Aqua* is a value 2 — light green-blue.
*Teal* is a value 5 — mid-dark green-blue.

*Lime, celery, and apple* are all value 2 or 3 light or mid-light greens.
*Forest, pine, and cedar* are all value 5 or 6 mid-dark or dark greens.

**Value Awareness** Skillful use of values is extremely important in painting portraits. Close values create harmony, while extremely contrasting values add excitement to a painting. A painting in light values (say 1 to 4) is termed a *high-key* painting, while one of values 4 to 7 is called *low key*. A painting done only in middle values may lack sparkle or punch; adding touches of strong lights and darks could revive it and give it contrast and life.

*Note:* Some teachers call values "tones." They will say, "a light tone against a midtone," meaning a light value against a middle value. In describing the values on a head, they may speak of "the light value, the midtone, and the shadow area." Don't let all this confuse you; the words are different, but the instructor is still talking about *value* — light and dark.

**Checking Values** To check values when you're working in color, photograph the painting in black and white (a Polaroid shot is good). If the darks are too black, you will know you have to lighten them. Frequently only an eyebrow or a corner of the mouth is too dark, or you may have painted the lights moving too quickly into the darks. These errors are easily corrected by trying to be more subtle.

# Step-by-Step: **Color as Intensity**

In this project we do not change the *hue* or the *value* of the color, only the *intensity*. The word "intensity" here means the *brilliance* or *saturation* of the hue. A pure primary red, seen in bright sunlight, is absolutely at 100-percent intensity, a totally saturated hue. We say that this red is at its maximum "redness"; it cannot be any redder. To paint a 100-percent intensity red in oil or watercolor, we must have a pure red pigment, with no other color added to it, not black or white either.

Now let's move that 100-percent intensity red out of the sunlight and look at it under a porch roof. What do we have? The color is still red, but its brilliance is diminished; it's duller. Perhaps the red is seen now at 70 percent of its full intensity.

If we were to paint this red in shadow, we would say we need a low-intensity red. How do we get it? The color wheel presents the answer: We diminish the intensity of a color by adding its *complement*; in the case of red, the complement is green. To gray a yellow, we add purple, its complement. To gray an orange, we add its complement, blue.

*The complement of any hue is found directly opposite it on the color wheel.*

These graying processes work both ways, of course; as green diminishes the intensity of red, so red diminishes the intensity of green. As purple dulls yellow, the yellow diminishes the intensity of purple. As orange diminishes the intensity of blue, so blue dulls the orange. Lay a straight line across the wheel, through its center, from any hue, and you will arrive at its complement on the opposite side, whether the hue is primary, secondary, or tertiary.

If you mix enough green with your red so that your mixture is totally neutralized—appearing neither greenish nor reddish—you will have a neutral gray, the hue in the center of the color wheel.

*Any hue, when mixed with its complement, is diminished in intensity.*

## Making Colors Appear Less Intense

The following exercise will show you how to make a color appear less intense—that is, how to tone down or neutralize a color.

**Procedure** You'll need the same materials as before, but squeeze out just three colors (no white or black): lemon yellow, alizarin crimson, and cobalt blue. Use a clean sheet from your paper palette, tear it off carefully and set it aside for a mixing surface.

Working with a ballpoint pen as before, trace the intensity charts, shown on the next page, as you see them through the next translucent palette sheet from the pad. You'll paint on this sheet. Paint the alizarin crimson (red) of your color wheel in the space at the left end of the first chart. Then put your color-wheel green mixed from lemon yellow and cobalt blue in the space at the opposite end. Paint each color out to the edges of its assigned space.

Make several mixtures of this red and green on your palette sheet and select the most neutral (neither reddish nor greenish) one. Paint it in the central space on the red-green chart.

Starting with the red, make more red-green mixtures and select those that you think should be in spaces 2, 3, and 4, moving from full-intensity red to neutral.

Then repeat the process with full-intensity green, painting gradations from green to neutral in spaces 8, 7, and 6. Repeat the procedure for the next charts using orange and cobalt blue, mixing the orange from lemon yellow and alizarin crimson. Then paint the third chart using lemon yellow and its complement, purple (made from alizarin crimson and cobalt blue). Again, allow them to dry and save your color-as-intensity charts and keep them handy for ready reference.

---

*Hint:* Neutrals made from the three different combinations are not the same neutral color. Each complementary pair produces a *different* neutral. Some are brownish, some gray, some more violet. Of course, none are brilliant colors. There are any number of other reds, yellows, and blues, too, and each pairing of these with their complements will produce a *different* neutral as well. You may want to work with them and prove this to yourself. The study of color is endless and always gratifying.

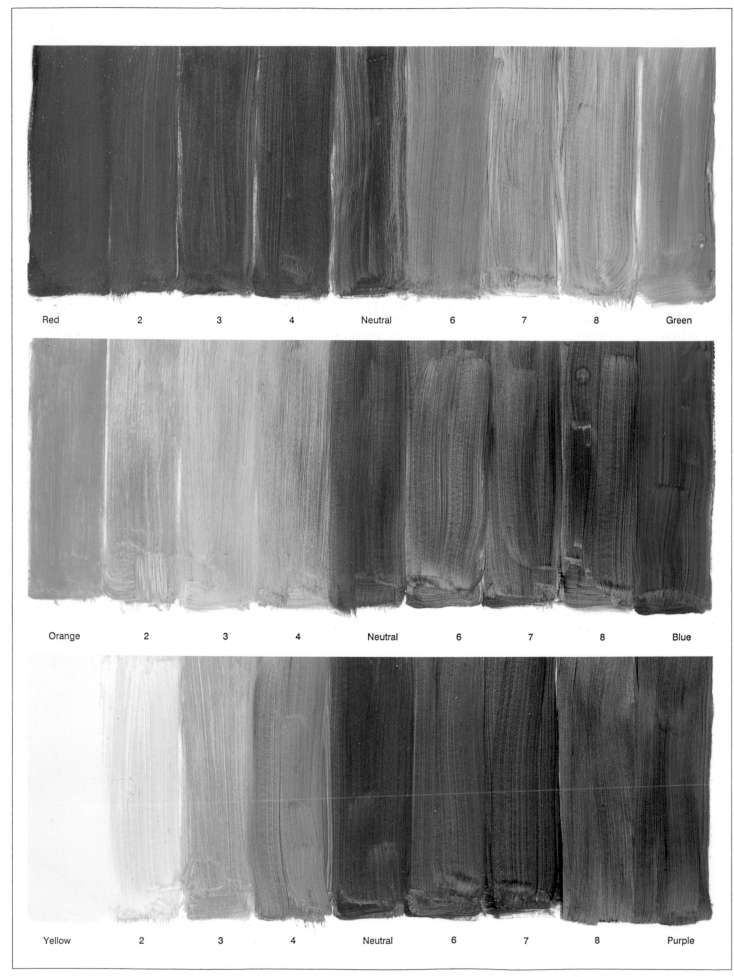

| Red | 2 | 3 | 4 | Neutral | 6 | 7 | 8 | Green |

| Orange | 2 | 3 | 4 | Neutral | 6 | 7 | 8 | Blue |

| Yellow | 2 | 3 | 4 | Neutral | 6 | 7 | 8 | Purple |

110

## More Ideas for Neutralizing Color

It's useful for a portrait painter to recognize the quiet beauty of neutral colors, and that mixing complements is the best way to get them. You have learned how to gray, or neutralize, the primary and secondary colors. If you wish to experiment with tertiary colors (as complements), make similar charts and proceed as before. The tertiaries neutralize very quickly as they are already made from three other hues, which diminishes the brilliance of each hue considerably.

Totally neutral mixtures are not always made by mixing 50 percent of one color with 50 percent of its complement. For example, it takes only a very small amount of purple to neutralize lemon yellow, but it would take quite a good bit of yellow to neutralize the purple. Do you start with orange or cobalt blue in combining complements? Experiment and see which works best, but it's usually easiest to start with the *lightest* color when making a mixture.

## Color as Temperature

Most all artists believe that yellows and reds are warm colors, and blues and greens are cool colors. Of course, this is an oversimplification; every color can be warmed or cooled. Yellows get warmer as they go toward red and cooler in the other direction on the color wheel, toward green. Even reds can be warmer going toward yellow and cooler leaning toward blue (orange-red or vermilion as opposed to cyclamen, fuchsia, or wine). Purples can go either way; they cool the red and warm the blue. This brings us to the understanding that color is really relative. In an all-green painting, even a pinkish purple will look hot. In a yellow and orange painting, a yellow-green will look cool! Each color is affected by whatever color is adjacent to it.

I hope you're beginning to understand our remark that "all color is relative." Sure, a red is a red, but as artists, we are in control—we can alter red dramatically by the hues, values, intensities, and temperatures of color we place next to it.

From now on, when we discuss painting flesh tones and say "warm or cool your color," you will know that the warm colors are yellows and reds, and the cools are blues and greens.

## Making Colors More Intense

Color pigments have their limitations, but by using complementary colors we can make any hue appear *more* intense too. For example, to make red appear its most brilliant, we surround it with its complement, green. All greens— light, dark, bright, or dull—will intensify red. The following exercise involves painting squares within squares to explore this color phenomenon (see the charts on pages 112-114).

There is a half page of squares for each primary and secondary color. Paint specific colors in the outer squares surrounding each of the six hues and then study the results. You will see the way the same color *appears* to change from one square to the next, depending upon the surrounding hue, even though we *know* the color in the inside squares is precisely the same throughout.

Again, you will be using the primary colors plus ivory black and titanium white, laid out on a sheet of the paper palette. Carefully remove this sheet and set it to one side; you'll be mixing colors on this sheet. With a ball point pen, trace the squares from the Red chart on the next clean palette sheet. Paint the entire square at the left and each of the five inner squares alizarin crimson (red), right out to the edge.

Paint each of the five outer squares a different color as suggested, as smoothly as possible, trying not to let these colors get mixed into the crimson of the inner squares. Remove this Red chart from the palette and let it dry.

Trace the Yellow chart on the next clean paper palette sheet and paint the square at left lemon yellow, and all the other inside squares as well. Paint the surrounding squares as indicated. Remove this sheet and proceed with the other four charts in the same manner, painting the inner and outer squares as indicated.

Upon completing these charts, you'll understand how a full-intensity hue can be further enhanced by its complement and how an artist can push one color into an aggressive or a passive mode. Keep these charts for future reference.

## Enhancing Intensity of Red

Red

Red and Black

Red and Orange

Red and Purple

Red and Dark Green

Red and Gray

## Enhancing Intensity of Yellow

Yellow

Yellow and Black

Yellow and Green

Yellow and Orange

Yellow and Purple

Yellow and Gray

112

# Enhancing Intensity of Blue

**Blue and Green**

**Blue and Black**

**Blue and Orange**

**Blue**

**Blue and Purple**

**Blue and Gray**

# Enhancing Intensity of Orange

**Orange and Red**

**Orange**

**Orange and Black**

**Orange and Blue**

**Orange and Yellow**

**Orange and Gray**

## Enhancing Intensity of Green

Green and Blue

Green and Red

Green and Gray

Green

Green and Black

Green and Yellow

## Enhancing Intensity of Purple

Purple

Purple and Black

Purple and Blue

Purple and Red

Purple and Yellow

Purple and Gray

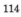

# Color Ideas for Portraits

## The Use of Complements

Do you begin to see the color wheel as a valuable aid to a portrait painter? Suppose your sitter has a very ruddy complexion—maybe too ruddy—and you decide you must de-emphasize the hot coloring. But you can't paint him without the vivid coloring or the portrait won't look like him. What can you do? One thing you know you *can't* do is paint the background green! Green would make the complexion appear even ruddier. If you use the hues nearer red on the color wheel, the vivid skin will contrast less with the surrounding background and appear more pleasing. On the other hand, you may *want* to emphasize a sitter's unusual red hair; using green in the background or clothing would help to accomplish this.

But changing the hue isn't all. By altering the value and the intensity of these nearby hues, many choices are open to us. It is recommended that you do several color studies before you begin a portrait, perhaps 5 × 7 inches or 8 × 10 inches large, so you can choose the very best color arrangement for your client rather than just settling for whatever is there.

## Harmony from Analogous Colors

To ensure color harmony within the portrait, play it safe by using colors adjacent to each other on the color wheel: these are called *analogous colors*. For example, using yellow with yellow-orange and yellow-green will never present a color problem. Blue-purple with blue and purple would be another harmonious scheme. Use your inventiveness by altering the values and intensities of these analogous color ideas—then they will never be boring. One idea could be a large area of pale blue with a medium-sized area of blue-purple with a sharp blue-green used as the accent. Can you think of another exciting color idea using analogous colors?

## Harmony from Split-Complement Color Schemes

A split-complement is a pair of complementary colors on the color wheel with one complement *split into the two hues adjacent to it*. Look at your color wheel and at the red-green complement. Split the green into the blue-green and yellow-green on either side (eliminate the true green). There is your split-complementary scheme: red, yellow-green, and blue-green. Blue with red-orange and yellow-orange is another. Yellow with red-purple and blue-purple another. Blue-purple with yellow and orange still another.

These combinations are slightly more complex than a direct complement and can give a bit more unusual effect to your painting. You still have all the options of changing the values and intensities of one or all three of the hues.

# Painting Flesh Tones

The first time I was confronted with a live model I thought all this talk about flesh tones was pretty silly. I said to myself, "What's so hard about painting flesh tones? I know how to find out how to paint them, I'll just mix the color to match the skin on the back of my hand." And I mixed a color and tried it on my skin, and mixed and tried and mixed and tried, and after a while I began to understand what all the fuss was about. There wasn't any way to match that marvelous skin—for good reasons. Skin is made up of many thin and translucent layers; you can see blue, brown, pink, green—even lavender—there. Skin is a live organ made up of blood and tissue, muscle and cells, while we, as artists, have only paint—pigments made from natural earths, elements, or chemicals. We can paint a *semblance* of the skin, but we cannot match it. Remember, art is not life; art is the *illusion* of life.

Nevertheless, flesh tones always seem to be the biggest stumbling block for students of portrait painting. To get you started, we are going to mix them from just three colors plus white— what we call a "limited palette."

## Using a Limited Palette and Oil Paints

We will be working on this chart of flesh tones with titanium white, raw sienna (Winsor & Newton), light red, and cobalt blue—less intense versions of the primaries. (By the way, light red is not cadmium red light; it is an earth color, like red clay.) Squeeze these four pigments out on a sheet from your paper palette, tear it off, and set it to one side for mixing. With a ball point pen, draw six panels the size of those from the *Flesh Tones in Oils—Limited Palette* chart below on the next sheet of the paper palette.

This limited palette exercise will simplify your first color portrait lesson, and you may be astounded at all these three colors plus white can do. In truth, this is a good choice of pigments for beginning any portrait, even after you have gained more experience.

## Flesh Tones in Oils—Limited Palette

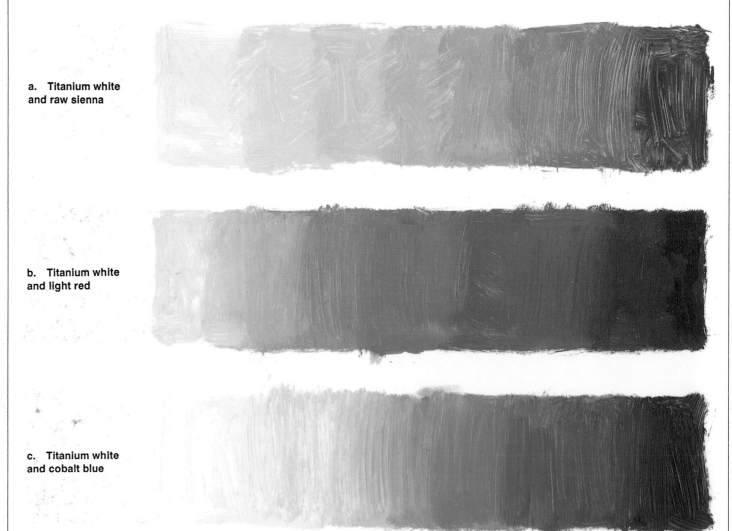

**a.  Titanium white and raw sienna**

**b.  Titanium white and light red**

**c.  Titanium white and cobalt blue**

**One Color at a Time** Take the time now to familiarize yourself with these three colors by playing with them, intermixing them on your palette with the palette knife. Now take some white and mix raw sienna with it, making four mixtures in values from very pale to pure color. Using a brush, paint these mixtures in one of the panels (a) you've drawn, with the lightest value at left, darkest at right.

Then mix the light red the same way—and paint the four values shown in panel b, light to dark, left to right. Do the same with the cobalt blue in panel c. Cobalt blue is an expensive pigment but it is the clearest blue and is especially useful in flesh tones.

**True Flesh Tone Mixtures** Now intermix the white with raw sienna and light red, from palest tint to saturated color. Try it a bit more to the sienna, then a bit more to the light red. Paint these mixtures as shown in panel d. Do the same with white, light red, and cobalt blue. You'll find some beautiful grays for halftones and exquisite warm shadow colors here. Paint these hues as in panel e.

Then mix the white, raw sienna, and cobalt blue. You'll be surprised at the subtle warm greens you get from this combination. Make them pale to pure, then more golden, then more bluish. These are marvelous low-key greens for flesh. Yes, there are greens in the face and neck, very quiet ones like these. These mixtures should be painted as shown on panel f.

> *Hint:* Always add color to white, not white to color, or you'll have mounds of excess color to contend with!

d.  **Titanium white, raw sienna, and light red**

e.  **Titanium white, light red, and cobalt blue**

f.  **Titanium white, raw sienna, and cobalt blue**

## Darks for Flesh Tones and Shadows

Now tear off a fresh sheet from your paper palette and trace the panels shown below. On this sheet you'll be painting mixtures that'll give vibrant darks for flesh tones and shadows.

Mix raw sienna and light red together without white to make a hot burnt clay color. These two do not produce a real dark. Paint them the same as those in panel g. Then blend raw sienna and cobalt blue together without white. Here's a good dark! Make a brownish hue with more raw sienna, a deep greenish blue with more cobalt blue. Paint these the same as shown in panel h. Now mix light red and cobalt blue together without white. Good powerful darks: deep eggplant purple hue, deep red-browns. Paint this pair as you see in panel i.

Write in the names of the colors of each mix with a permanent marker, so you'll be able to refer to them when needed. Keep the charts handy for future portraits.

By now you're aware that light red has more tinting strength than raw sienna or cobalt blue. If you're not careful it will dominate every mixture it's in.

## Flesh Color Families in Oils — A Full Palette

Study the chart on the next page. To do this color study, we will use the same method used previously. Squeeze the colors onto the top palette sheet and then set that sheet to one side. Trace the chart onto the next palette sheet and paint on that image. You will need the following colors: three yellows—Naples yellow, yellow ochre and raw sienna; four reds—light red, Venetian red, alizarin crimson, and burnt sienna; two blues—cobalt and ultramarine; and one green—viridian. Your small flat brush should do the work for you.

Each flesh color family is made up of two warms and a cool, plus white. Theoretically, a family could be made from any other pair of warms and a cool.

## Complexions

A fair person with light hair has thinner skin than a person with a darker complexion, and therefore more blues are visible. In summer when these skins become tanned from the sun, the blues give way to warmer hues.

Red-haired people often have the thinnest skin of all. Their general skin tone may be extremely pale, very "white." Where their flesh tones do get warmer you'll see a unique coral or peach color, not a rose pink.

Ruddy complexions may be rosy red, red-orange, or red-violet color, and often have purples in the shadows and darks. Sallow skins have more yellow tones, are less rosy, and may be tinged with olive greens. Midtone skins on brunette people are often golden, more yellow than red, and have greens in the shadows.

There's also a type of "Irish" coloring with very black hair, fair skin, and really rosy cheeks, with hints of blue around the eyes and the temples where the skin is nearly transparent.

Dark complexions are seldom tinged with red but tend to gold-browns, orange-browns, with halftones toward violet, and sometimes pale blues in the highlights. Use combinations of cobalt blue and burnt sienna so you can vary the complexion either to the cool or to the warm. Try not to mix the hues too much on the palette but lay them side by side on the painting and blend them as little as possible to give the skin a feeling of life. At the nostrils, eye openings, and ears, you may want to add an earth red to bring vitality to the portrait, but study the individual first. (There are several earth reds, e.g., burnt sienna, light red, Venetian red, terra rosa, Pozzuoli red.)

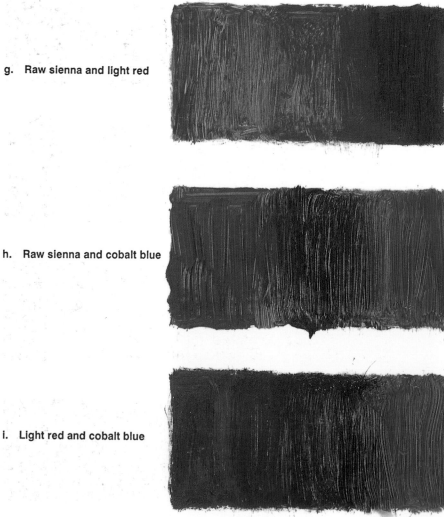

g.  Raw sienna and light red

h.  Raw sienna and cobalt blue

i.  Light red and cobalt blue

## Flesh Color Families in Oils—A Full Palette

a.  White, raw sienna, light red, cobalt blue; good for all-around basic flesh-tone beginnings. Good for men too.

b.  White, raw sienna, Venetian red, cobalt blue; another basic mixture, but softer.

c.  White, yellow ochre, burnt sienna, ultramarine blue; for medium to medium-dark complexions. More yellow tones here.

d.  White, Naples yellow, light red, viridian; a luminous combination. Good for children.

e.  White, raw sienna, alizarin crimson, cobalt blue; good for ruddy complexions, for warmer medium to dark skins. Also for warm shadows and darks.

f.  White, burnt sienna, alizarin crimson, viridian; good for men and ruddy complexions.

## Flesh Color Families in Watercolor

a.　Yellow ochre + scarlet lake + cerulean blue. A good combination for an all-around flesh tone, especially for children; good first wash for all complexions.

b.　Raw sienna + brown madder + cobalt blue. This is deeper than the preceding mixture; stronger, richer. Good for medium complexions; also for men.

c.　Raw umber + alizarin crimson + ultramarine blue. Use for deeper colored complexions, but not reddish ones.

d.　Cadmium lemon yellow + scarlet lake + cerulean blue. Luminous; used very pale, it's good for flesh tones in sunlight outdoors. (Use it stronger for complexions with more golden tones.)

## Flesh Color Families in Watercolor

As in oil, each flesh color family in watercolor is made up of two warms and one cool color. Try these, then create your own combinations. Rather than darkening flesh tones with brown or black, which would make the mixtures dirty, add cools to the warm pairs and use less water to thin the pigment. This will give your watercolor portraits a clean, fresh appearance.

**Procedure** Mixing specific colors in watercolor is far less predictable than in oil. For your practice mixtures, use Arches 140-lb. cold-press or a similar watercolor paper with some tooth, and draw the squares similar to those at left, but measuring approximately 5×5 inches. Make eight or twelve panels, for some will be spoiled. Clip or tape your paper to the drawing board and prop it up at a 45-degree angle. The flesh color washes do not work so well on a flat board.

Squeeze out the following tube colors on a watercolor palette or a white dinner plate beginning at left: cadmium lemon, yellow ochre, raw sienna, scarlet lake, alizarin crimson, brown madder, cerulean blue, cobalt blue, raw umber, and ultramarine blue.

Take up a 1-inch flat brush and clean water and paint the first square *with water only.* While the paper is damp, add a wash of the first color in the family *a,* yellow ochre. Don't worry about going outside the lines. Keep a paper towel or tissue in your other hand to mop up drips. Lay this one color on from top to bottom, stroke by stroke *across* the square, and allow it to dry. *Under no circumstances should you go back into the wash, no matter how messy it looks; let it dry!* When dry, repeat the same process with a second clean wash of water, then add the second color, scarlet lake. You'll find this color very intense, so you won't need much pigment. When this wash is dry, repeat again with water, and, before it dries, add a wash of cerulean blue. As your board is tilted, the color will glide downward with the flow of the water, and so it should be stronger at the bottom third of the square. Just for fun, mix together the same three colors *on*

*your palette* first, and paint one square. You will see that the results are not the same as with our glazing technique. Laying one color on at a time gives us a clear beautiful flesh tone, while premixing the same three colors gives us a gray hue.

It will take some practice before you get nice clean flesh colors, but in the process you'll learn a great deal about how much water to use, how much color, when the wash is dry and when it isn't, and many other things about handling this elusive medium of watercolor. You will get some marvelous clear transparent flesh colors. When you do, cut the best squares out and paste them on white paper. Pin it up on the wall for reference, recording the pigments used in each triad. Incidentally, you may want to start painting several squares at once so you can work on one while the others are drying.

The head is seen as if divided into three areas which simulate bands across the face and head. The forehead band is seen as golden or yellow in color. The nose-cheek-ear band across the central part of the face is seen as warm, rosy, or ruddy. The chin and jaw band is cooler. The chin itself may show a hint of orange, but the lower chin and the jaw become bluer, grayer, or greener.

When starting the portrait head, the side planes, which are in shadow, are all one *value* and all one *color,* too. Only when the work nears completion do you paint any subtle color changes you see *within that value.*

## Bands of Color on the Portrait Head

There is one more color idea to consider when painting the portrait head. As we discovered earlier on page 83, the *values* on the head vary from lightest on the forehead band, to slightly darker on the nose-cheek-ear band, to still darker on the chin and jaw. The *color* of the skin tone varies in a similar manner: the forehead band is more golden, more yellow; the nose-cheek-ear band is warm, more rosy, or ruddy; and the chin and jaw band is cooler. The chin itself may show a hint of orange but the lower chin and jaw is bluer, grayer, or greener. You can paint this head in color if you like, but it is here mainly as a reminder. If ever you find yourself working on a portrait and it isn't going well and you're not sure why, try this color system. It might help to make the head more natural, more interesting, more "lifelike."

# Painting Hair

Shape, texture, and sheen are the qualities to emphasize when painting hair in a portrait. We also have to notice the way an individual wears his or her hair, the style; this is an expression of the personality and an important part of the likeness. Painting the hair well takes some observation, but it's not difficult—in fact, it's fun to do.

Like flesh tones, hair color varies considerably from one person to another, but there's one rule you can rely upon: natural hair colors are seldom the same color all over the head. You'll see lighter and darker places, warmer and cooler colors, all on the same head. Artificially colored hair, however, is not likely to have the variation of warm and cool lights and darks.

### Painting Hair in Oils

Study this chart at right showing some hair colors mixed from a full palette. Try mixing these blends yourself, using the method for the previous flesh color chart. On a clean palette sheet, squeeze out the oil colors listed below. Remove that sheet carefully, set it aside, and trace the six rectangles on to the next clean palette sheet, then paint your hair mixtures in those shapes.

The colors you will need are titanium white, lemon yellow, cadmium yellow-orange, yellow ochre, raw umber, alizarin crimson, burnt sienna, cobalt blue, ultramarine blue, and burnt umber.

You will find you need a slightly different brushing method for painting hair. The quarter-inch flat brush is about right, along with a small pointed brush. Less mixing of the colors is re-quired. Allowing the brush strokes to show lends a more convincing hair texture.

If you want a more smoothly brushed look, sweep your hair mixture very lightly in the direction of the strands of hair with the flat brush; this will give you the hair's sheen. (Be careful with this, as your work can become very slick looking if you "polish" it too much.) Following are the color mixes you'll find in a variety of hair colors, plus specific color traits to look out for.

**Light blond** Titanium white, lemon yellow (a cool yellow), raw umber and a touch of cobalt blue. This color hair is never really yellow; of course, lemon yellow and cobalt blue will turn green when mixed together—just be careful to balance them properly. For platinum blond hair, you really have to build up the lights in an impasto (thick paint). You might have to heighten them with white, allow them to dry, and glaze them with titanium white and lemon yellow to get them light enough.

**Light brown, or "ash blond"** Titanium white, yellow ochre, raw umber, cobalt blue. We want to avoid any look of red in this hair; raw umber is a dark yellow, and yellow and blue give us a green, so we will have to adjust these two carefully.

**Red** Titanium white (not much), yellow ochre, burnt sienna, alizarin crimson, cobalt blue, sometimes flashes of yellow-orange. The major color to use is burnt sienna, but you will see that mixing white with it kills its intensity.

You can heighten with white, let it dry, then glaze it with burnt sienna, or you can paint the lights with burnt sienna and use a slightly damp brush to lift out where you want the lights to appear, allowing the light ground to glow through. Darks are burnt sienna and purple made from alizarin crimson and cobalt blue. There are *never* any greens in red hair!

**Dark brown** White, yellow ochre, burnt umber, ultramarine blue. Warm the highlights with yellow ochre, cool the highlights with more blue. Too much white and they will turn gray so easily! Darks are burnt umber and ultramarine blue.

**Black** Ultramarine blue and alizarin crimson give a rich colorful dark, but you need to add burnt umber to give the color weight and body. Highlights are a cool blue from white and ultramarine blue, applied with a very light touch. Don't mess around in it! I never use black paint in black hair; black oil paint turns grayish when dry and doesn't have the depth of alizarin crimson and ultramarine blue.

**Gray** Titanium white, raw umber, cobalt blue. Observe this hair color carefully; often a gray-haired person has some dark hair as well! Raw umber and cobalt blue will do nicely for that. Usually people don't want yellows or gold in their gray. Your job is to paint gray hair in a very crisp and clean way so it doesn't look drab or "dirty."

**Light blond**

**Light brown**

**Red**

**Dark brown**

**Black**

**Gray**

## Painting Hair in Watercolor

For painting the hair in watercolor mixtures proceed in the same manner as before. Draw the rectangles at right on your watercolor paper.

Hair textures are not smooth as flesh tones are, so we don't use a glazing technique here. Instead, we paint one wash of one color on the rectangle, and then, while it is still damp, stroke the second pigment into it. It's important not to mix the second color into the first color very much; just stroke it on with a no. 8 pointed brush and *leave the brush marks*. The streaks give the texture of hair. To accentuate the feeling of hair, leave some areas very light or lift them out with a barely damp brush. If there's a third color indicated, drop it into one area only. It's usually needed to give us a dark, and the dark and the light work together to make a shimmer, like the sheen on hair.

Remember, the less you touch these rectangles with your brush, the more like hair they'll look. Too much tinkering will make them look overworked. When you have four hair rectangles you like, save them for reference.

Painting these mixtures will give you a hands-on understanding of the wonderful way a cool color can help a warm one—if you don't mix them into mud!

**Blond** Raw sienna + cerulean blue + yellow ochre. This must be kept light and airy. Use the cerulean blue judiciously, for yellow and blue will give you green. *Pale* is the word for the blue.

**Brown** Burnt umber + cerulean blue; when dry, a yellow ochre wash over parts of this rectangle. The magic of cerulean blue comes to the fore once more and keeps the burnt umber from being too harsh.

**Red** Burnt sienna + cobalt blue + a touch of mauve in the darks. You might want to add a light wash of yellow ochre to this group too, when dry.

**Dark** Burnt sienna + ultramarine blue. The less mixing you do with these two, the better.

Blond

Brown

Red

Dark

# Controlling Color in Portraits

A true colorist does not open all his tubes of brightest color and squeeze them out on the canvas in equal amounts and expect to achieve exciting blazing color in the painting. This doesn't give you brilliance, any more than having all the instruments in the orchestra playing as loudly as possible and all at the same time gives you powerful music.

Dull (low-intensity) colors placed next to bright (high-intensity) colors make the bright colors look brighter. Dark (low-value) colors next to light ones make light (high-value) colors look lighter (see pages 112-114).

The distribution of color across your canvas also means so much. Do you want a large amount of bright color with a smaller number of quiet hues? Or would you prefer to reverse this color idea? Do you want the most brilliant color in a necklace, scarf, or tie near the face? Or would you want it as a background for your figure? Remember, you are the artist; you are in control.

## Learning from Other Artists

If color really intrigues you, start looking at the greatest colorists of all time: Matisse, Gauguin, Bonnard, and Van Gogh. Try looking at reproductions of their work upside down. Only then will you really appreciate the experimental color innovations of these artists. Start keeping a notebook and write down color arrangements that excite you. Anything that forces you to look at paintings in a more analytical way will help you beyond measure.

While you're at it, study the great nudes and figures and portraits by Modigliani. See what he did with all that flesh color in the nudes, the colors he used as complements to the light-value orange that is the flesh color of his Caucasian people. Also look at the wondrous hues Gauguin used in his paintings of Tahitian women with their dark skins.

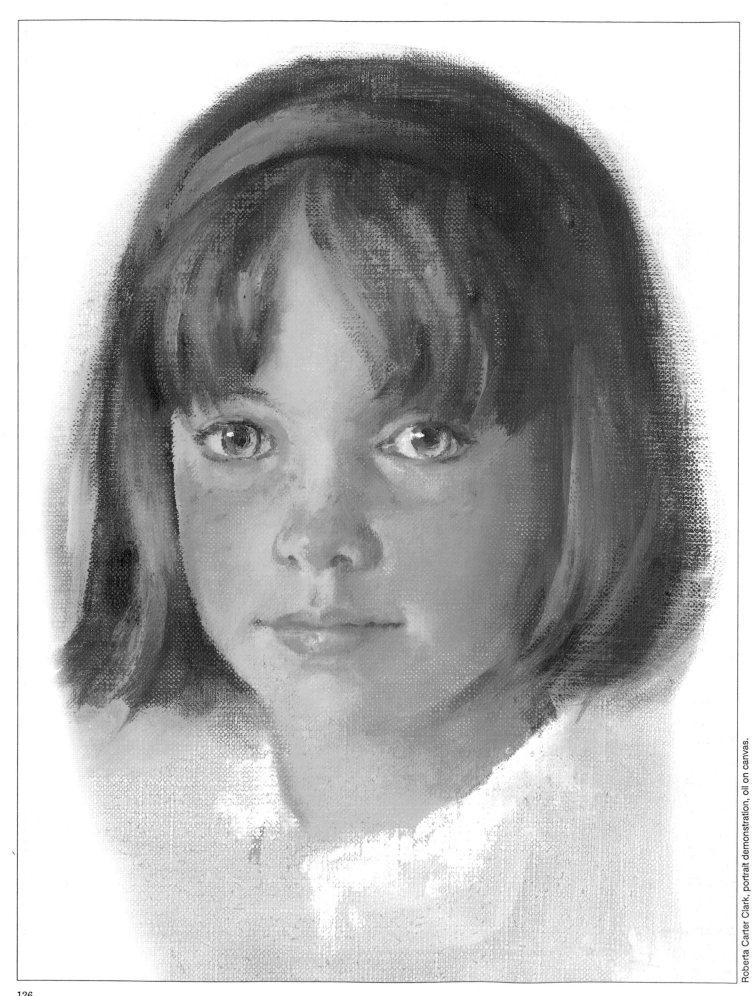

# PAINTING OIL PORTRAITS FROM LIFE

In this chapter we'll progress to an actual portrait painting in oil, the medium of the masters. The many reasons for the continued popularity of this medium can be reduced to one colossal attribute: its versatility. Oil is not an easy medium to master, but it will give you more than any other coloring process.

You can build an impasto by laying oil on thickly, or you can drag one color across another color and get a unique broken color effect. Oil paint can be as delicate as a butterfly wing, with one veil of color thinly glazed over another. You can draw with it, glaze with it, knife it on, get the best rich, transparent darks and the airiest, sunniest lights. There really is no other medium to compete with oil.

In this section we'll examine three oil painting techniques: a monochrome portrait, an alla prima wet-into-wet approach, and a built-up, or glazed, technique. In each one we will be working with a live model; perhaps you can get a friend or a member of your family to pose for you.

# Working in Monotone

You don't have to paint with many colors to do a good portrait. The portrait below was done with just raw umber and titanium white oil paints, and retouch varnish and turpentine. This varnish is thin and watery and dries hard very quickly. You can draw fine lines with it and paint over them almost immediately without smearing them.

Highlands is a seashore community near my home, and this gentleman has retired from fishing after spending years at sea. You will seldom see more character in a face than in that of this gentle, introspective man; he was still proud enough to come to pose for our group in a shirt, tie, and overcoat rather than his working clothes.

This painting started out to be a full-color portrait, but while it was still in the raw umber I liked the effect so much I decided to leave it a monochrome.

I used an untempered Masonite panel which I had prepared with two coats of acrylic gesso. Next, raw umber was thinned with turpentine and rubbed over the entire panel with a paper towel. This veil of color is called an *imprimatura*. The imprimatura gives the white panel a mid-tone to paint on so you can work up to the lights and down to the darks, just as you did with charcoal on tinted paper. The imprimatura is quite transparent, allowing the white ground beneath to glow through.

Then I thinned the raw umber paint with enough retouch varnish to enable it to flow easily and drew the portrait with a soft pointed brush. I also used no. 4 and no. 6 bristle brushes to model the drawing and the shadows on this portrait head.

When the raw umber halftone and shadow work seemed right, I began to look for lights and highlights. I lifted out the light areas with a brush and turpentine. Using very stiff white paint, not thinned at all, I applied it where I saw the lights. I started with the brightest light on the forehead, closest to the light source. Working my way around the head I painted the white on the hair, the brow bone, the nose, cheekbone, eyelids, lips and chin, then the shirt collar.

## Edges

Notice the whites: they are quite soft where they round the form to the halftones. There's a crisp white edge on the lower lip where highlight meets cast shadow; this edge is curved to tell us the lower lip is a rounded form. The right edge of this highlight white dissolves to a blur, which tends to make the fisherman look as if he *might* move.

We have not spoken much about edges in our portraits except in the painting of hair; this study will show you that it is wise to keep some of the edges of forms that turn away from you indistinct. Notice the blurs at the back of the head above the ear and on the coat collar.

A portrait in which all edges are hard appears flat, cut-out, and rigid. A portrait in which all edges are soft and blurred is mushy and unresolved. You need *both* kinds of edges in a realistic portrait.

The head is 9″ high (lifesize). It was done in one sitting in bright artificial light, and no photography was used.

---

*Hint: Hard edges* advance a form. *Soft edges* make the form recede. *Hard edges* indicate solidity and describe a form. *Soft edges* indicate movement and atmosphere.

---

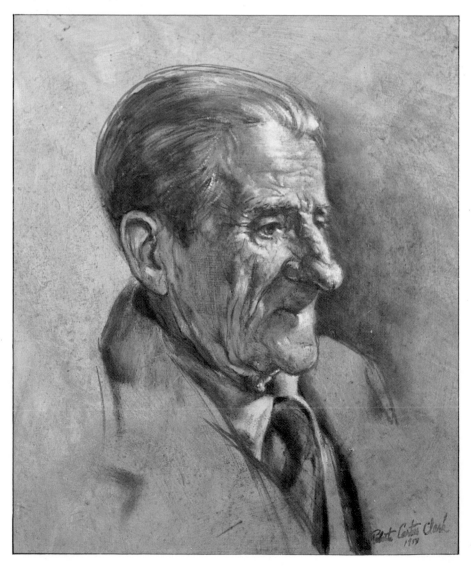

*Highlands Fisherman*
Oil on panel: 20″x16″
Collection of the artist

# Working Wet-into-Wet

Alla prima painting is direct painting, working wet-into-wet to arrive at the finished portrait in one sitting. One good point about working wet in wet is that the whole painting will have a freshness about it, because it is done all at one sitting, on one day. A possible disadvantage of this technique is that not all of us are good at sloshing around in all that wet paint, and if we are not *extremely* careful, we get darks in the lights and cools in the warms, and everything in the painting ends up a sort of a mid-tone gray—very dirty looking. Only with experience do we learn we can scrape off ugly dead colors with a palette knife when they appear, and go in again with fresh, clean color. In this technique, we use three steps. First, an imprimatura of raw sienna thinned with turpentine is rubbed over the entire primed canvas.

Next, the sketchy drawing of the head, which serves as your road map for laying in the full colors and values, is put in with the brush and the same paint color as the imprimatura. Then the transparent colors for the shadows and the opaque colors for the lights, mixed to approximate the colors and values found in the model, are laid in side by side like pieces of a mosaic, followed by the halftones, saving the highlights and dark accents for the end. The minute details and blending of tones are kept to a minimum, since we are striving for a fresh, vigorous portrait that doesn't look labored.

Choose a model with a fair to medium complexion and have him or her wear a white shirt or blouse. The white clothing will aid your value perception and help you to see that even the lightest skin is a long way from white. The white collar will lend a crispness to the portrait.

**Materials** Surface: An 18″ × 24″ stretched and gessoed canvas or primed canvas board.

Oil paints: Titanium white, raw sienna, light red (not cadmium red light; this is a red earth), and cobalt blue.

Brushes: Filbert-shaped bristle brushes, nos. 2, 4, 6, 8, and 10; also a half-inch flat synthetic fiber brush, and one small, round, no. 3 sabeline brush.

Other supplies: Gum turpentine or odorless paint thinner in a brush washer; easel; disposable paper palette, 12″ × 16″; paper towels; palette knife; hand mirror (at least four inches in diameter); kitchen timer (for timing posing and rest periods for the model); and painting table or taboret (covered with old newspapers for easy clean-up).

For clean-up: A brown paper grocery bag for dirty paper towels and the used sheet of the paper palette (everything you're working with is *highly flammable,* so discard the bag cautiously).

## Toning the Canvas, the Imprimatura

Squeeze out about 1½ inches of raw sienna at the top of your palette (no other colors for now). Add turpentine to some of it to mix a thin solution and scrub it over the canvas with your largest brush or a crumpled paper towel. (Do not add white paint.) This imprimatura should be quite strong in color, but with no clumps of paint, just clear and transparent. Don't bother to smooth it out; the more painterly it looks, the better. Notice that this heavy ugly color becomes a glowing gold when made transparent. This thin wash will dry quickly, for the turpentine evaporates rapidly.

## Setting Up for the Portrait

1. Set the timer now for 25 minutes, and have the model begin the pose. Pose your model in a good light, seated on a high stool or in a chair on the model stand as you did in the charcoal portraits. The head should be approximately at your eye level. Your canvas is on the easel at the same level as the sitter's head, the easel right next to the sitter. If you are right handed you will want the easel and canvas to the right of your sitter; if left handed, place the canvas at the left of the sitter. Select

your looking spot and make the masking tape mark on the floor, eight paces from the easel, next to the painting table. Be sure the palette is not on your shadow side; it must be in a good light or you will not be able to judge your color mixtures.

Let the model face into the light, assuming a pose that will allow you to paint a three-quarter view of the head.

2. Step back. Squint. Visualize the head transposed on the canvas. With your no. 6 brush, dip into the raw sienna—not thinned so much this time, just enough so you can draw with it and it will not run. Try to keep the paint at the tip of the bristles—the paint won't do anything for you if it is pushed up into the ferrule. Also, it will be much harder to clean out later.

Draw your egg shape, not too high or too low on the canvas. Very often the base of the nose is about halfway down the canvas. If the model is looking to the right, be sure there is extra air space on that side for him or her to look into. Where you place the head on the canvas is of great importance; take your time.

Remember the male adult head is approximately 9 inches high; the female, 8¼ inches. Hold the brush at the end of the handle and draw with your whole arm. (This is the reason the handles on oil painting brushes are so long—to allow more space between you and your canvas. You just cannot paint an oil painting with your nose three inches from the canvas!)

**Blocking in the Head in Paint** Step back. Now hold the brush horizontally and align it with the line of the eyes of the model. Draw this line halfway down the oval or where you see it. Next, draw the center-of-the-face line. This is your framework for the head.

## Portrait Demonstration

**(Step 1)** The imprimatura, the toning of the canvas with thinned raw sienna oil paint, was applied with a crunched-up paper towel. Then, with this same color, thinned only with turpentine or odorless paint thinner, the head was drawn with no. 4 and no. 6 brushes. This is the first stage of Linn's portrait, the head in monochrome.

Use this method for starting any portrait in any medium: (1) geometric shape of the head; (2) eye line; and (3) vertical center-of-the-face line.

Looking over your shoulder, check the canvas and the model together in the mirror. Does the angle feel right? Add the brow line just above the eye line. Using the brush handle as an indicator again, sight and draw the angle of the nose. Make a mark for the base of the nose and another for the mouth. At this point it is easiest to draw the head with straight lines. Add the cylinder of the neck and the general contour of the hair shape. Now you have a diagram of the head, a foundation for a more studied drawing.

If you aren't happy with your start, wipe it off with a dry paper towel (no turpentine) and begin again. Now is the very best time to make sweeping changes; it takes only seconds to wipe it all off and begin anew. (Once the canvas is covered with heavy paint in several colors, this is quite another matter!) Your second or third attempts will be infinitely better—you'll feel freer and the model will have settled into the pose.

Squint and select the most obvious feature. Is it a dark hair shape? A long nose? Chubby cheeks? Whatever you think it is, put it in with firm strokes—emphasize it. You're still working only with raw sienna. Stop and take a five-minute break for the model.

**Looking for Darks** Start to look for shadow shapes. Is there shadow on the side of the face away from the light and under the chin? Alongside the nose? Under it? Look for the side plane and the underplane of the nose and the cast shadow from it. Think that you are changing this flat drawing into a solid three-dimensional form by laying in the shadows.

*Hint:* The colors used here aren't the only colors that can be used for an imprimatura. In future portraits, try cobalt blue, burnt sienna, or terre verte; each gives a different effect.

Put in the eye shapes next (dark ovals now, no whites indicated yet). Then the corners of the mouth and the shadow under the lower lip. Is the upper lip in shadow? If the light is from above, it often is.

Look for shadow in the hair. If the hair is dark, you may want to lay in the entire hair mass as the shadow value.

Give your figure a collar, making it go around and behind the neck.

## Check Alignment and Proportions

Hold your brush at arm's length, perfectly perpendicular, elbow locked, to line up the features vertically. Does the corner of the mouth line up under the center of the eye? Does the wing of the nose line up with the tear duct of the eye? If not, just where does it fall? Do the shoulders slant? Which way? Can you align the ear with any other part?

You can use the brush handle to check proportions too. Close one eye, and looking at the model, line up the tip of the brush handle with the eye line. Move your thumb up to a point on the handle where you sight the chin line. Now, using this as a measurement, check to see if the distance from the eye line to the top of the head is the same. If not, how is it different? These relative measurements help solve problems of proportion.

Always try vertical aligning, horizontal aligning, and relative measuring if something appears wrong, or just to check your work. It's easy to get a portrait head out of alignment—especially a three-quarter head. Give the model a five-minute rest now.

## Looking for Lights

Up until now, we have been looking just for darks. Now start looking for light areas on the head and face. Wipe out the light areas with a dry paper towel wrapped around your finger. If you can't get them clean enough, use a brush dampened with turpentine. Try not to confuse the lights with the darks. The head is either light where the light is striking it or dark where it's not. Don't allow lights to sneak into your darks, or darks into your lights. Keep it simple for now; there's plenty of time for subtlety later.

## *Portrait Demonstration*

(Step 2) The raw sienna imprimatura is still visible as the background color in the lower third of the face and in the neck and teeth. An opaque flesh tone of titanium white, raw sienna, and venetian red has been laid in on the forehead band, the same hue slightly darker and more rosy in the cheek-nose-ear band.

Although Linn's hair is an outstanding feature of her appearance, I decided to put one section of it behind her shoulder to avoid two long, very similar dark shapes that would dominate the entire portrait.

**Suggesting Background** Think about your background. Even when using just raw sienna, you can darken the background next to the light edge of the face or collar to throw the head into relief. Check your painted head in the mirror; even in monochrome it should have some resemblance to your model now.

Stop for five minutes and let the model rest. Use the time to set out your colors: titanium white, light red, and cobalt blue.

**Shadows in Color** Reset the timer for 25 minutes and have the model resume the pose. For the shadow areas, mix raw sienna and light red without white. I know this is warmer than you think it should be, but if the shadow color is too cool, the head will lack life; if it's too hot, it's simple to cool later. Paint all the shadow areas the same color and value: dark ovals for the eyes, along the side of the face and hair (observe carefully the contour where the shadow meets the light), under the nose, the upper lip, under the lower lip, under the chin, the shadow cast upon the neck. Apply it thinly, allowing the raw sienna imprimatura to show through.

**Painting the Lights** With a full brush, lay in the lightest brightest white in the painting on the collar where the light strikes it. This will be a guide for your flesh tones; the complexion can *never* be as light as this white.

Step back and study the model, this time for color. With your knife, mix a small quantity of the color you see on the forehead—perhaps titanium white and raw sienna. With the tip of the knife, paint an area about an inch in diameter on the canvas in its proper place and check the color. (You cannot really judge the hue until you see it on the canvas and next to the model. It looks quite different there from the way it looks on the palette.) This will be our lightest light on the head.

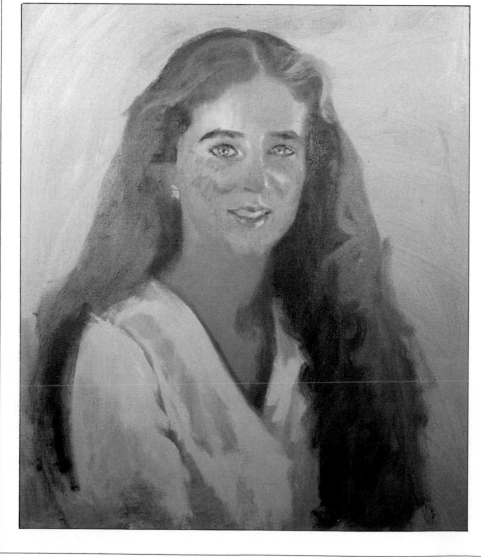

*Portrait Demonstration*

(Step 3) Though we started painting this portrait in the morning with the light coming from the left, the light has shifted to afternoon light, stronger and lower, coming from the right. We took a break after some morning work and then resumed painting in the afternoon. This is a good way to get into trouble on a portrait, changing light directions. The effect of light coming from two sources is visible here. The features are beginning to be defined. The left shoulder has been trimmed down; it is easy to paint it the wrong size when only one shoulder is seen. Cool flesh tones of titanium white, yellow ochre, venetian red, and a touch of cobalt blue are added to the receding side planes of the face, jaw, and neck. We decided a gold earring would be an asset. I wanted it because I want to break up the hair mass.

**Placing the Flesh Tones** Work in the light areas; try to place the right color and value in the right place as if the head were a jigsaw puzzle of painted tones. Remember the rule: three values in the light and one in the shadow. If your model has a fair complexion, try for value 2 light at the forehead band, value 3 mid-light at the nose-cheek-ear band, and value 4 midtone at the chin and jaw band. The shadow would be value 5½.

Look for muted golds in the forehead, warmer rosy nose, cheeks and ear, cooler colors at the jaw areas. Between colors wipe the brush or rinse it and squeeze out all the turpentine — you want nothing but paint on the brush! Don't try to blend the colors on the canvas now; just place each one next to the other as you see variations within the flesh tone occur. Don't forget, nostrils, mouth, ears — all openings in the head are warm! Take a five-minute break for the model.

**The Background** When the model resumes the pose, decide on your background color. Mix it up and paint it in boldly with a large brush, covering the outer edges of the hair silhouette. The background should be a midtone: darker than your light areas, lighter than your dark areas, and the color should enhance your subject's coloring and clothing. Define the shape of the

> *Hint:* The basic rule of oil painting is *opaque lights* and *transparent shadows.* Don't thin the paint with turpentine, just lay it on less heavily and scrub it out more.

## Portrait Demonstration

(Step 4) The next morning, our next sitting, I added the broken color suggesting sunlight in the background, laying it in mostly with the palette knife. The colors are titanium white, lemon yellow, cobalt blue and ultramarine blue. I attempted to achieve a balance of cool and warm colors throughout the portrait. I felt the need to further break up the hair mass. Every part of the portrait has been advanced: features, hair, neck, background, and clothing. The light is back again on the left (after a good deal of effort) and I vowed to keep it that way, with just a back light on the right to brighten the hair and add air and light. Even though the mouth is quite defined, it is still soft.

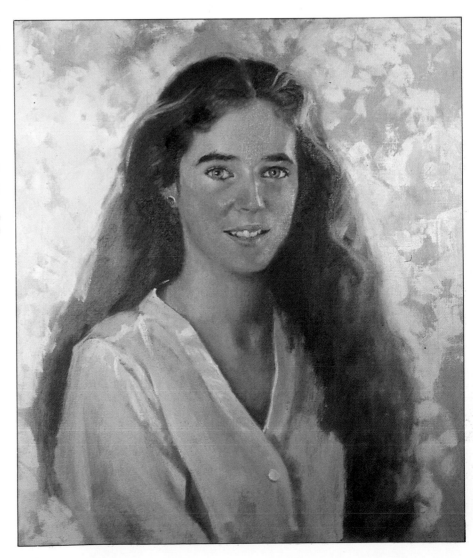

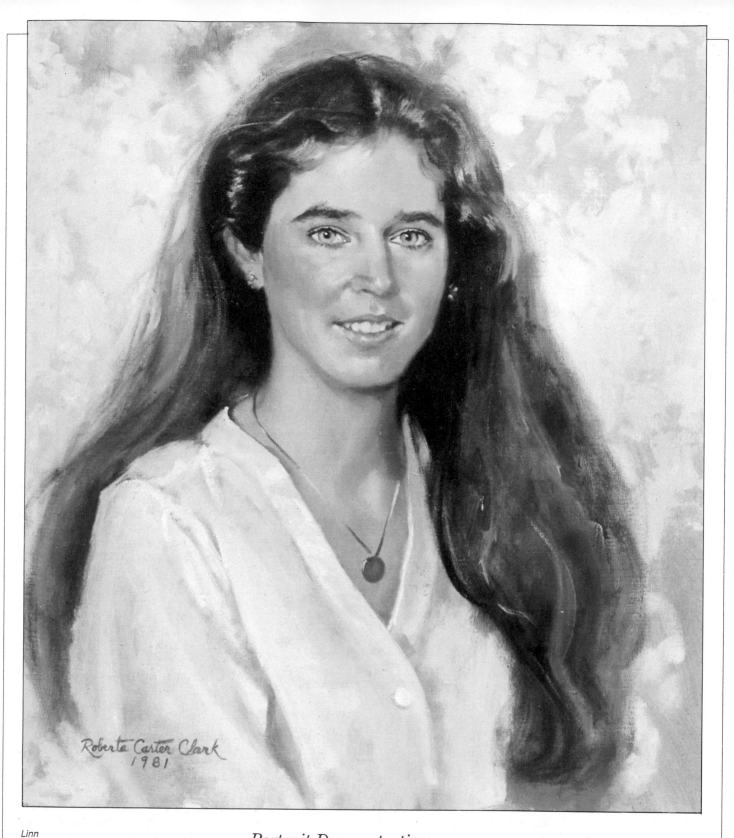

*Linn*
Oil on canvas: 24″ × 20″
Courtesy of Mrs. Peggy Florer

## Portrait Demonstration

(The finish) This is the third sitting. To make a better painting I have calmed down the razzle dazzle of the background. I've played down the action in the hair everywhere except where it surrounds the face. I have added strong darks in the hair for more contrast with the fair skin and added more lights, which "open up" the face. More delicate earrings are chosen and we add the simple gold chain and medallion. The expression in the eyes is retained while the eyes are made lighter in color. The brows and teeth are perfected. Linn's fair complexion is glowing now. The true Linn is portrayed to the best of my ability.

This portrait was done from life. No photography was used.

face by painting the background up to the boundary of the cheek, the jaw, the neck, wherever the background and flesh coincide. Also paint the background out to all four sides of the canvas.

**The Hair** We have covered the edges of the hair so we can paint the hair *over* the background, which will help give the illusion that the head is in front of the background. Now study the model and mix two or three values for the hair: a light and a dark, or a light, midtone, and dark, depending on the color of the hair and what you perceive. Paint the hair by treating it as a mass first, working from midtone both up to the lights and down to the darks. Remember the hair is a completely different texture from that of the skin. You can emphasize this in two ways: by making the hair edges soft, blending them into the background (wet paint) in some places, and by indicating with a smaller brush the direction of the hair, whether straight or curly, and the shine on it. This you would do in a more linear fashion, within the mass. But don't overdo it—we don't attempt to show each hair on the head any more than the landscape painter shows every leaf on a tree.

**Painting the Features** With the lights, shadows, halftones, hair, and background in, it's a simple matter to slide the features into their proper places.

Using the light tone of the hair, lay in the eyebrow, perhaps breaking the stroke where the light strikes the bone. Using your no. 2 bristle brush, lay in the line of the upper lid with a midtone color, a warm brown, and pull the color down to define the iris of the eye. Put in the gray of the whites of the eyes. Touch the iris with the specific eye color of the model. If you aren't sure what it is, step up and study the color at close range. Usually it takes only a bit of blue in your midtone color to make the eyes read as blue from a distance. Light eyes are difficult. If you paint them very light they appear to be sightless. You may have to paint a darker line around the iris. Soften the eyelid line to become the shadow it

casts upon the eyeball. Put in the dark pupil. Paint the shadow under the lower eyelid, under the brow or wherever you see it defining the eye socket. Especially important is the shadow between the tear duct (pink) and the nose bridge. This shadow is often bluish.

Changing to a lighter, warmer color, define the nose. There's quite a light color on the side plane of the nose on the light side; it's slightly darker on the shadow side. Define the ball of the nose and the flare of the wings over the nostrils. The underplane, including the nostrils, is painted slightly darker than the shadow, but warmer. Blend this with the shadow the nose casts upon the cheek or above the mouth. Remember, don't put anything in you can't *see*.

Travel down to the indentation between the nose and the center of the upper lip with the midtone color (not so warm), then go on to the extremely subtle modeling around the mouth, the "muzzle" area. The corners of the mouth are warm darks. The lip color is white with light red; the lower lip is considerably lighter than the upper lip in shadow. The line between the lips is broken and *warm*. Then put in the cool olive green shadow beneath the lower lip.

Define the chin with more orange and less rosy hues. Paint the cool side planes of the face going back to the ears or into the hair. Then the warm cheekbones and warm ears. A man, especially a dark-haired man, will always have some cool shadow (perhaps blue-gray) where his beard grows.

**Refining Lights and Highlights** Now go back in with lights. Add light on the brow bone, then the upper eyelid as it rounds itself over the eyeball. Place light on the top edge of the lower lid, the bridge of the nose, and the cheekbone. Place that important shine, the highlight, on the ball of the nose. On a child's portrait, this highlight always makes it seem as if the child has just had his face scrubbed shiny clean! Is there a light on the boundary of the upper lip? Shine on the lower lip, the chin, the hair? And the most fun of all, paint the tiny highlight in the eyes.

That can be white; use your small round no. 3 for this.

None of the other highlights are white; all are tints of flesh tone. Sometimes they have a bit of yellow in them, sometimes a bit of blue.

**Refining and Adding Accents** Now go back and "hit" the brow, or eyes, or nose, mouth, hair, or ears where you think some part should be darker or more pronounced. Remember, sharp edges advance, soft edges recede. Make those defining strokes on the ball of the nose crisp!

Check everything in the mirror. Is there a reflected light under the chin or the nose? It can be cool and bluish on the chin or jaw, but keep it *warm* on the nose! Also add highlights and accents to the clothing.

**Finishing Up** How do the flesh tones look? Are they too cool? If so, carefully add a bit more light red with a clean dry no. 6 brush, particularly on the boundary between the light flesh and the shadow at the cheek. Add it pure to the wet paint already on the canvas. If the tones are too warm, add a little cobalt blue using a very light touch—not enough to make the flesh look blue, just a hint to cool it. At this time just work back and forth between the lights, midtones and darks, warms and cools, until the portrait suits you. But be forewarned: This is an easy time to "lose the likeness"! You are working so intently on the parts you may lose a sense of the whole. Of course, you can get it back, but it takes some effort.

This is the most generalized kind of instruction and is meant to be only a guideline. Every portrait is different, every *light* is different. I can tell you how to paint eyes, noses, mouths, and ears, but I cannot tell you the sequence in which to paint them. You just have to learn to *observe*. And you will develop your own procedure, as you work on many more portraits.

Now put the portrait aside and don't look at it until tomorrow. You can make any corrections you feel necessary then. You should have completed this portrait in 2½ to 3 hours, though it may take a bit longer if you're new at it.

# Step-by-Step: Painting the Features in Oil

All the steps for the eyes, nose, and mouth are painted over a raw sienna imprimatura on primed linen canvas. Bristle brushes, no. 2 and no. 4, filbert shaped, were used, along with a small pointed sabeline brush, no. 3. I used titanium white, raw sienna, Venetian red and cobalt blue—combination *B* on the Flesh Color Family Chart on page 119. Because I could not get the warmth I wanted from these colors, I added cadmium orange and cadmium red light to the palette, along with some Liquin to make the paints flow more easily.

1. I blocked in the eye oval, eyebrow, and a hint of shadow under the eye and alongside the nose with raw sienna.

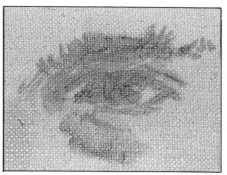

2. I drew the brow and eye more carefully with raw sienna and Liquin and lifted out some of the lights with a small brush and turpentine. Because the imprimatura was put on the canvas the day before, it was thoroughly dry, so when I lifted color, I got down to that, not to the white canvas.

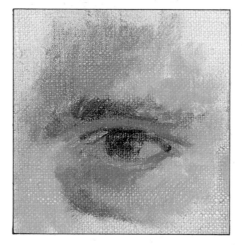

3. White, raw sienna, and Venetian red add color for flesh on the forehead and around the eye. Cobalt blue was added to cool the shadow areas. All three pigments mixed together plus white made a gray for the "white" of the eye. The colors mixed without white made a dark for the eyebrow, iris, and more eye and lid definition. I added just a touch of orange and cadmium red to make the eye opening warmer.

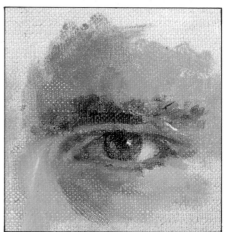

4. The finished eye. The eyebrow was treated in a broken, rough-brushed way with light and dark accents to create the texture of short, crisp hairs. There is a value change as the brow curves over the brow bone. The lines around the eye are soft, not brittle. The darkest—the pupil and the upper third of the iris—lies next to the lightest light, the pure white highlight. The contrast between the white of the eye on the light side and the green-brown of the iris gives the image snap and draws your attention. Again, a tiny bit of orange and red were added to warm up the eye and give it more life.

1. The block-in for the nose was painted with raw sienna. The keystone area is dark as the brows nearly meet there in the shadow.

2. More crisp definition is indicated at the nose bridge, and lines were softened.

3. A warm flesh mix of white, raw sienna, and Venetian red was painted in with the no. 2 bristle brush. Blue was added in the shadow near the inner corner of the eye, and pure Venetian red was brushed in on the top plane of the nose. Some orange was added to the flesh areas to make the color clearer.

4. (The finish) The construction of the nose was emphasized. The contrast of high-lights and darker shadows was added to make the nose appear to project from the face. Orange-red was painted in the nostrils, in the reflected light around the left nostril and under the nose in the shadows.

1. Using raw sienna, I blocked in the forms—the indentation from the nose down to the lips, the upper lip in shadow, and the shadow areas around the mouth and under the lower lip, leaving the lower lip light.

2. The edges were softened and the shapes were refined. Some darker accents were placed at the corners of the mouth and at one spot between the lips. Please note that I did not draw a line between the lips.

3. Flesh colors were painted around the mouth and into the lip areas, then Venetian red was painted over the lips. I felt I needed more of a chin. In some places the pale gold of the imprimatura glows through and makes the skin look luminous.

4. (The finish) Orange was added at the cheek and on the lips and chin for warmth. Warm shadows were placed under the nose and around the lips on the shadow side. Cobalt blue was added to cool the moustache area and the shadows on the chin. Venetian red warmed the lip area in the light; it was laid on in short broken strokes, as was the nearly white highlight there. The lightest of flesh tones was used for highlights above the lips and under the right corner of the mouth. The broken line between the lips was a warm dark. It was put in as the last stroke, very delicately.

# Glazing Technique

In this oil technique we are taking a different approach—building our portrait in stages. A careful monochrome drawing that is allowed to dry is accomplished in the first sitting. We get into color on the second sitting, and we have plenty of time to correct the parts we don't like and to reinforce the areas we do like. We can refine the details of the eyes, the nose, the mouth, and the expression. We can get nuances of color by laying one hue over another or by breaking our strokes so the undercolor peeks through.

The best point about the glazing technique is that with it we have more *control*. If we don't like the way the paint is going on during the second sitting we can always lift it off, and the underpainting will still be there. A bad point of this more studied technique is that the portrait can become dead and lifeless with too much overpainting unless we think very carefully about what color we are laying over what. Corrections can be made, of course, but a light touch will work best on the second day of painting.

Again, we start with the imprimatura, the paint thinned to a watery consistency. Next, the head is drawn with the brush using the same color paint as the imprimatura, but, in this technique, we dilute the paint for drawing with a little retouch varnish and turpentine. (*Note:* Retouch varnish is not used in the actual painting of the portrait, only in the initial drawing.) Because retouch varnish is quite fluid and dries quickly, it allows you to make a more finished and detailed drawing. This drawing dries hard and will not lift even if you wipe off the subsequent painting laid over it. Shadows on the face, neck, and shoulders are put in as indicated. Lights are defined, then heightened with white. The portrait is fully developed in monochrome. *Highlands Fisherman* on page 128 is considered a finished portrait at this stage.

The head is painted in color at the second sitting. You have a large family of colors from which to choose in this method. Colors are laid in in the lights with a good bit of paint on the brush in crisp strokes, side by side and one over the other, with a minimum of blending. We stress opaque mixtures for the light areas on the head, neck, and shoulders. We stay away from the shadow areas as long as possible, allowing the original shadow color, raw umber, to remain visible. When the lights, halftones, and dark accents are in and the background is covered, we scumble a thin application of color over the shadows where necessary.

For this portrait, find a model with different coloring from the previous sitter.

**Materials** A panel of untempered Masonite, 20″ × 16″, the smooth side primed with at least two coats of acrylic gesso (or a stretched canvas, if you prefer).

Oil paints: Study your model and choose one Flesh Color Family from the charts on page 119—raw sienna, light red, and cobalt blue; raw sienna, Venetian red, and cobalt blue; yellow ochre, burnt sienna, ultramarine blue; Naples yellow, light red, and viridian; raw sienna, alizarin crimson, and cobalt blue; or burnt sienna, alizarin crimson, and viridian.

If you prefer, you can use the full palette, 12 colors, listed here: lemon yellow, cadmium yellow-orange, yellow ochre, raw sienna, cadmium red light, Venetian red, alizarin crimson, burnt sienna, cobalt blue, ultramarine blue, viridian, and burnt umber. And titanium white, of course.

Brushes: Filbert-shaped bristle brushes, nos. 2, 4, 6, 8, and 10; a small round sabeline or synthetic fiber brush, pointed, no. 3; and a half-inch flat synthetic brush.

Other supplies: retouch varnish; Liquin (Winsor & Newton); turpentine (*gum* turpentine) or Odorless Paint Thinner by Grumbacher—Turpenoid (Weber) and Permtine (Liquitex) are also paint thinners; and brush washer; easel; paper towels; paper palette,

12″ × 16″; palette knife; hand mirror; timer; and painting table or taboret.

For clean up: A brown paper bag for waste.

**Getting Started: The Pose, Imprimatura, and Block-in** Seat your model next to the easel. Let's choose a semi-profile pose this time, facing the light, with head turned toward you just enough to see a bit of the eyelashes and eyebrow on the far side of the face, similar to "Anne" on page 96.

Squeeze out about 1½ inches of raw umber on the palette and with a large brush or a crumpled paper towel scrub a thin solution of raw umber and turpentine over the entire panel (the imprimatura). It should be about value 3, mid-light.

Set the timer for twenty-five minutes and have the model assume the pose. Place the head on the canvas and block it in with a no. 4 brush and thinned raw umber. Check the block-in in the mirror and refine it. Let the model rest for 5 minutes.

**Drawing the Head** Pour a small amount, say a teaspoonful, of retouch varnish onto the palette at the lower left. With the no. 4 brush, mix it with some raw umber—no turpentine—and begin the actual drawing of the head and the refining of the features. You can get a far more detailed drawing with retouch varnish as the medium, and the image will remain when you work the overpainting colors on top of it.

Squint as you study the model for shadow shapes. Lay the shadows in, keeping them transparent. Align the head and its features, lifting out any part you don't like with the brush or paper towel just slightly dampened with turpentine. Allow it to dry, then repaint it.

Stop and let it dry, possibly overnight. This is the end of the first sitting. Restrain yourself from working on the face of the portrait when the model is not posing.

**Finishing the Head in Color: Second Sitting**

**Preparing for Color** Set up the palette, squeezing out about two inches of white, then about an inch of each of the colors left to right across the top and down the right: lemon yellow, yellow ochre, cadmium red light, alizarin crimson, Venetian red, raw sienna, burnt sienna, cobalt blue, ultramarine blue, viridian, and burnt umber.

By now the underpainting should be dry. Pour out about a teaspoon of Liquin and, with your no. 8 brush, brush the medium over the portrait. Then wipe the panel with a clean, dry paper towel, leaving just enough to make a sympathetic surface for this day's application of paint. This sheer glaze of

medium will allow the new paint to blend more easily into the old, and bring the dry paint up to its original intensity since all oil paint looks duller when it dries.

**Painting the Lights** Set the timer. Resuming the pose, we now begin with the light areas. (The dark areas—the shadows—are already there in raw umber.) Mix three values for the lights you see on the model. For example: white with raw sienna and just a touch of Venetian red; white with less raw sienna and a bit more Venetian red; white plus Venetian red with a touch of cobalt blue (cooler); or white plus raw sienna with a touch of cobalt blue (cooler). Lay the mixtures where you see them with a no. 6 bristle brush.

**Painting the Halftones** Now go to the halftones, laying them on the areas where the light planes turn obliquely away from the direct light. These are cooler hues on the forehead and chin bands, warmer hues on the cheek-nose band. Scumble these transition tones on with opaque or semiopaque paint. To scumble, hold the bristle brush so that you are painting with its flat side, and drag the paint lightly across the surface creating a broken color effect (in this case, allowing the raw umber shadow color to peek through).

**Hair and Background** Paint the hair, keeping the darks transparent and adding opaques only in the lights and halftones on dark hair, using more opaque mixtures in light hair. Mix a dark, a

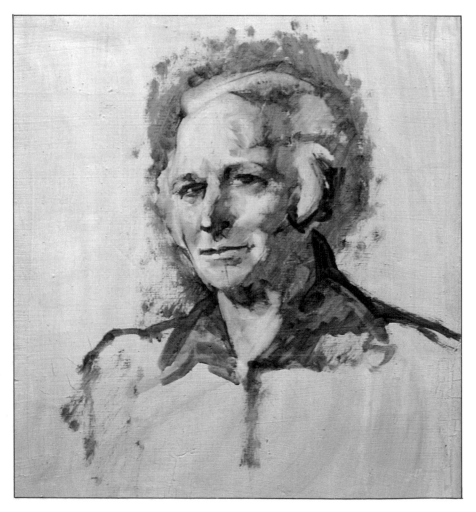

*Portrait Demonstration*

(Step 1) The smooth side of the quarter-inch Masonite panel has received 2 coats of acrylic gesso applied with a 3-inch housepainting brush, one coat north to south, one coat east to west, and allowed to dry. With a crumpled paper towel, a thinned raw umber imprimatura has been applied.

The head was drawn with no. 4 and no. 6 bristle brushes, a no. 3 round synthetic brush, and raw umber thinned with retouch varnish; it has been applied thinly in the shadows to maintain their transparency.

light, and a midtone color for the hair, saving the highlights for the last. Keep the edges soft around the face. There is often a slightly blue halftone where the hair begins to grow at the forehead. Treat this area with subtlety. If there are earrings, paint them now, gleaming out of the hair shadows.

Before you finish the hair shape, work on the background near the head so the hair edges can be painted over the background wet-in-wet, blending the hair color into it in two or three places. Paint the entire background, trying to keep the color to two values.

Study the general look of the painting from a distance. Take five!

**Defining the Features** Set the timer. After the break, work on the features,

referring to the model constantly for information. If you need to see the drawing underneath, you can rub away the overlying color with a dry paper towel. If the overpainting is fairly heavy and you want to make a correction, just scrape the paint off with the palette knife.

Force yourself to use opaques only in the lights; keep the shadows transparent. Remember that all the openings in the head are *warm* — nostrils, eyes (tear ducts), mouth, ears — and don't make the whites of the eyes really white; study them carefully, squinting hard, and gray them.

Add the dark accents where you see them: the pupils in the eyes, under the collar, wherever no light can get. Are you ready for a highlight or two? Add

them, then stop and rest five minutes.

**Further Refinement** Set the timer and resume the pose. Study the portrait and compare it to the model, both directly and in the mirror. Is the painting too light? Too dark? Too red? Too dead? Begin correcting passages you feel are not right.

Now the process is one of going back again and again, refining each feature and the way it relates to the others and to the entire head. If you can't figure out what's wrong, take the portrait off the easel and prop it up against the stool or model stand at the model's feet. Study the model and portrait from your looking spot. Then return the painting to the easel and correct it.

Move down the face from the fore-

## Portrait Demonstration

(Step 2) I have started to lay in the flesh tones mixed from combinations of titanium white, raw sienna, Venetian red, burnt sienna, and cobalt blue. I like parts of the portrait such as the light on the lower lid of the right eye, the form of the nose becoming evident, the cool variations in the lower third of the face. The ugly gray background has got to go; I know I was just rushing and put in any color in the right value so I could play the light hair against it. And the color on the neck is just *raw*.

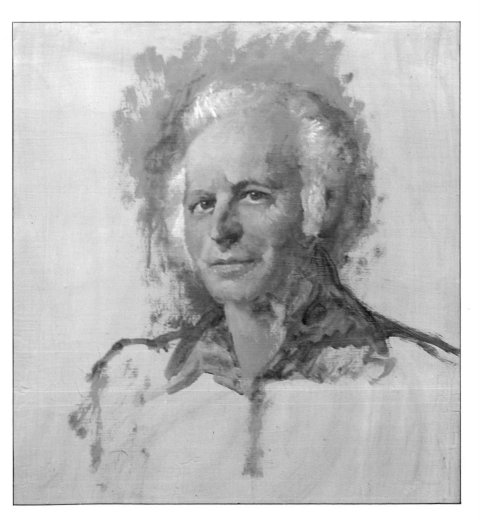

head to the warmer cheek and nose area, then the cooler chin and neck. This is an extremely difficult part of the head to paint, since the relationships there are so subtle. Try to analyze what each form is doing and give it your best painting effort.

Work out the light and shadow patterns on the clothing, if you haven't already done so. The clothing is *easy* compared to the head, so I often turn to the collar or the folds of cloth whenever I get tired of working on some part of the head. The shift of emphasis is beneficial.

**Shadows and Reflected Light** By now you may feel the raw umber shadow area is out of key with the lights and halftones. You can mix a shadow color from the chart on page 118—Darks for Flesh Tones and Shadows. The shadows should be applied thinly in contrast to the more heavily painted lights. Scumble the color on in the shadows, allowing the ground to show through. This gives us the transparent glow. Don't paint color indiscriminately all over the raw umber shadow, but only where you feel it's needed to give the portrait head more solidity.

You may see a reflected light at chin and cheek and jawline on the shadow side. Cobalt blue with a small amount of white and raw sienna makes a good reflected light color. Just remember the reflected light can never be as light as the halftones. It belongs to the *shadow*. The shadow under the lower lip can use a touch of a *subtle* green.

**Finishing Up** Study the portrait again from a distance and in the mirror; restate your highlights and accents. Let's call it finished. Allow it to dry; this should take at least two to three days. This portrait should have taken approximately four hours divided into two sittings: two hours for the monochrome underpainting, and two hours for the color overpainting. You will find your own best painting schedule, but don't work too many hours at one time on one painting or you'll tend to lose your ability to see it objectively.

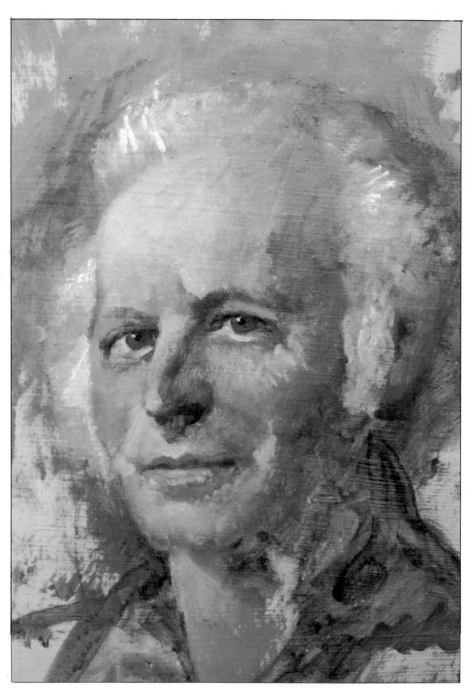

## Portrait Demonstration

(Detail) This detail of Step 2 allows you to see the brushstrokes better, both in the gesso ground and in the superimposed oil mixtures. Much of the original raw umber is still visible: in the nose, under the nose, the shadow side of the face. At his left temple I have begun to better define the form with a cool semi-transparent scumble of broken color, allowing some raw umber to show through.

I have had to squint hard at Tony to determine that the hair near the face is lighter than the flesh colors. The roundness of the dome of the forehead is conveyed by the cooler half-tones carrying the form back to the hairline.

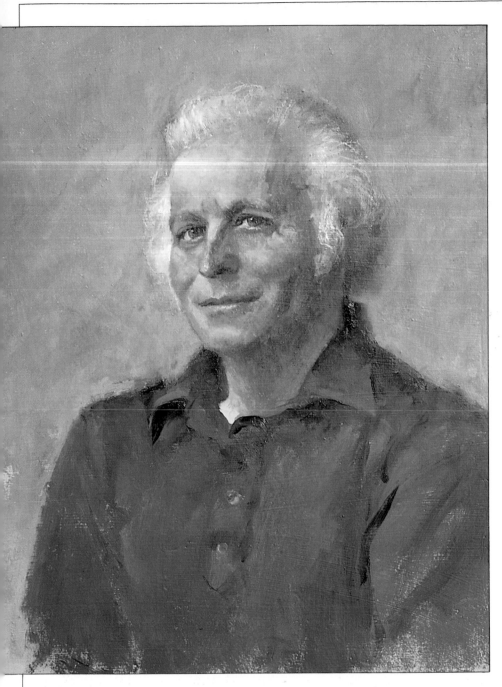

*Tony*
Oil on panel: 24" × 30"

## Portrait Demonstration

**(Finish)** This is the second sitting for Tony. Every part of the portrait has been refined. Tony's complexion is on the olive side, so it would not do to use warm, ruddy colors in the flesh. However, without warmth, a portrait lacks life, therefore, some warms are concentrated around the eyelids, the end of the nose, the wing at the nostril, and the lips. I had asked Tony to wear something with color and he appeared in this cool, low intensity red. A brilliant red would have made Tony's skin look green gray. I used white, alizarin crimson, burnt sienna, and cobalt blue in mixing the shirt color, and I repeated it everywhere in the head and in the background in varying values and intensities to give the portrait unity of color.

You can see the two dark marks where the left sleeve folds against the body of the shirt. These were dashed in, not incorporated into the forms beneath them, so they really pop out.

**Retouching** It's a little difficult to make changes later in this technique. On dry paint you have to reglaze with a small amount of clear medium and then paint into that. *Never* paint on dried oil paint without first applying and then rubbing off a medium like Liquin. Some painters use retouch varnish as an interim coat, but I find it makes the surface too slick to work on.

**Varnishing** In six months, you can varnish the painting. Dilute picture varnish half and half with gum turpentine so the painting won't be too glossy when it dries. Lay it on a flat surface and apply the thinned varnish with a new two-inch foam rubber brush, available from the hardware store. Work in a warm room, and calmly stroke on the thinned varnish from left to right without hurrying. Use a full brush, overlapping your strokes so that they touch and leave no dry streaks. If you shake the varnish up or stir it too much or stroke it on too fast you'll get bubbles. When this happens, leave the varnish for an hour or so until the bubbles disappear. Once you make the stroke, don't go back into it.

Keep moving slowly across the canvas or panel until it's covered. Leave the painting flat in a dust-free room overnight and you will see good results in the morning. Picture varnish is available in spray cans, but it has a tendency to drip and form dribbles on the painting unless you're very careful or experienced with spray painting. It is also harder to get an even coating over the whole surface. Of course, the reason it dribbles is that the painting must be upright to spray it, rather than flat.

This may sound like a lot of trouble, but it really isn't. It's better to know how to varnish your own oil paintings than entrust the job to someone else. All oil paintings should be varnished for two reasons: (1) to even out the dull and shiny patches that may occur but become visible only after the painting is totally dry; and (2) for protection from dust, dirt and cigarette smoke, fireplace soot, and any number of elements in the environment, as oil paintings are rarely framed under glass.

## Portrait Demonstration

(Detail) In this detail of the finished portrait, notice that as the right side of his face turns away, you will see hard edges and soft edges. There's a lost edge where the hair meets the background on his left side. A sharp edge at the end of the nose, plus a highlight, makes the nose project. The mouth has lost and found edges too. Some raw umber with retouch varnish shadows are still visible through only the minimum scumbling of semi-transparent paint.

This is not a very polished portrait, but it does express Tony's personality as a fellow artist and has a considerable amount of quiet verve to it. This portrait was painted from life. No photography was used.

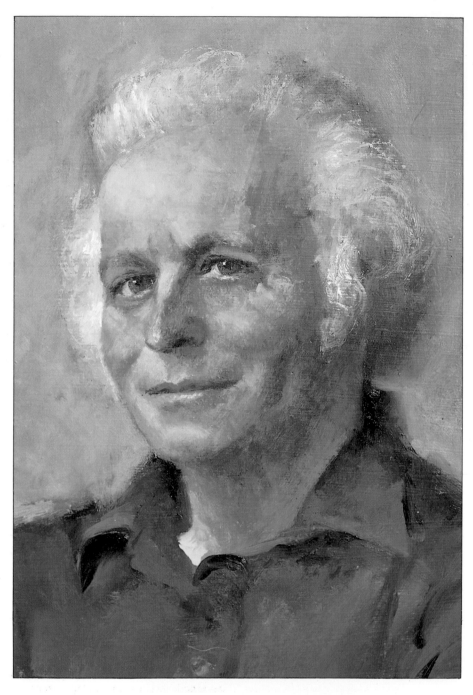

# Other Approaches to Oil Portraiture

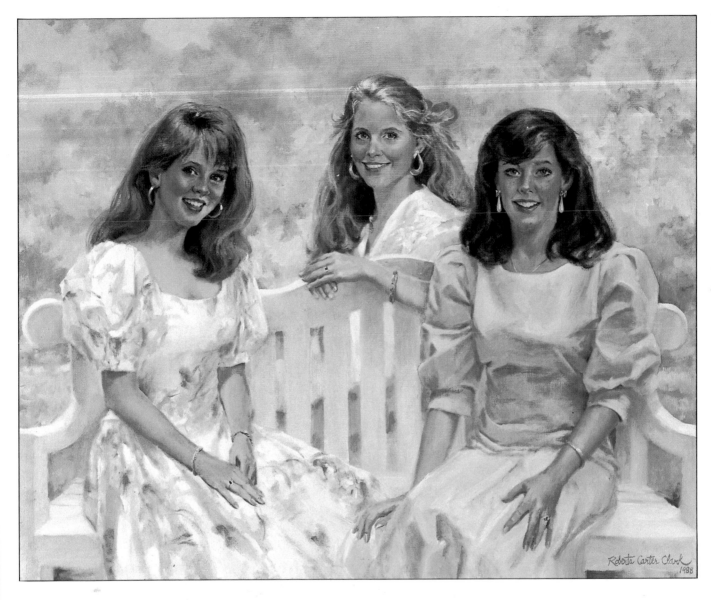

Roberta Carter Clark
*The Glenn Girls*
Oil on canvas: 40" x 52"
Courtesy of Mr. and Mrs. Robert Glenn

## Characterization through Composition

The most difficult part in starting this portrait was developing a composition that would allow each girl to be of equal importance and still have the painting read as one unit. Three individual sketches of each girl were painted from life and then many photographs were taken of the sisters alone and together, in various poses. I wanted a design that the girls and their parents would like and that I would enjoy painting.

I placed Ann, the eldest sister, in the center, and from the start I knew I wanted an outdoor setting, so this was a place to begin. The garden bench served to hold the group together; I wanted Ann behind the bench so there wouldn't be three figures all in a row.

Even with all the photos, each girl had to pose for several hours. I used the photos mostly for clothing, hands, and jewelry.

## Characterization through Distortion

Olga Dormandi was a Hungarian-born portrait painter who achieved considerable success by painting the children of wealthy families in the United States and in Europe. Dormandi drew beautifully, and this remarkable ability allowed her to distort her figures, elongating forms and interweaving all those arms and legs in such a wonderful way. Note how she tipped up the plane of the floor to give her more room to organize the figures. (With conventional perspective, they would overlap and obscure each other.) She weaves her figures together with line, which comes and goes throughout the composition, with a dark line accent where needed. If this line were the same density throughout, it would flatten the forms and destroy much of the painting's interest.

The color is quite arbitrary and often floats in and out of these linear forms. The work is thinly painted; in many places the canvas shows through. The landscape, with its hints of birch trees, seems to echo the sinuous arms and legs of the family.

No one is looking at us in this portrait—how do you feel about that? And note the bare feet, a most informal touch.

Olga Dormandi
*Family Portrait*
Oil on canvas: 69" × 48"
Private Collection
Photograph courtesy of Portraits, Inc.

## Characterization through Face and Hands

When this commission to paint the Monsignor came, I was really excited, thinking I would paint him in his red robes. However, during my first visit with him, he informed me he was going to wear his everyday clothes, and I had to accept his decision. After taking many photographs and thinking long and hard, I decided to play down everything in the portrait except his quiet, sensitive face and his hands.

First, I covered the canvas with raw umber thinned with turpentine to the consistency of water, and applied it while the canvas was upright on the easel, so this paint would run and drip and make interesting patterns and textures. Then, when this had dried, I drew the figure with raw umber, turpentine and some retouch varnish over the textured imprimatura, which remained as the background of the portrait.

The head and the hands were developed with a full palette of color, leaving the suit almost as a drawing, with ivory black used for definition and as a glaze over the brown of the raw umber. No white paint was used in the suit at all. There was no heavy build-up of black paint anywhere on the suit, but it read as a black suit anyway, partly because the shadows were inky dark with black and raw umber, and partly because everyone knows Catholic clergymen wear black suits. The white of the collar and the backlighting on the head and coat collar give the portrait a little more interest. I went back for two sittings from life to complete the head and hands, and it was finished.

Notice how his glasses, with their black and silver frames, cut right across the eyelids. Note, too, the emphasis on the hinge point where the earpiece is attached to the frame itself.

This portrait was painted in three sittings, one for photography and two for painting from life. I chose to start the portrait from photographs because of the Monsignor's busy schedule and because he was a little shy about having his portrait painted—and because I was a little shy about painting it.

Roberta Carter Clark
*Monsignor Monahan*
Oil on canvas: 36″ × 24″
Courtesy of St. James Catholic Church, Red Bank, New Jersey

147

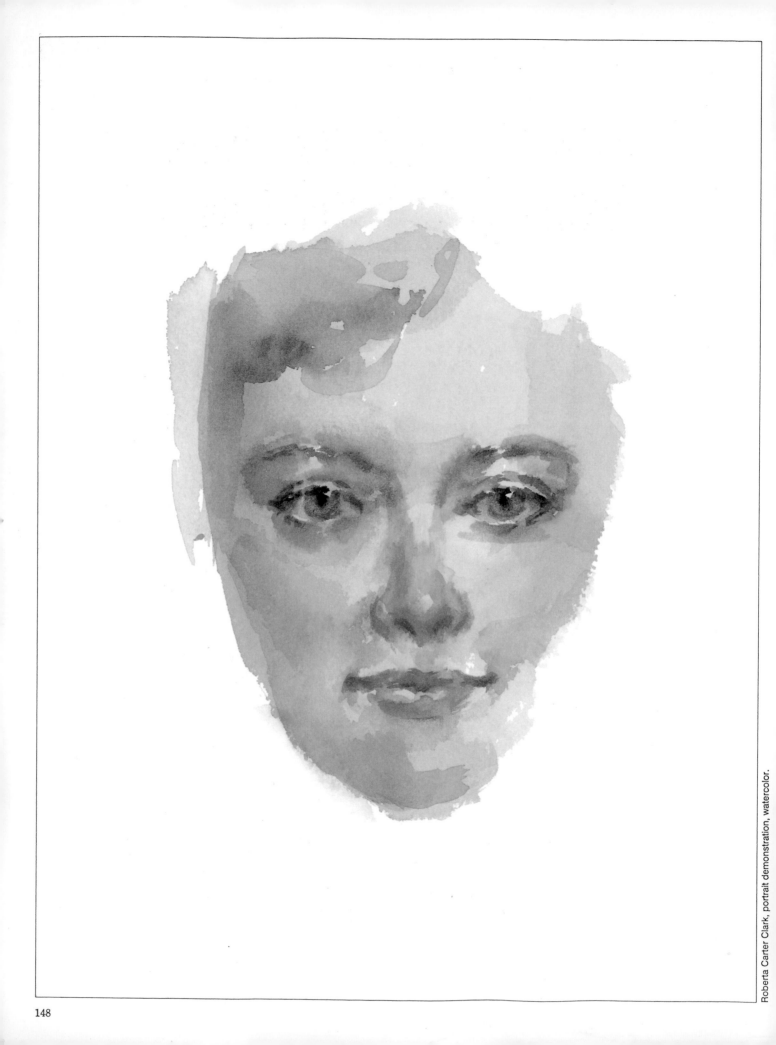

Roberta Carter Clark, portrait demonstration, watercolor.

# PAINTING WATERCOLOR PORTRAITS FROM LIFE

A portrait painted in watercolor can have a special clarity, a spontaneity and charm unique to this medium. Most portrait painters never even try watercolor for a portrait because of the great myth that says, "When you paint in watercolor it is down for good; you can't change it." To some degree this is true: you can't lift the entire head from the paper and you can't change a profile to a front view. But you *can* make numerous alterations on a watercolor portrait.

Here are two techniques, both of which allow for change as the work develops, so necessary for any portrait. You may even want to use watercolor for preliminary sketches for a portrait in oil. At any rate, try to develop some fluency in this medium. Watercolor is like tennis—you have to do a lot of it, and do it almost daily. It is by far the most exciting medium, for, by its very nature, it is very fluid! Some previous experience with watercolor will be of great help in preparing you for these portrait techniques.

# Lifting-out Technique

The first watercolor technique is done on Crescent illustration board no. 300, cold-press, medium-weight. The idea behind this technique is to get enough color on the board so that the lights and highlights can be lifted with a damp brush or sponge and thereby the head is modeled with a complete range of values. We use only transparent, non-staining pigments, with no white, and the lights are achieved by lifting more and more pigments off in smaller and smaller areas, allowing the white surface of the board to show through. Forms can be fully developed like this with considerable subtlety.

This is no runaway quick technique for watercolor but rather one that offers maximum control in every respect. Color can be built up to considerable richness, too.

Illustration board (which is nothing more than paper mounted on cardboard) is used because it's relatively rigid and has a harder surface than watercolor paper. In this watercolor technique the paper surface really matters, for, as a lifting technique, the paper is being dampened again and again by the lifting brush or cosmetic sponge, and some papers can't take this kind of abuse. On a student-grade illustration board, the paper actually bubbles up and lifts away from the mount. On at least one other brand of quality illustration board the paper surface begins to fuzz up in little rolls, the paint no longer sits up on the surface but soaks in as if on a blotter, and the whole thing is best discarded. The Crescent cold-press board, however, has enough tooth to hold the watercolor and its surface allows you to work on it (within reason) indefinitely.

**Procedure** A careful drawing of the model is made using a standard no. 2 pencil and a kneaded eraser. Flesh tones and hair and clothing colors are applied in mid-light values over all the forms without having to think about leaving white paper for the lights and highlights. Halftones and even shadows are added and allowed to dry. A barely damp, clean sponge is used to begin the modeling in a lifting action,

pulling out the lights from the midtones and mid-lights. Color can be added with a barely damp brush and stroked on in a dry brush manner. When the larger forms begin to feel solid, the features are added. Dark accents are placed, and lights and highlights on smaller forms are lifted out with water on a no. 3 brush and blotted with a tissue. Edges can be softened with the large brush or made sharp, adding variation and interest to the portrait. The background may be given a light wash or left as clean, white paper, giving a contemporary air to the work.

A watercolor portrait in this technique can be strong and dramatic. The model should wear vivid colors. The silhouette of the head, hair, shoulders, and maybe arms or hands should make an interesting pattern, particularly if it is going to stand out from a white or very light background. Allow two sittings of two hours each.

**Materials** A 15" × 20" piece (¼ sheet) of good quality cold-press illustration board. Crescent is best; Bainbridge will do.

A drawing board (slightly larger than the illustration board); practice paper or sketchbook, 9" × 12".

*Watercolor paints:* In tubes, in the following colors: New gamboge (a clear transparent yellow); raw sienna (Winsor & Newton is best for its transparent gold color); cadmium orange (rarely used, but can brighten up a dull passage); scarlet lake (transparent and beautiful, a very *intense* light red—watch out for this one, you need only a touch in a mixture); brown madder (transparent, a deep red with no purple undertones); burnt sienna (an indispensable rust color, good darks with ultramarine blue, transparent); cerulean blue (good for cooling mixtures and shading whites); cobalt blue (transparent, a good blue to use in flesh tones); ultramarine blue (transparent, makes good violets in mixtures, good darks with burnt sienna, brown madder, or burnt umber, but when used in flesh tones turns them gray); viridian (transparent, good mixer, very useful); burnt

umber (a good warm brown, makes good darks); mauve (transparent, wonderful in halftones, a purple that does not take over in a mixture, good in darks or tints). Raw sienna, brown madder, and cobalt blue are used for the flesh tones in this technique.

*Brushes:* Sable, oxhair, or synthetic fiber—one-inch flat, no. 8 round, no. 3 round.

*Other supplies:* Palette (a folding metal palette or a John Pike palette are good choices, but even a large white dinner plate will do); No. 2 pencil; kneaded eraser; water (a pint or more in a wide-mouthed container); paper towels or tissues; natural sponge (called an elephant-ear sponge or cosmetic sponge); masking tape or clamps (to hold the paper to the board); spray bottle for water; hand mirror; easel; and a kitchen timer.

**Preliminaries** Pose the model in daylight, if possible, with the light coming from one source, such as a window. If it's a dark day and you aren't getting enough light to work by, you can use a clip-on utility light with a reflector, or a photographer's spot on a stand. A 200-watt bulb is fine. Just remember to place this auxiliary light at the window, as if the artificial daylight were coming from the same direction as the natural daylight. We're trying to avoid crossed lights! Set out the colors on your palette and spray them lightly with water.

Set the timer for twenty-five minutes and have the model sit on a high stool or on a chair in this light. Pick up your pencil and sketchbook and walk around the model looking for interesting angles and portrait ideas. Get into the habit of doing four or more thumbnail sketches before you begin the actual pose. This will loosen you up, relax the model, and help you decide how to portray the sitter. Choose the best pose or picture possibility from your sketches, allowing your model to have a voice in this decision if you wish. Usually you'll both prefer the same one. Don't choose anything too contrived or complex when trying out a new technique, though.

Stop and rest for five minutes.

During the break, set out the colors on your palette. We'll start with a limited palette of three colors for flesh tones and hair, from left to right: raw sienna, brown madder, and cobalt blue, at least half an inch of each color. Spray the paints lightly with water now to give them time to absorb the water while you're drawing. It's even better if you wet them down the night before. *Never* use little hard rocks of color. Watercolor must be moist to behave well.

**Drawing the Head** Model resumes pose. With a pencil, lightly block in the head close to life-size, visualizing the head as a large geometric form—an egg? A block? Perhaps a combination of both. Look for the cylinder of the neck, and put in the collar, then the shoulders. Place the horizontal eyeline and vertical center line on the face next. Block in the ear if it's visible. And if you see both ears, or eyes, draw them both at the same time. Squint and look for the boundaries where the light and shadow on the head meet; lightly draw them. This will help you place the features later.

Holding the pencil at arm's length (which forces you to stand back from your drawing) loosely draw in the features and the shape of the hair. Using vertical aligning, horizontal aligning, and relative measuring, plus the mirror, correct your drawing with the kneaded eraser until it satisfies you. Keep your pencil line light. If you make little grooves in the paper, the paint will settle in them later.

When you're satisfied with the drawing, sweep your kneaded eraser from side to side *across* the drawing, taking out about half of the pencil line. Do not erase up and down on the line for it will only smear it, but *across* the lines, leaving a broken-line drawing to help you place the color. (If we leave all of the construction lines, they will show through the transparent watercolor washes and spoil the portrait.)

This is probably the end of your second work period. It takes at least two, sometimes three, to get the drawing accurate. Don't hurry. Take the time you need for this important beginning.

## Portrait Demonstration

(Step 1) After the pose was decided upon, the figure was blocked in with pencil on a sheet of Crescent illustration board, cold press surface no. 300. Searching for geometric forms, I drew the construction lines of the head. I have tried for a strong, solid, large-scale look. The wrist is treated as a block. The index finger of the right hand has been completely drawn, even though it will be partially obscured by the letter he is holding in that hand. The body is drawn, and the clothing is drawn over it. The abstract shape of the chair has been indicated.

(Step 2—The completed drawing ready for painting) All the forms—the head, the features, the arm and hands, the shirt—have been refined. Vertical aligning, horizontal aligning, relative measuring, and the mirror have all been used to bring the drawing to this stage. Lines of demarcation between light and shadow areas on forms have been drawn. I have tried not to draw too tightly or with heavy black lines, so that improvement can be made when the paint is overlaid. Lines will be erased across the forms with the kneaded eraser before painting begins.

## Portrait Demonstration

(Step 3—First and second wash on flesh only) Using the one-inch flat brush, the first flesh tone wash of a mixture of raw sienna and brown madder has been painted on the head and hands and allowed to dry. The second flesh tone wash, the same colors mixed to a darker value, is painted in, working around the areas where the flesh is light and leaving those parts untouched. It is then left to dry.

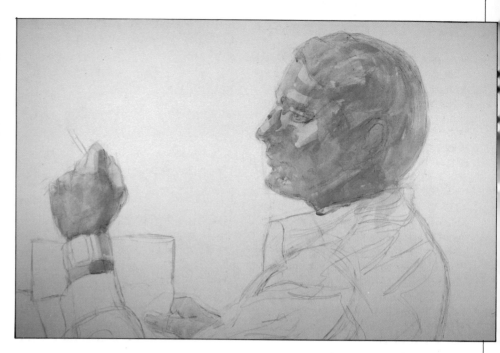

**Starting with Color** I recommend that you do the pencil drawing with the watercolor board *upright* on your easel for minimum distortion. You can leave it there when you begin to paint and catch the drips and runs, as I do, or you can prop it up on a table at about a 40-degree angle. Decrease the angle a bit now for these first washes, but whatever you do, please don't work completely flat on a table; the paint just won't act the same.

Notice that these pigments—raw sienna, brown madder, and cobalt blue—are a dark yellow, muted red, and clear blue. The brown madder and raw sienna will give you the warm you need and the cobalt blue will cool them. Without the blue, your portrait would look as if a very sunburned model had posed for you!

When the model resumes the pose, study the flesh color and mix up a fairly light wash to resemble its general color. Raw sienna is a very good base color to start, then add a bit of brown madder to warm it. With your largest brush, paint it over the whole head—face, neck, hair—quickly. Don't worry if it drips; blot it with a tissue or a clean barely damp sponge. Lay the wash on from top to bottom or side to side, but don't go back into it while it is wet. No matter what streaks or blobs or bubbles you have, leave it alone for now and let it dry undisturbed. If the color goes where you don't want it, mop it up with a barely damp and very clean sponge on the outside edges of the head shape.

When working with watercolor remember that it's always possible to lay one wash over another to make an area smoother, darker, to change its hue, or for any other reason—but only *after* the first wash is *dry*. It is easiest to work light in the early stages, then see how dark you need to go later for the eye areas, shadows, and so on.

**Shadows and Mid-darks** Now mix up the second wash, the shadow wash, with the same colors (brown madder and raw sienna) but using less water so it's darker. Decide on the value by studying the model and squinting. For this shadow lay-in, all the shadows are the same color and value. On the value scale of 1 to 7, if the flesh tone in light is a value 2, the shadow is value 5, mid-

dark. This is easy to say, but difficult to do. It's hard to get the values accurate in watercolor because the wash always dries lighter than it was when wet. About all you can do is to proceed with clean washes, one at a time, allowing each one to dry, always with the option of adding a second or a third wash when the portrait is nearly finished to get the values as deep as you want them.

To go on, with your large brush, lay in this warm, dark wash over the first wash wherever you see shadow, loosely defining the shapes of the forms—for instance, the eye oval, beneath the cheekbone, under the nose, perhaps the side plane of the nose, the upper lip, under the chin, within the ear, beneath the ear lobe. Paint hair shadows in this dark flesh color too, if the hair is darker.

Leave the first wash as is in the light areas. You don't want to cover the lights with shadow. Lay this shadow wash in quickly so you don't disturb the first wash and let it dry.

When the head is dry, lay a cobalt blue wash over the shadow areas to cool them and diminish their intensity.

Now, it's time to paint some of the midtones and darks in the clothing. Lay out the colors on the palette and spray them with water.

**The Hair** Decide what color the hair is. (Refer back to page 124 if you need help with this.) Lay in a proper middle value for the hair, and then drop in the darks. Let it dry. Wet the brush, squeeze it out, and with this barely damp brush lift out the lights and soften some of the edges where the hair meets the skin. Remember, hair has a very different texture from that of skin and should have some soft edges. You don't want it to look like a wig.

**The Background** Choose a color for your background and decide where it will be. Will it cover the entire board out to the edges? If you want to leave it white paper, just clean up the edges of the head and body silhouette with a sponge.

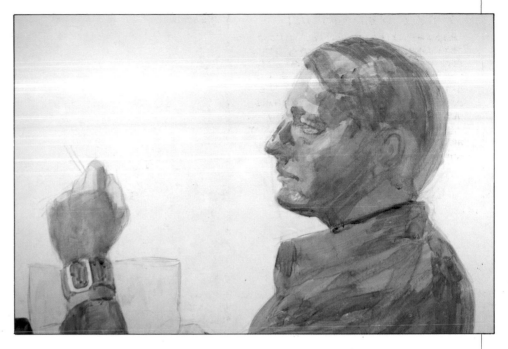

## Portrait Demonstration

(Step 4—Third wash, shadow wash, three values on shirt, two on hair, cobalt blue added) The flesh areas, having already received two warm washes, are now painted with a darker cooler color, a mixture of raw sienna, brown madder and cobalt blue. This is shadow wash, this time preserving the mid-light values by working around them and leaving them untouched. We have been building up the flesh tones, layer by layer, allowing each wash to dry before proceeding with the next.

The shirt has been painted with three progressively darker values. The jeans are just dark. The watchband has been painted leaving the white of the paper for the silver buckle. A gray wash is painted over the letter in the right hand and one brown wash on the hair over the flesh tone. Some fourth washes are laid in defining the eye socket, the sideplane and underplane of the nose, the downplane of the chin, the sideplanes of the face.

You will recall we said earlier that the whole principle of this technique is to get enough mid-light, mid-dark and dark values on the portrait so the lights may be lifted out and the facial forms modeled in this manner. We are still working only with raw sienna, brown madder and cobalt blue.

This is the end of the first sitting.

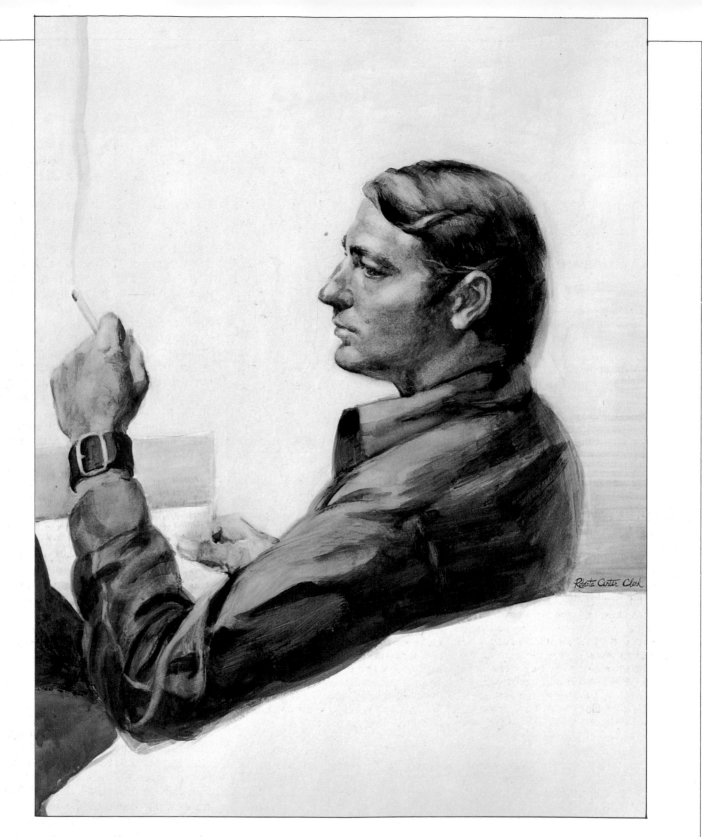

*Dean*
Watercolor: 40″ × 30″

## Portrait Demonstration

**(The finish)** Some mid-lights have been lifted from the shirt, carefully leaving the entire shirt darker than the flesh tones so it will read as a dark green. The cigarette has been painted in very simply. A pale ochre wash has been laid over all the background while the board was turned upside down so the paint would not run into the figure. The chair form has been left white paper. When this wash was dry, a gradated wash of gray was added to the right of the figure from clear water at the top to more concentrated color near the chair with the board right side up. The gray smoke was added. The smoke travels up and out of the painting as a design element at the top edge. The portrait was painted from life—Dean is my son.

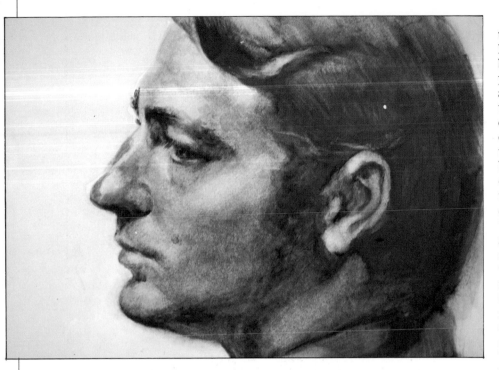

## Portrait Demonstration

**(Detail)** Here the texture of the paint on the board can be seen and its similarity to the visual texture of skin. You will notice the blues in the area from nose bridge to eye. The merest suggestion of eyelashes helps direct the gaze. The hazel eyes are nearly lost in shadow, as is the highlight in the eye. More pronounced is the light on the brow bone, the fleshy eyelid, the upper plane of the lower lid, and the shine at the bridge of the nose and below the tear duct. The temple is both warm and cool, one laid over the other. The shadow under the eye is mainly cool. Light is lifted out on the cheekbone which becomes warm and then abruptly darker as the plane changes on the side of the face. The top plane and side plane of the nose are indicated with warm color; the nostrils are lost in the underplane shadow.

Cools and warms interact in the muscles around the mouth and under the lower lip and chin. You need the cools in these areas, for a mature man has beard there even if he has just shaved. Squint your eyes and observe how the areas of the face step down in value from the light band on the forehead, the mid-light warm nose-cheek-ear band, to the chin and jaw band, which is *farthest from the light.*

You can lay a very pale wash over the background, or you could even have tinted the entire illustration board before you began the drawing. After you choose a color, mix quite a large amount of it. You might try a soft neutral green made from raw sienna and cobalt blue. (Greens and blues, cool colors, enhance the warmth of flesh tones). Lay this wash in with the large brush, up to and overlapping the hair edges. When it's dry, soften some of the hair edges with a clean, barely damp brush. (Some painters call this a "thirsty brush." It lets you move paint around without adding any water to the surface.) When the background is dry, take the damp brush and pick up some fairly dry hair color from the palette. Split the hairs of the brush by spreading them like a fan with your fingers, and drag a few of these drybrush strokes over the hair edges in places. This will give you another hair texture—fine lines—in addition to the soft edges of the hair mass.

Stop and allow a five minute rest for the model and artist. Change the paint water now. For painting flesh, the paint water must be *clean*. With tissues or paper towels, make a clean area on your palette for mixing flesh tones.

### Getting Ready for the Features

When your model resumes the pose, set timer for twenty-five minutes.

It's important to stop, think, and study the model before you go any further.

Begin to develop the under-construction for the features, the form of the brow, the cheekbones, and the moving muscles around the eyes and mouth. No small brush yet; stay with your one-inch flat or no. 8 round. You are working from midtone to dark.

Always let one wash dry before you add another. If you do this you won't get muddy color. This process is called glazing.

Look for the planes of the nose: top, side, and underplane. Perhaps a third wash of raw sienna and brown madder will define them. To be safe, you could apply one color at a time and not mix them on the palette at all. The nose, cheeks, and ear band are warmer than

the forehead so perhaps more brown madder is needed in that section.

Move down to the neck. Is it darker? Cooler? Does it need another shadow wash? A cool blue wash? The neck can never be as light as the forehead. Remember, let each wash dry before over-painting.

**Lifting out the Lights** Before you do anything else, change the paint water. Then, squinting hard, decide where the lightest light is—usually on the forehead. Take a clean, damp sponge and lift out this light area from the flesh tone. Try not to wipe it along or you'll smear the color. If it's still not light enough, rinse the sponge and try again. Repeat until the highlight is the shape and size you want.

Using this lifting process, move on to the next highest light. Is it the cheekbone? Proceed down the face and then to the neck and collar. The lights in the hair can be picked out too. If the sponge is too large for the smaller lights, you can use a brush. Wet the brush and touch just the spot you want to be lighter. Wait a moment, then blot with a clean tissue. Repeat with clean water and clean tissues until you attain the result you want. Just be sure to wash the brush out after every light, or you will be redepositing the color instead of working your way down to the clean paper surface.

Lifting out with a sponge or brush takes practice, but you'll soon find it quite easy. The Crescent board allows you to lift again and again without disturbing or roughing up the paper surface. Since we're using only nonstain-

ing colors, you should not find it difficult to lift them. If the particular area you're working on is getting soggy and the color isn't coming off cleanly, stop and let that part dry. Then you can go back into it with the damp sponge or brush and get better results. You can even scrub lightly with just the wet *tip* of the brush hairs to loosen the particles of pigment before you blot in a particularly stubborn spot. Lifting is the essence of this technique. I am sure you will master it.

Stop and rest. You've been working for 2 to 2½ hours. Ideally, it's time to stop for the day.

## The Second Sitting

Now you can see your portrait with a fresh eye. Set out new colors and spray them lightly with clean water. As you study the model, you may see changes you want to make before you proceed. When you resume work, paint in the eye color in the iris, then paint the upper lid, the shadow cast on the eyeball by the upper lid, and the shadow under the lower lid. Mix your darkest dark and put in the dark pupil. With a fairly dry brush and a light touch, put in the eyebrow. With the warm brown madder and perhaps a touch of red or orange, touch in the nostrils, inner corners of the eyes at the tear ducts, ears, and mouth. As we know, all openings in the head are *warm*.

Look for the shadow areas in the mouth and paint them. Perhaps the corners of the mouth, then the upper lip. Just remember, in any medium we never outline the mouth. Define the lower lip by laying the shadow beneath it. Add a touch of dull green (raw sienna/cobalt blue mixture) under the lower lip. If the whites of the eyes are darker than they should be, lighten them by lifting out. Also lift out the highlights you see in the hair.

**Finishing the Portrait** For the small bright highlights in the eyes, proceed as follows: Dip your no. 3 brush in clean water and shake off the excess. Touch the spot where you want the highlight to be, let it sit a moment but don't let it dry, and immediately lift the dot with a clean dry tissue. Don't

smear it; just lift it. You will have a clean highlight. If it's not light enough, let it dry and repeat the process. To get a crisp highlight, you can't niggle with it very much.

If the light is not right, lay in the eye color again, let it dry, and proceed once more with the clean water dot. Any small highlight can be attained this way—the light on the edge of the lower eyelid, the light on the lower lip, the highlight on the nose, the sparkle on jewelry.

If you need a brighter highlight in the eye, pick it out with the corner of a razor blade. You only get one chance at this, for you're cutting into the white paper beneath the paint. Keep this highlight small. Carefully decide where you want it, then, with one deft stroke, nick the paper surface. Done!

Continue working this way, adding halftones and shadows, subtracting lights, letting the painting dry between each step until you complete the portrait. Don't forget to check it in the mirror frequently. You can complete a profile in four hours, but it's advisable to split the time into two two-hour work sessions. After two hours of intense concentration, you're weary and less capable of making the fine judgments of value and color necessary to bring the portrait to a happy conclusion.

**Accents** These darks can strengthen the portrait and give it life and sparkle. You'll find accents at the corner of the mouth, in the eye, on the hair, and under the collar. Placing the darkest accent next to the lightest light—for instance, the highlight in the eye—is a wonderful way to add life to the portrait. Squint and search for these small darks. Just remember, *never* place the dark accents *in* the light areas! Lights are lights and darks are darks. Do your best to keep them that way.

Even when the entire head is finished, if it looks too pale or too cool, you can mix a warm colored wash and glaze it over the entire head. If you use your large brush and work quickly, the existing image won't be disturbed. Of course, the painting underneath must be thoroughly *dry*.

---

*Hint:* When working in watercolor, keep it clean. Don't mess around in previously laid wet paint.

In these transparent watercolor techniques, the only white is the paper shining through the layers of paint. No white paint is used.

Accept the fact that you will be spending more time thinking about what you are going to do next than actually doing it.

---

# *Step-by-Step:* **Painting the Features in Watercolor**

As these features belong on a man's face, they are painted in stronger shapes and bolder colors than the features of a woman or a child.

The palette consists of raw sienna, scarlet lake, cerulean blue, cobalt blue, burnt umber, olive green.

This is direct painting on 140-lb. Arches watercolor paper.

1. An initial wash of raw sienna mixed with scarlet lake is painted over the entire eye area and allowed to dry. With a mixture of raw sienna, scarlet lake, and a touch of cerulean blue to cool the color, the eye, eyebrow, and structure around the eye opening are painted and allowed to dry.

2. Shadows, brow, and structure are strengthened with a darker mix of these same three colors and allowed to dry. Lay in the color of the iris. A still darker mix of these three colors is painted in at the edge of the upper eyelid running right into the iris. Leave a break in the lid-line and leave the highlight in the eye so the initial wash shows. Let dry.

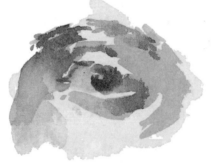

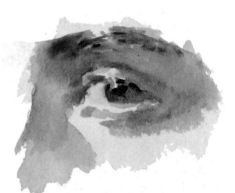

3. Cerulean blue is added to cool the area between the bridge of the nose and eye; also over the "whites" of the eyes. Scarlet lake is dropped into the inner corner of the eye and a bit above while the blue wash is wet. Let dry. A darker warm mix of raw sienna, scarlet lake, and cobalt blue defines the eyebrow in short strokes and broken lines, and is also brought down with water over part of the blue area and into the fold line of the lid and definition of the lower lid. The light edge where the lower lid catches the light is left unpainted. Let dry.

4. Finish. Accents of cobalt blue and burnt umber mixed together define the brow further. A darker warm flesh mixture of raw sienna, scarlet lake, and cerulean blue covers the fleshy area between the eyebrow and the fold of the eyelid, and further defines the lid and the area surrounding the eye opening. I painted the pupil with the darkest dark I could make with cobalt blue, burnt umber and scarlet lake.

1. An initial wash of raw sienna and scarlet lake is applied over the nose area and allowed to dry. Using a slightly darker mixture of these same colors, I indicated the placement and structure, thinking about the top plane, side planes, and underplane. Hard edges are left next to lights for clearer definition. Paint up to the eye, down to the lip, leaving light areas *untouched.* Let dry.

2. Here, I further defined all forms, still using only raw sienna and scarlet lake, but darker. Lights are left untouched. A light wash is painted over the top plane where the fleshy ball of the nose begins, and allowed to dry.

3. A cerulean blue and cobalt blue wash is added at the keystone area where the nose becomes the forehead, at the inner eye area and on the face between nose and lip (the moustache area), and on the far cheek. While wet, a darker warm wash as in Step 2 is added, further defining the nose and far cheek, isolating the lights, and let dry. A stroke of warm dark indicates the nostril, fleshy wing of the nose, and a touch is painted on the eyebrow. Let dry.

4. Finish. With the darkest warm color (a mix of raw sienna, scarlet lake, and a bit of blue) accents are added defining the underplane of the nose, pushing against the highlight at the bridge of the nose, hitting the bit of eyebrow and corner of the eye one more time. Highlights on the ball of the nose and at the bridge are painted around and left the color of the initial wash in Step 1. You may want one more warm mid-dark wash, and one more blue wash near the eye and on the lip area. Keep fleshy areas of the nose *warm.*

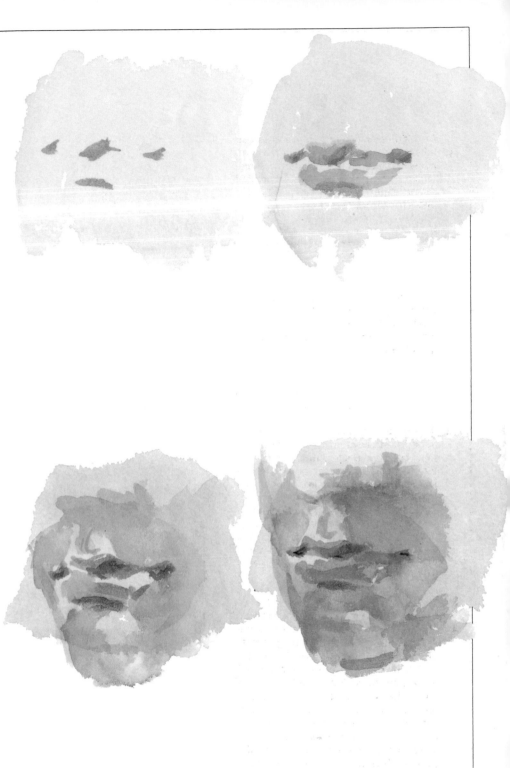

1. An initial wash of raw sienna and scarlet lake is applied all over the mouth area and allowed to dry. With a mixture of raw sienna, scarlet lake, and a touch of cerulean blue, the mouth is placed by indicating the corners, upper lip and lower lip in a most minimal way. Let dry.

2. A light wash of raw sienna and scarlet lake is painted on the upper and lower lips in a broken manner to avoid hard edges around the lips. The light on the lower lip is left as the first wash.

3. With a darker mix of raw sienna and scarlet lake the halftones are painted, indicating the structure of the mouth up to the nose and down to the chin. While wet, cerulean blue is floated in on the moustache area and lower chin; a stroke of olive green is painted under the lower lip. When dry, more definition of the "muzzle" and chin area is made with the warm mixture allowing the light areas to remain the light value of the first wash.

4. Finish. More definition of the "muzzle" area around the mouth with a cerulean wash, a warm, slightly darker flesh mixture, and an olive green wash. Put each wash down and allow it to dry before applying the next. This way you avoid the muddy colors you would get if these warm and cool colors were mixed on the palette or wet-in-wet on the paper. Again, allow the edges of the washes to remain, to show. A more masculine appearance is achieved when forms and edges are not "smoothed out." Minimal dark warm accents were added at the corners of the mouth and the center of the upper lip and under the lower lip. No line is ever painted *between* the lips. A bit more definition of the chin and far cheek was added with a deeper flesh tone.

# Direct Painting Method

This technique is freer and less developed than the first. It looks easier and *is*, in a way, but only after you have had a little more practice painting the head in watercolor. The first method, working on illustration board and modeling the head by lifting with the sponge, gives you more *control*, and it's better to be able to work in a slower, more precise way at first. Both methods involve transparent watercolor and use the white of the paper for lights, rather than white pigment.

On this portrait we'll be working on a good-quality watercolor paper. We draw the portrait in pencil quite loosely. We're not concerned with detailing the features but are looking for expression and a feeling of spontaneity.

This is a free watercolor style, more interpretive than realistic, and utilizing the watercolor medium to its full advantage. Transparency and clean color take precedence over carefully modeled forms. Each part—the face, head, hair, clothing—is executed in three or four values. Then accents are added, a highlight or two lifted out, and the portrait is complete.

**Materials** 20″ × 24″ sheet Arches 140-lb. cold press watercolor paper cut from a 22″ × 30″ sheet. Plywood or Masonite board slightly larger, with clips or masking tape to attach the paper to the board.

Watercolor paints: In tubes, the same colors as in the previous watercolor technique plus the following: yellow ochre (a dark yellow, wonderful mixer in flesh tones), raw umber (the darkest yellow, a rich gold brown), alizarin crimson (transparent deep rich red, good in flesh tones when very diluted; makes good warm darks with burnt sienna or burnt umber; makes lively purples).

The rest of the material, including brushes, is the same as before.

**Lighting, Pose, and Preliminary Sketches** Arrange the easel so there is good light on your board, natural or artificial; set up your materials and begin the pose. Set the timer for twenty-five minutes.

Begin with at least four thumbnail

sketches of the head, two or three inches high, in your sketchbook with pencil, moving around the model, selecting different views. These preliminary sketches should be standard practice whenever you have a new sitter, for this is the best way to familiarize yourself with this particular person. Have the model assume various attitudes until you find one that is comfortable for him or her and interesting for you, the one you cannot wait to paint!

Stop. Let the model rest for five minutes.

**Placing the Head and Blocking It In** Begin the pose; set the timer. Step back eight paces and visualize the head on the paper. Holding the pencil at arm's length, lightly block in the life-size head, thinking about placement on the paper. Reduce the hair mass to an abstract shape. Now draw the neck and the collar passing around behind.

Put in the horizontal and vertical construction lines for placement of the eyes, brows, nose, ears, and mouth.

Squint and look for the places where light turns into shadow and lightly draw in these boundaries.

**Drawing the Features** Next, sketch the features: eye ovals connected to the shapes at the brow bones, the temples, and, at the inside corners, to the bridge of the nose, the keystone and the side planes of the nose. Work down and around the muzzle area, the corners of the mouth, and the line between the lips. Then move to the chin and jaw, then the ears. Refine the hair, the edges where it touches the face, the movement in the hair. Is it wavy? Curly? Establish what it is that makes *this* hair unique.

Decide just how much of the ears you can see. Perhaps you will have to draw the hair over them.

Check your drawing in the mirror and correct it. An accurate drawing makes it easier to get a spontaneous, unworried feeling later. Just keep it light!

**The Flesh Tones** Study your model's coloring and mix yellow ochre with a touch of scarlet lake to make the over-

all flesh tone. (Be careful, scarlet lake is a very strong color!) With the one-inch brush, paint this wash over the entire head and neck—eyes, hair, and all—quickly. Mop up any drips and *never go back* into the wash while it is wet. The secret of success here is to make this wash in one pass, so be certain you have enough flesh color mixed beforehand. Now let it dry.

Don't worry about streaks or blobs now. Most "mistakes" at this stage won't even be visible later.

Now mix a second slightly stronger wash of the same two colors. In another place on your palette, mix a third wash of yellow ochre, scarlet lake, and a little cerulean blue to cool the color and diminish its intensity. Lay the second wash into the midtone areas working broadly, leaving the first wash untouched for the lights. Let it dry.

Timing is essential in watercolor—knowing when to go back into the painting and when to wait. This can't be taught in any book, but you'll learn it by working and making a few mistakes. After you paint a passage, look at it from the side. If you see the sheen of the water on the paper, you'll know it's wet and you'll have to wait a bit before going back into it.

*Note:* After you have laid the first flesh wash, feel free to paint elsewhere on the portrait. Remember, it doesn't make sense for me to tell you in what order to paint the parts—the flesh, the background, the hair, the clothes. You'll develop your own system. Never doubt yourself. You may feel you won't know how dark to paint the flesh until you put in the deep blue of the shirt. So paint that next and you'll be right. Since all color is relative, the flesh tone that looks perfect with a white shirt may fade out next to an intense red scarf.

**Correcting Flesh Tones** Study your work. Should the face be more rosy? More golden? Mix another wash and gently lay the correct color over the area.

When the face is dry, plan where the third wash, the one with cerulean blue in it, should go. It could be the lower third of the face, or the receding planes

of the face going back into the hair, or the cooler areas around the mouth. To add more color or a deeper value to only a section of the face, lay a wash of *clear water* in that area first and while it's still wet, drop in the color. You'll see it spread softly in the wet spot as the water does the work of carrying the color. With this method you will avoid hard edges around the newly added color. Take the board off the easel and tilt it to encourage the color to flow in a particular direction.

At first this may be alarming, but after your tenth watercolor portrait you won't be so nervous when the ochre drips into the blue, the red runs up and over the eye, and a few hundred other things occur that let you know you're out of control! In all honesty, this very unpredictability is in itself why so many artists are fascinated with this elusive medium. Have faith! With

good paper, clean water, and clear mixtures, you will get unbelievably beautiful effects that will keep you coming back to try again.

The most discouraging thing that can happen to your watercolor portrait is having your flesh tones look muddy. This happens when you mix warms and cools together on the palette. The fool-proof way to avoid mud is to mix the colors on the painting instead of on the palette, and to lay a wash of only one color at a time. First, yellow ochre; when dry, pale scarlet lake; when dry, pale cerulean blue wherever you want cooler color. Then repeat the ochre, scarlet lake, then alizarin crimson, each one by itself with plenty of water. Try this method. Successive washes, one color at a time, was the traditional method for the early English watercolorists and they achieved superb luminosity with it.

## Portrait Demonstration

**(Step 1)** Rather than the solid, masculine forms of Dean's portrait, here we search for the grace and softness of this very feminine child named Rebecca. The drawing has been carried out with repeated curving lines and rounded shapes. No shadow boundaries are indicated.

This portrait was painted at night in artificial light, general overhead room illumination plus one spotlight with reflector on a stand with a 200-watt bulb, to the right of Rebecca.

**(Step 2)** You can see the first wash of yellow ochre and scarlet lake has been laid over the pencil drawing on the face, neck, part of the hair, the arms and hands. A wash of yellow ochre and alizarin crimson is applied to the background, leaving the top third white paper. Alizarin crimson is painted on the blouse and spills over into the jumper where cerulean blue mixes with it on the paper.

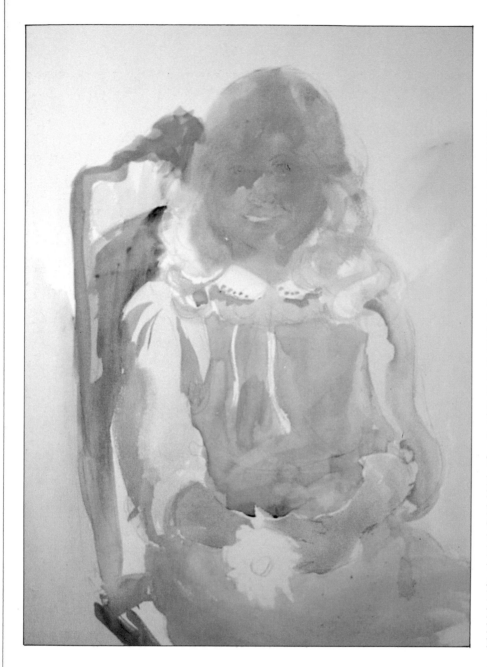

## Portrait Demonstration

(Step 3) A second wash is laid on the flesh area and begins to define the features, some shadow areas in the hair, and the cast shadow on the neck. A second wash also goes in on the hair, chair, blouse and jumper.

**The Background** Decide what you want to do with the background. Is it to be a plain color? Choose one that will set off the sitter's hair and complexion. You can gain harmony of color if you use the colors of the head in the background; just mix them in different proportions. More yellow ochre and cerulean blue will give you a muted green; scarlet lake and cerulean blue, a violet. You have great latitude here for again you have varieties of the three primaries, yellow, red, and blue.

Mix up plenty of paint and lay it on all around the head and shoulders, and even into the drawing, so the hair, costume, or complexion overlaps the background in some places and doesn't just meet it with a hard edge. Plan on the background color going out to the edge of the paper in at least one place so the head is not surrounded by a halo of color surrounded by white paper. If you want color variation within the background, drop another color into it while wet and let it blend as it will.

**The Hair** Mix a wash that approximates the middle value and general color of the hair (not the highlight or the shadow). With the one-inch brush, lay it over the hair area, working around the highlights so your initial flesh wash serves as the highlights. If the edges of the hair are too hard, soften them with a barely damp clean brush after the paint has dried. Stop and rest five minutes.

**The Features** Thinking in terms of planes of light and shadow, develop the features. I always think the easiest place to start is with the eyebrows. You can paint them drybrush if you like—with a squeezed-out and split brush. Leave a light area, however small, where the light hits the brow bone. Add the iris in both eyes, leaving a highlight if you can; then the dark pupil. Then do the shadow under the upper lid and lower lid, leaving the top plane of the lower lid light.

You may not have to do much for the nose. Paint the halftone alongside it, the shadow under the nose, and warm nostrils if you see them. To define the ball of the nose you may have to add some warm color there; while doing this, try to leave the highlight on the nose light. Then put in the local color of the upper lip, then the lower lip, trying hard to work around the highlight on it. Do you see the cool shadow under the lower lip? Reread earlier sections of the book if you need to refresh your memory about the forms of the features. Keep your color warm when working on the curves of the ears.

**The Neck, Shadows, and Reflected Lights** The neck is usually cooler; wash in a tone with a touch more blue or green there. As the cheek turns away from the light, you may see a reflected light bouncing up on the jaw or under the chin. Is it warm or cool? Try not to allow this area to be as light as areas in the light, for it is still within the shadows. Sometimes there is stronger color in this reflected light—it may be quite orange—which lends a decided glow to the face.

**Clothing** If the costume requires it, you may want to use some of the other colors here. Use the same method as for the head: Brush a light wash over the entire mass and let it dry. Then lay in a darker wash where needed. If the clothing is white, leave the white paper showing and try clear cerulean blue for the shadows. This gives an immaculately clean look to your whites.

**Accents** You will surely need dark accents in the hair, eyes, corners of the mouth, and under the collar. Look for them, and check it all in the mirror.

**Highlights** In this technique, we didn't lift out the lights as before, but instead planned them before we painted and then worked around them. However, if there are one or two areas where a highlight was covered inadvertently, of course you can lift it out with the small brush and a dot of water. Use this same procedure for the highlights in the eyes, if they aren't bright enough. If you want them *very* white, you can always scratch them in with your fingernail after you dampen the area with clean water. Remember, not too large!

This entire procedure should have taken about 2½ hours. Face the painting to the wall until tomorrow. Only then will you be able to decide if you are finished or if you want to do more. This technique loses its freshness if many corrections are made, but after you spoil a few watercolors, you'll learn how much you can alter without totally destroying the piece. In watercolor, it is often better to lay the first painting aside and do another than to try to make corrections, using what you learned from the first attempt to achieve a better result the next time.

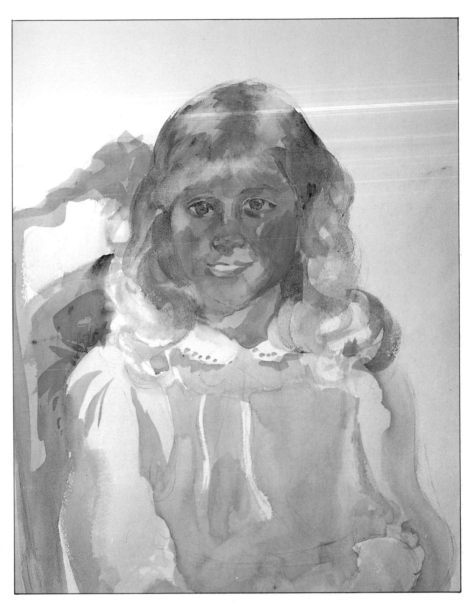

*Portrait Demonstration*

**(Step 4)** A slightly more subtle flesh color of yellow ochre and alizarin crimson is painted on the face, and the facial forms become more evident. The hair is developed in raw umber and cerulean blue in a free and rhythmic movement of the brush. Lights in the hair are left as is. The blue of the eyes, cerulean blue with a touch of raw sienna, is dropped in, leaving the highlight the pale flesh tone of the first wash. The eyes are cooler than the dress. The beginnings of the nose, eyes, and mouth forms appear.

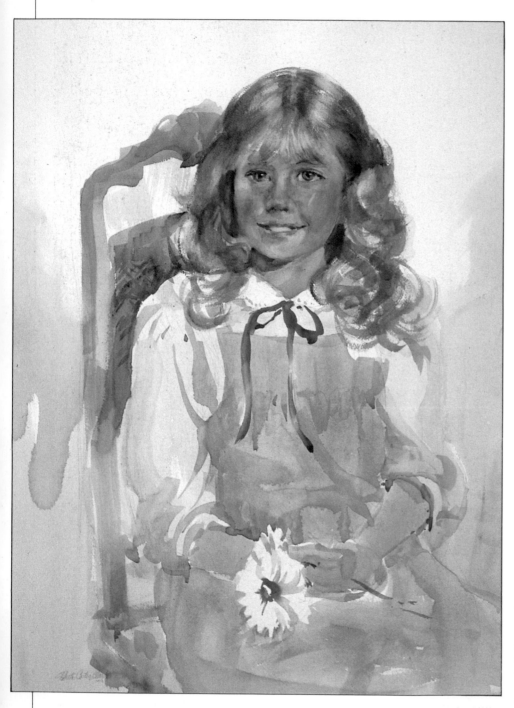

*Rebecca*
Watercolor: 30″ × 22″

## Portrait Demonstration

(The finish) A burnt sienna and cobalt blue wash is added to the chair, cooler where the shadow meets the shoulder and sleeve. The very long vertical of the chair back must be broken up; the color varies from warm to cool, with mid-dark at the top to light, to mid-tone, to cool, to very loose splashes of color on the chair seat, both warm and cool.

A bit more raw sienna and some burnt sienna and cobalt blue are added to the hair. Some lights in the hair that were covered with paint are lifted out with the sponge. (The sponge leaves a very soft edge.) Some light streaks on the bangs on the forehead are lifted with the damp brush. Dark warm accents are added to the hair in places.

The facial forms and the cheeks are developed with warm flesh-tone washes, leaving the highlights as the first wash. Side planes of the nose are added, and the ball of the nose is rounded. Some cool color is touched in between the inner corners of the eyes and the bridge of the nose, on the shadow side of the nose, and around the mouth.

The eyelash-eyelid line is painted with a blue and brown mid-dark. The iris is outlined with the same colors; the pupil added with burnt sienna, ultramarine blue, and alizarin crimson, dark. Warm marks at the tear ducts are burnt sienna and/or scarlet lake.

The smile line on the cheek is painted only slightly darker than the darkest flesh wash: we don't want heavy darks on the face of such a young person. The parted lips are put in *very* loosely with broken strokes of rosy flesh tone. The teeth area is left as the first wash. Deeper warm (alizarin crimson and burnt sienna) accents define the smile with *no line* across the mouth.

Pale blue washes are added to the lower sleeve areas to tie the sleeves to the dress visually. Pure alizarin crimson is added for the ribbon bow, also broken into light spots on the long lengths.

The orange of the flower center picks up the facial and hair colors, allowing your eye to travel back and forth without really detracting from the head. The tiny strokes of green stem are a pleasant color note, a cool. Total sitting time: One hour and forty-five minutes.

# Other Approaches to Watercolor Portraiture

## Sargent's Bold, Incisive Brushwork

John Singer Sargent was a master at the incisive brush stroke in oil and watercolor. When he squinted his eyes and looked for the big forms, he did not see the form of the head against the background but the light mass of the face against the dark shadow side, which melded into the background. The lights and darks were developed here without features or accents, just a solid shape. The eye on the light side doesn't disturb the solid form by making a dark cavity there but rather floats upon the light form. Each accent was studied and laid in with a bold direct stroke and left alone, not niggled with. Note the "marks" for eyebrows, the vertical between the brows, the eye socket construction, nose, nostrils, and moustache; the determined and definite dark hair shape against the light boundary at the left side of the face. The only spot that looks as if he *may* have lifted the paint with the sponge or brush is in the beard where it meets the vest. The hand is incredibly masterful.

And after saying all this about the paint handling, we would be doing Sargent a disservice if we overlooked the intense expression of the man in the portrait. The direct gaze. Thoughtful. Reserved. Dignified.

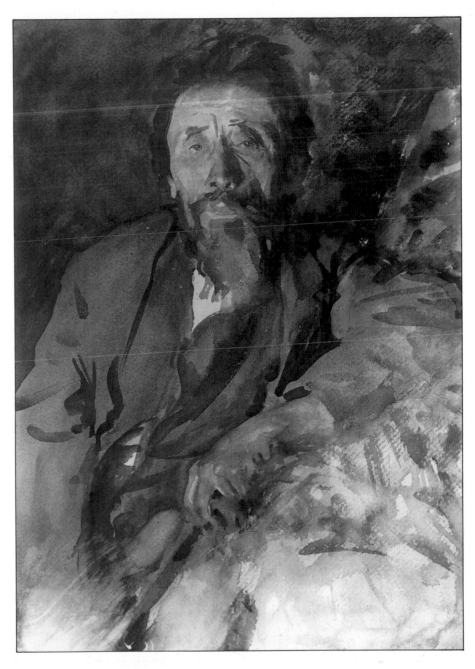

John Singer Sargent (1856-1925)
*A Tramp* (after 1900)
Watercolor: 19¹¹/₁₆″ × 13¹³/₁₆″
Collection: The Brooklyn Museum; Museum Purchase

## Spontaneous, Unposed Portrait

*Hard Hats* is not, of course, a commissioned portrait. It's a "group portrait" I painted to enter exhibitions and competitive shows where a commissioned portrait would not be acceptable.

I saw these fellows on their lunch break sitting in front of the window of a bank on the corner of a busy intersection in New York City. They were ironworkers constructing a new skyscraper just across the street. It was fortunate that I had my camera around my neck ready to shoot. I asked them if I could take their picture and they smiled and I quickly snapped the shutter. As soon as I saw the developed photograph, I knew I had to paint it, although this whole idea was a new departure for me.

This painting is included here to help you to realize another way of using your portrait painting skills; the possibilities are endless. Working from a candid photograph, the thinking and planning about what to leave *out* is the most important part. The dark of the window is as dark as I could get it; I used ultramarine blue and burnt sienna intermixed mostly on the paper rather than on the palette, as it seems to stay darker that way. The remaining values are keyed to the midtone shadow value on the ledge and the wall, which actually appeared much darker. In the photograph these cast shadows were black. I simplified the figures considerably.

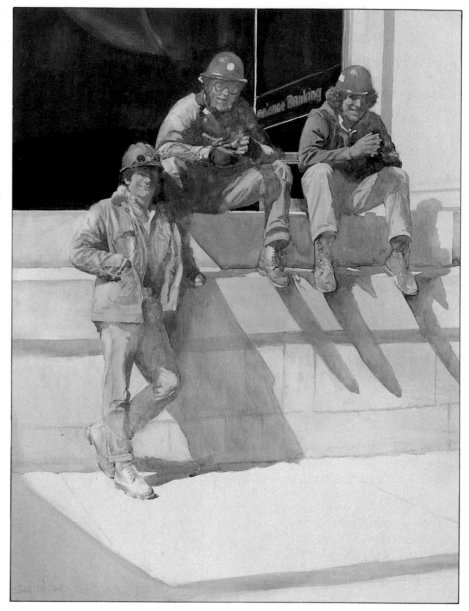

Roberta Carter Clark
*Hard Hats*
Watercolor on illustration board: 40″ × 30″
Collection of the artist

# B I B L I O G R A P H Y

**Drawing and Painting in General**

Chaet, Bernard, *An Artist's Notebook, Techniques and Materials.* New York: Holt, Rinehart and Winston, 1979. A general handbook of materials and techniques, this book is filled with information not found elsewhere, to my knowledge, such as how to make your own stretchers, recipes for making ink, varnishes for oil paintings, for grounds. Useful.

Edwards, Betty, *Drawing on the Right Side of the Brain.* Los Angeles: J. P. Tarcher, Inc., 1979. On perception. An interesting concept, particularly for people who are a bit shy about attempting to draw.

**Figure and Portrait Painting**

Bridgman, George B., *Bridgman's Life Drawings.* Studies of the human figure in motion. Also *Heads, Features and Faces; The Book of 100 Hands; The Human Machine; Constructive Anatomy.* All, New York: Dover Publications, Inc., 1932-1974. Bridgman was a dedicated teacher at the Art Student's League and trained thousands of artists. Every one of his books is packed with clearly written and ably drawn information. The style of the figures is heroic, but this only helps to get the point across. You will use these books for years and years.

Gordon, Louise, *How to Draw the Human Head.* New York: Viking Press, 1977, 1979. Penguin Books, 1983. Written by a woman trained as a medical illustrator, this book offers exceptionally clear and uncomplicated drawings to help the artist understand bone structure and muscles of the head. I cannot imagine any portrait painter not benefiting from this little book. Essential.

Nicolaides, Kimon, *The Natural Way to Draw.* Boston: Houghton Mifflin Company, 1941-1969. Presently in print in paperback. A complete program in drawing the figure, from contour drawing to gesture drawing, from basic to highly sophisticated ideas. The person who spends time investigating this book cannot help but benefit enormously. I would call this book essential. You will still, however, need live models to pose for you.

Ruby, Erik A. *The Human Figure: a Photographic Reference Book for Artists.* New York: Van Nostrand Reinhold, 1979. The first time I saw this paperback book I really couldn't believe it; it consists of over 600 photographs in black and white and without distracting backgrounds, of male and female figures from 2 to 75 years old, in action and in repose. Numerous heads, hands, eyes, noses, mouths and ears are here as well. Extremely useful for any artist who wants to practice his drawing and has no model from whom to work. Large format too.

**Specific Artists**

Dunlop, Ian, *Degas.* New York: Galley Press, a division of W. H. Smith Publishers Inc., 1979. This is only one of a number of books on Degas.

Haak, Bob, *Rembrandt: His Life, His Work, His Time.* New York: Harry N. Abrams Inc., 1969. This is only one of many books on Rembrandt.

Pach, Walter, *Renoir.* New York: Harry N. Abrams Inc. 1960. Many books on Renoir are available too.

Charteris, The Hon. Evan, K. C., *John Sargent.* New York: Charles Scribner's Sons, 1927. This book is mentioned here even though it is long out of print. It was written just two years after Sargent's death by someone who knew him in life. A very chatty biography of the artist, his dealings with portrait clients, remarks from his students, his habits and thinking about painting, and the way in which his paintings were received by critics and contemporaries when they were first shown. Well worth searching out. Very few black and white reproductions.